QuickTime for Filmmakers

QuickTime for Filmmakers

Richard K. Ferncase

ELSEVIER

AMSTERDAM • BOSTON • HEIDELBERG • LONDON
NEW YORK • OXFORD • PARIS • SAN DIEGO
SAN FRANCISCO • SINGAPORE • SYDNEY • TOKYO

Focal Press is an imprint of Elsevier

Focal Press is an imprint of Elsevier
200 Wheeler Road, Burlington, MA 01803, USA
Linacre House, Jordan Hill, Oxford OX2 8DP, UK

Library of Congress Cataloging-in-Publication Data
Application submitted.

British Library Cataloguing-in-Publication Data
A catalogue record for this book is available from the British Library.

ISBN: 0-240-80496-1

For information on all Focal Press publications
visit our website at www.focalpress.com

03 04 05 06 07 08 10 9 8 7 6 5 4 3 2 1

Printed in the United States of America

"There's only one thing that can kill the movies, and that's education."
—*Will Rogers (1879–1935)*

For Anita~
Rop på sommeren så kommer den
. . . og det gjorde den jammen

Contents

Preface

"Only connect!"

—**E.M. Forster**

When I was a graduate student in film school at UCLA many years ago, I sat in on a seminar class led by a high-profile movie producer (and one-time president of Sony Pictures). He exhorted the group to stop thinking about just trying to make movies and think about the entire field of entertainment. I found this heretical at the time; back then you were still either a "film person" or a "video person," and there was a great deal of debate on the superiority of one over the other. It took a while to sink in, but surely enough, I began to think that the concepts of "entertainment" and even "storytelling" were too limiting. After all, there was also art, education, communication, and more to think about. I realized that to connect with others through your medium was foremost, but it was a difficult task to complete if you were strictly a "filmmaker." You needed something that the painter and the photographer take for granted. All you needed to enjoy their works were your eyes. To complete the connection from the artist to the audience in the medium of film, you needed a projector, a theater, or at very least, a television and VCR. And the film you made often never made it past a small circle of friends, family, and acquaintances. There had to be a better way.

The filmmaker has never had an easy time getting his or her work on the screen. It has become relatively painless to write the scripts using computers and word processors; easier to shoot films using lightweight, affordable equipment; cheaper using digital video tape; and much easier to edit them using the revolutionary nonlinear editing programs. The one elusive element has remained distribution. Indeed, the entertainment industry has kept a closed gate on this avenue since the days of the Motion Pictures Patent Company, and simply connecting with an audience continues to be the most difficult part of the film to complete.

The lock on theatrical distribution, exhibition, and broadcast is as strong as ever today. But today's filmmaker has an option not available to their predecessors: the Internet, specifically the World Wide Web. And the best solution for Web delivery of motion pictures? QuickTime, hands down. No less a figure than *Star Wars* creator and director George Lucas chose QuickTime as the medium of choice to deliver his groundbreaking movie trailers (previews) of his long-awaited *The Phantom Menace* on the Web exclusively in QuickTime. QuickTime movie trailers routinely win accolades as simply the highest quality film experience to be had on the Web.

This book is for filmmakers, photographers, and artists—independents without a lot of money to invest in capital-intensive distribution. I've centered most of the discussion in this volume around QuickTime Player Pro, Apple's $29.95 editing, compression, and

presentation software, because it is so versatile and so inexpensive. Most of the topics in this book deal primarily with this application, but because QuickTime itself is multimedia architecture, a wide array of software applications takes advantage of its many benefits. You will find a number of tutorials and discussions on QuickTime as it is used in these other applications, and you are encouraged to download the demonstration versions of the various applications to see just how far QuickTime can take you. But you can explore much of QuickTime simply by using the QuickTime Player Pro, and that's what this book is about.

The computer, the World Wide Web, and other digital technologies, such as satellite delivery, are changing the way we watch film. A computer display is not a movie screen, or even a television set, you may say. You are right. The computer display far outpaces the television screen in terms of resolution alone, allowing scalable (playable at any size) video. A computer screen offers a wider gamut, translated into many more colors and shades of gray. And the computer screen provides infinitely better gamma characteristics, with blacker blacks than television can muster.

If your computer uses the Windows platform, you are probably wondering: "I have a PC, so wouldn't Windows Media Player be a better choice for putting my movies on the Web?" Not at all. Windows Movie Player (WMP) is a fine product capable of streaming and playing high quality video and audio. Windows Movie Player is particularly well suited for streaming content. If you want to do Fast Start or progressive download movies, however, QuickTime is a much better choice. And if you are interested in going beyond the limits of mere linear video and audio and want to explore Virtual Reality (VR), interactivity, custom media skins, seamless integration with Macromedia Flash, and other applications, QuickTime is hands-down your best choice. QuickTime provides superior playback capabilities over Macintosh as well as Windows platforms. QuickTime has embraced the new Web video standard MPEG-4 so that you can encode and play all media compressed with this protocol, which WMP does not and will not support. It may be prudent to offer your media in other player formats as well as QuickTime, but deliver in QuickTime as well, if only for all the options. George Lucas decided on QuickTime early on as the Internet media architecture of choice for his Internet movie trailers, so who could argue with that?

You might ask, "Streaming media is really the way to go, so I'm with Real Networks player." Well, if you want the very best quality video, it will not be streaming over a server. In fact, downloadable movies have the potential to offer the best resolution, size, and sound quality on the Web. The best quality movies on the Web are movie trailers downloadable and playable as QuickTime Fast Start movies. Streaming video usually requires a server capable of sending high bandwidth video out to numbers of users simultaneously, which can be incredibly expensive. And though Real Networks is a reputable firm with a relatively long history (in Web terms) streaming media, know that you will have to pay licensing fees if you decide to go with their streaming solution. QuickTime's streaming software is free.

You may assume that you don't want to bother your target audience with the possible download of yet another plug-in. In fact, most users who seek out movies on the Web will

not balk if they have to download a plug-in. The QuickTime format certainly didn't hurt the download numbers of the *Star Wars* trailers, the first of which logged more than 25 million downloads within a few short weeks. Besides, many Web surfers and Internet users already have QuickTime installed, and all Macintoshes come with QuickTime as standard equipment.

Because QuickTime is a dual-platform technology running on both Windows and Macintosh OS, I have included illustrations depicting applications running on both platforms. However, in many if not most cases, the differences in the interfaces are often skin deep and inconsequential.

You will find assets for the various tutorials in the accompanying CD, along with Website links where you can download software demonstrations, reviews, and more tutorials. The book is meant for filmmakers, photographers, artists, and others who are more concerned with creativity than technical know-how when it comes to computers. It's not "QuickTime for Broadcasters," therefore I haven't concentrated on broadcasting and streaming server solutions such as QuickTime Broadcaster in this volume. By the same token, I believe that most filmmakers are already using one of the many nonlinear editing (NLE) applications for postproduction, so I don't dwell on instruction in Final Cut Pro, Avid, or other NLE solutions. There are more comprehensive books on QuickTime for sure, and I encourage you to check them out if you wish to go further. For now, though, I only ask you to come along and stake out your piece of the Web as a venue for your movies. I can't guarantee you will make your fortune or any money at all doing so, but you will connect with an audience whom otherwise might never know your work. That's a lot better than a closet full of unseen films.

I would like to thank the many individuals for their encouragement and guidance on this project, especially my editor, Elinor Actipis, as well as Terri Jaddick, Marie Lee, and the whole staff at Focal Press for their invaluable help and support. Thanks to Steve Garfield, Ravi Jain, Andreas Schenk, and Clifford VanMeter for reviewing the first draft and providing invaluable advice. Thanks to Jeff Cogan for allowing the use of some guitar pieces he performed and to Michael "Tug" Buse for contributing a film clip.

I'd also like to thank Janie Fitzgerald for her inspiring work and for taking the time to chat with me about QuickTime and QTVR. Thanks to Arnie Keller as well, whose quote appears at the beginning of Chapter 4.

Thanks to my colleagues at Chapman University for their support in this project. Special thanks to my nephew Mathieu X. Mauser at the Vancouver Film School for access to tools and good vibes.

And most of all I'd like to thank my wife, Anita, for her unwavering support, trust, dedication, inspiration, and love.

—RKF
June 2003

1 QuickTime: An Introduction

"The amazing thing about QuickTime is that there was nothing like it before, and everything has been like it since. Look at the guts of Real Player or Windows Media Player, and you'll see structural copies of QuickTime. It is very hard to be an original, to be the first, and to still survive a decade later, but QuickTime does all that. And it might even get the last laugh."

—**Robert X. Cringely**[1]

Every 10 or 20 years since the invention of the motion picture, a development comes along to revolutionize the way movies are made or shown. In the 1890s, the Lumiere brothers' Cinematograph changed the way people looked at movies, allowing viewers to sit together in a darkened theater to watch films on an illuminated screen rather than through a peephole. In the teen years of the early twentieth century, renegade immigrants went west to duck the Pinkerton detectives of the East Coast motion picture cartel to make their own pictures and the seeds of Hollywood studios were sown. In the late twenties, sound picture technology transformed the cinema while putting hundreds of actors out of work overnight. After World War II, lightweight cameras and sound recorders gave rise to the independent filmmaker. In the 1960s, Super-8 made moviemaking cheap enough for nearly everyone, and the 1970s ushered in video as a viable portable medium for anyone who wanted to record events on the go. While motion picture production developed and evolved, however, a key link in the movie chain largely resisted change: movie distribution and exhibition. A filmmaker could make a film and still find no outlet to reach an audience.

Video continued to drive innovation with the emergence of the digital capture and non-linear computer-based editing, but the real innovation occurred in the winter of 1991. This was the dawn of QuickTime.

As 2001 drew to a close, QuickTime was celebrating 10 years of existence as the world's most versatile and innovative computer media technology. And as Cringely points out, the technology was very much a viable force in the world of media and computing as the world rolled into the second millennium.

The Apple team that evolved QuickTime had a groundbreaking concept. They not only wanted to control video presentation with a computer, they wanted videos to play over the computers themselves. QuickTime kicked off a visual revolution that led to innovative programming such as *MYST* and Peter Gabriel's *XPLORA 1*. And QuickTime is still in the forefront; the most advanced video protocol to date, MPEG-4, was modeled after

QuickTime's own architecture. The MPEG-4 connection alone ensures QuickTime's role in any future developments regarding multimedia.

Many people know QuickTime as merely a video player, but in reality it encompasses and far transcends this simple function. QuickTime has been described as a "multimedia architecture" that manages an array of media and acts as a controller between a computer's operating system. QuickTime is not so much an outright application as it is a media helper that allows you to handle a huge array of electronic media. It can show movies, display still images, render three-dimensional (3D) images, present text, synthesize music, play animations, immerse the viewer in virtual reality scenes, and lend interactive multimedia capabilities to the computer landscape. Indeed, QuickTime can manage more media types than any other multimedia technology. Think of QuickTime as a magic platter that gains you access to a grand buffet, allowing you to utilize and implement a smorgasbord of applications. QuickTime lets you view, edit, combine, transform, and generally manipulate more media than practically any comparable technology and in practically any way you wish. Some applications that take advantage of QuickTime's versatile technology are the QuickTime Player, Internet Explorer, Netscape Navigator, Adobe Acrobat, Apple Filemaker Pro, and more than 18,000 others. In fact, QuickTime can import or export more than 70 different media formats (Table 1.1).

The primary QuickTime vehicle for multimedia data is called the *movie*, but it can deliver much more than moving pictures. It can be considered a container to hold all of the information needed to organize data in time—not the data itself. This is a rather loose term used to describe both time-based linear audio and video (playable) files, such as video clips and songs, and immersive media files, such as 360° panoramas and 3D objects. The QuickTime movie can also feature interactive buttons, actual text, and other elements that set it apart from a simple movie. Thus, the term movie can be much more than a film or video program.

If the movie is the shell that carries the media, the building block of the movie itself is known as the *track*. Tracks are designated to present media such as video, audio, text, sprites (animation), and other information. The track does not contain movie information; it only provides references to specific program information, much as WebPages do not contain graphics but contain HTML code that refers to separate graphics files.

The QuickTime Player

The QuickTime Player (formerly known as the Movie Player) is the most familiar and widely used component of QuickTime. Whenever you click on a QuickTime movie icon, the file will play within the window of the Player. When you click directly on the Quick-Time Player icon itself, the Player will appear and you will see the "QuickTime 6" greeting, which will then connect you to QuickTime's "Hot Picks." A click on the poster illustration in the Player window will open your designated Internet browser, taking you to the movie featured in the poster. Unless the QuickTime Player has been given a special

Table 1.1. QuickTime-supported file formats

32-bit IEEE	64-bit IEEE	Advanced audio coding (AAC)
AIFF/AIFC	ALAW 2:1	Animation
Apple Graphics	Apple Video	ARGB
AU	AVI	BMP
CCIR 601	Cinepak	DV
DV NTSC	DV PAL	Flash
FlashPix	GIF	GSM
H.261	H.262	IMA ADPCM
JPEG/JFIF	LPC	MACE 6:1
MACE 3:1	MacPaint	Microsoft Video 1
MIDI	M-JPEG-A	M-JPEG-B
MPEG-1 Layer 3 (MP3) playback	MPEG-1 Layers 1–2	MPEG-2 playback
MPEG-4	MS ADPCM	MS DVI
OpenDML	OpenDML M-JPEG	PCM
Photoshop	PICT	PNG
QDesign 1 & 2	Qualcomm PureVoice	QuickTime Image File
QuickTime Movie	RGB	RTP DVI
SGI	Sorenson Video 1, 2, & 3	Sound Designer II
TARGA	TIFF	H.263
Vector Animation	WAV	Windows RLE
Windows Uncompressed	YUV 4:1:1	Adaptive multi-rate (AMR) audio

AIFF/AIFC, audio interchange file format/audio interchange file format compressed; ARGB, alpha, red, green, blue; AVI, audio-video interleave; CCIR, Comité Consultative International des Radio Communications (International Radio Consultative Committee); DV, digital video; DV NTSC, digital video National Television Standards Committee; DV PAL, digital video Phase Alternation Line; IMA ADPCM, Interactive Multimedia Association Adaptive Differential Pulse Code Modulation; LPC, low pin count interface specification; MACE, Macintosh Audio Compression and Expansion; MIDI, musical instrument digital interface; MS ADPCM, Microsoft Adaptive Differential Pulse Code Modulation; MS DVI, Microsoft Digital Video Interface; PCM, pulse code modulation; PNG, portable network graphic; RGB, red, green, blue; RTP DVI, Real-time Transfer Protocol Digital Video Interface; SGI, Silicon Graphics, Inc.; RLE, run-length encoding; YUV, luminance, B(blue)-y, R(red)-y.

"skin" or unique designer interface by the author or content provider, the Player retains the clean, no-nonsense lines of a viewing screen and control panel.

The controls of the QuickTime Player are simple and straightforward (Figure 1.1). They consist of an audio volume slider on the far left, five buttons at the center of the strip allowing you to play, stop, review, or move ahead in fast mode, rewind, and fast forward to the beginning or end. A long rectangular window between the controls and the picture-viewing window is known as the liquid crystal display (LCD) area. This is where text infor-

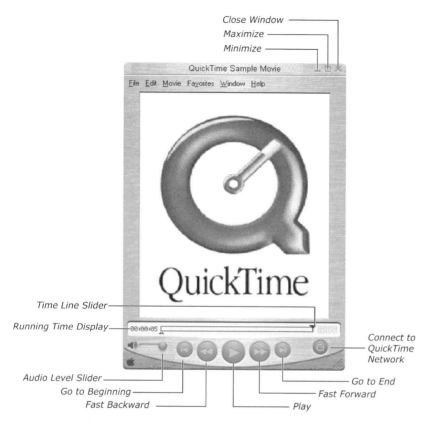

Figure 1.1 The QuickTime player and controls.

mation about the program appears, which may vary according to the movie's content. A QuickTime Virtual Reality (QTVR) movie will bring up a slightly different player window, as we will see later in Chapter 6. To the far right of the navigation controls you will find the TV button, and this will show you the various QuickTime Channels you can access when your computer is online. A tab behind the QuickTime Channels designated by the heart symbol is the "Favorites"; this allows you to make bookmarks to various QuickTime content on the Web that you wish to revisit.

Along the top edge of the Player window you will find three boxes that allow you to collapse, maximize, or completely close the movie. Now that you know what the Quick-Time controls do, you can open a file in the Player.

Opening QuickTime movies

The simplest way to play a movie is to simply double-click on its icon. If it is a file that QuickTime understands, it will open the file. Sometimes a file will be tagged by another application. For instance, Preview in Mac OS X often tags image files such as JPEG and

GIF with its own logo and, in effect, becomes the default opening program. When the icon is double-clicked, the file opens not in QuickTime but in the application that created the tag. In this case, quit that program and open the file within QuickTime Player.

To open a QuickTime movie within the Player, first make sure the Player is open by clicking the QuickTime Player icon. Then, simply go to the File menu and choose Open Movie. In the "Open" dialog box, find the movie you wish to open, select it, and click the "Open" button. If there is already a QuickTime movie open, the file you have just elected to open will replace this one in the Player window.

To open a movie from the Internet, open QuickTime Player, then choose "Open URL" from the File menu, and enter the address or universal resource locator (URL) of the movie file. You can also open a movie by dragging a movie file on top of the QuickTime Player icon.

Opening other media in QuickTime

You can open non-QuickTime media in the QuickTime Player. In fact, with but a few notable exceptions (Real Media files, for example), you will find that QuickTime Player can open the most commonly used video, audio, and animation formats found on the Mac and Windows platforms. You can open and play MPEG-2 files once you buy the Quick-Time 6 MPEG-2 Playback component. You can purchase this separately from QuickTime through the online Apple Store (www.apple.com).

To open a non-QuickTime file, go to the File menu and choose "Open Movie." In the Open dialog box, find and select the movie you wish to open. In Windows and Mac OS 9 and previous, the "Open" button will turn into a "Convert" button, whereas in Mac OS X, the button will remain an "Open" button. Click this button, and the file will open in a standard QuickTime Player window.

Other QuickTime Components

In addition to the Player, QuickTime features two other playing components: the Quick-Time Plug-in and the ActiveX component for Internet Explorer 5.5 and later versions for Windows (see Chapter 8 for more details on the ActiveX component). These components are placed on your hard drive at the time of installation. The QuickTime Plug-in will install itself automatically into any browser you have installed, such as Internet Explorer or Netscape Navigator. The Player is a stand-alone application that plays movies by itself without the aid of a browser, whereas the plug-in plays content through your browser. The plug-in is not essential for playing content on the Web; however, the Player will also play content from the Web along with its many other functions.

2 From Grain to Pixels: Film, Video, and QuickTime

"This 19th century idea of sprockets and film and projectors—it's slow and costly. The photochemical process is so complicated and films get scratched and dirty and they degrade. The thing about digital, it is the medium of the masses. It's infinitely more malleable than film, which is so arcane. The independents are embracing it and so will everyone else eventually. This is going forward with or without the industry."

—George Lucas[2]

If you are a traditional filmmaker, Lucas' observations may strike you as nothing short of heresy. But much has changed in the world of film in the last 5 years, let alone the last 50. I am referring now to actual stock, processed in a film lab, and printed or transferred to video. If you have been a filmmaker for more than 5 years, you may have even cut the actual celluloid itself. I make this distinction of film as a photochemical medium because it has become commonplace to use the term "film" as another term for "video." We often hear about news crews "filming" segments for television broadcast when they are in fact videotaping content. The term "video" always refers to electronic media, motion pictures captured by electronic—not photochemical—means. And although I use the term "film-maker" to refer to any producer of motion pictures, whether film or video, I use the term "film" in its proper form. Film images can be captured and stored in one of several film gauges (width of the actual film ribbon measured in millimeters): 8 mm, Super-8, 16 mm, 35 mm, and 65/70 mm. As you may know, the quality of the film image is always dependent on the size of the gauge—the wider being better in terms of information captured—as well as the camera and optics used for photography. (When referring to film or video as program material to be distributed or exhibited via a computer screen, I will use the plain but universally accepted term "content.")

Many cinematographers still consider film to be without peer in photographic quality, despite the vast improvements made in electronic image gathering. Why has film endured to this day as the premiere medium for making motion pictures? Because 100-plus years of watching celluloid movies has conditioned us to expect a photographic look, not a scanned electronic look in our movies. Film exhibits better contrast characteristics than video and can resolve many more shades of gray and hue than any electronic medium. And only the laws of physics limit film in its ability to resolve fine detail (which allows a film

camera a much longer useful life than any video camera, able to utilize breakthroughs in film emulsion technology such as flat or "tabular" grain). The resolution and detail of video images, on the other hand, are limited by the video protocol itself: 525 nominal scanning lines in the NTSC standard used in North America and Japan, and 626 lines in PAL/SECAM, the standard used in most of the rest of the world. SECAM stands for Systeme Electroniquie Couleur Avec Memoire. Both traditional video standards share a common boxy aspect ratio, or the relation of the frame height to width, of $1:1.33$ (1.33 for short) or 3×4. The only way to screen video of a different aspect ratio is to waste some of the screen area (for instance, the black bars along the top and bottom of a letterboxed video), or to crop the right and left edges of the widescreen film or video.

But the crucial visual difference between the film "look" and the video "look" lies in the way film images are sampled. Film plays at 24 frames per second (fps) in North America (25 fps in many other parts of the world), with each frame recorded in its entirety 24 times per second. Whereas early film was recorded at whatever rate the camera operator cranked (before the advent of sound movies), the sampling rate of video was pegged to the rate of the alternating electrical current in the region where the video would record and play as a way of ensuring stability and consistency. A disparity in alternating current standards led to two worldwide standards: the NTSC the standard based on a 60-Hz AC system, and the PAL/SECAM standard based on a 50-Hz AC system. The frame rate for NTSC became 30 fps (actually 29.97 after the adoption of color television) with two interlacing fields of video captured per frame, and 25 fps (or 50 fields per second). The primary perceptual difference in the way we see of film versus video is due mostly to these distinctions.

Despite its virtues, film is not perfect as a recording, editing, and archiving medium. The problems stemming from dirt, scratches, fading, and other analog artifacts are easily as distracting as any video aberration. The fact that filters exist to duplicate these artifacts in order to give video an appearance similar to film is an amusing nod to the defects that belong to film alone.

Motion Picture Production for the Web

Probably film's greatest drawback in the digital age (some would call this an asset) is also its most appealing aspect: it is an analog medium. The original negative can pick up dirt and scratches and can fade over time. Whenever it is duplicated—an essential part of the distribution process—the copies, be they positive or negative prints, introduce more contrast, grain, dirt and scratches, and loss of sharpness with each generation of printing. After many years of fading, handling, and duplicating, film prints and negatives become ghosts of their former selves. In most cases, the best versions are the ones you see after they have been remastered and converted to digital video (DV) in the digital video disc (DVD) format of MPEG-2.

You may have realized this by now but the future for Web motion pictures lies not in film or analog video, but in the media we know as DV and high-definition television (HDTV) (see sidebar). DV camcorders can be purchased for under $1000 nowadays and

can yield pictures that far surpass those from state-of-the-art Ikegami cameras of only 10 years ago. And the DV they produce can be reproduced over and over again with virtually none of the generation loss and contrast/noise build-up of traditional analog media. With a Firewire (IEEE 1394) cable, you can bring your footage to just about any personal computer made in the last 3 years with a Firewire card installed or any modern Macintosh with a built-in Firewire port. In addition, you can edit this footage without incurring any of the traditional scratches, noise, or contrast gain of former days. Only when you get ready to compress your content will you have to compromise the quality, as you will see in Chapter 3. Whereas DV adopts and works within the NTSC or PAL television standards, HD is very high resolution.

What about HDTV?

We all still live in a mostly NTSC or PAL world when it comes to video, but what about HDTV? Was not this high-quality television standard supposed to replace the antiquated systems we are still using by now? Once again, it is a familiar story of standards and multinational firms wanting desperately to further their own protocols and license their technology to the rest of us.

What Is HDTV, Anyway?

HDTV has been called the biggest milestone in broadcasting since color TV. It offers an experience closer to theatrical movies than does our current NTSC. It boasts twice the luminance definition, both vertically and horizontally, with a 16:9 aspect ratio (do not ask me how they ever evolved this cumbersome ratio), 25% wider than the boxy 3:4 NTSC screen. Today's HDTV gives superior resolution of 1080 active scan lines (1125 total), compared with NTSC's 486 (525 total). This translates to five times more picture data, accompanied by multichannel compact disc (CD) quality sound.

Basically, HDTV has been promising to supplant the post-war television systems we still use today since 1981, when the Japanese Broadcasting Corporation (NHK) demonstrated a 1125 scan-line system at the Society of Motion Picture and Television Engineers (SMPTE) annual conference in San Francisco. Technophile, winemaker, and sometime director Francis Ford Coppola was impressed enough to authorize his Zoetrope Studios to produce two 6-minute

Continued

shorts in the format. At the time, Sony Corporation had developed digital tape recorders with HDTV capabilities, but this important breakthrough was somehow overlooked and HDTV instead evolved as an analog technology. The new Japanese HDTV protocol garnered much attention over the next few years and Sony offered an HDTV camera for purchase at the 1984 National Association of Broadcasters (NAB) convention in Las Vegas. The Advanced Television Systems Committee (ATSC) approved the parameters for HDTV: 1125 scanning lines, an aspect ratio of 3:5 (essentially identical to the standard 1.66 European aspect ratio for feature films), and a 60- or 80-field rate.

As it turned out, this rare moment of harmony—and a single standard for the world—was not to last. Later that year (1984), the Radio Corporation of America (RCA) proposed its own HD standard using similar bandwidth and field rate along with 750 lines scanning progressively (noninterlaced). The ATSC was unmoved and recommended the NHK system with a slight modification: a wider aspect ratio of 3:5.33, or 1.78—an odd compromise between the European 1.66 and the American 1.85 theatrical movie standards. Nonetheless, the standard had yet to be adopted in any significant way by major broadcasters outside of Japan.

One big factor in the slow adoption of HDTV was the Federal Communications Commission's (FCC) reluctance to approve the existing protocol. The commission tentatively moved to require that HDTV broadcasts be compatible with NTSC sets but did not approve additional spectrum allocations outside existing VHF and UHF bands for HDTV. The bandwidth and existing equipment incompatibility were major stumbling blocks for the analog version of HDTV. Satellite and other methods of delivery were explored.

By the 1990s, manufacturers were seriously exploring digital options to HDTV and the writing was on the wall: NHK's once revolutionary analog HDTV standard was obsolete. Digital HDTV was the way of the future, and by 1998, major television stations in the United States began transmitting digital HDTV, albeit in limited amounts. Because the new standard used digital technology similar to computers, it was decided that HDTV would use square pixels like computers, unlike the tall skinny rectangular pixels used in conventional television.

When Will HDTV Supplant NTSC and PAL?

They will coexist for some years to come, because retooling is very expensive for broadcasters, manufacturers, and consumers alike (Table 2.1). All television stations are supposed to convert to digital HDTV by 2008. Likewise, all current

analog commercial TV broadcasts are scheduled to cease by then, provided 85% of homes are capable of receiving DTV. That deadline will most likely be pushed back a few years if it has not been by the time this book is published.

Table 2.1. Comparison of NTSC, PAL, and HDTV

	HDTV (ATSC standard)	NTSC	PAL
Active lines	1080	486	586
Total lines	1125	525	625
Aspect ratio	16 × 11 (1.78)	4 × 3 (1.33)	4 × 3 (1.33)
Maximum resolution	1920 × 1080 pixels	720 × 486 pixels	720 × 586 pixels
Sound	5.1 channels (surround)	2 channels (stereo)	2 channels (stereo)

So Do We Have One HDTV Standard Now?

Well, we now actually have four digital TV standards—two standard-definition television (SDTV) standards, and two HDTV standards:

- 480i—This is a digital cousin to NTSC, more or less, with 480 interlaced lines, 30-Hz signal.
- 480p—This system is similar to 480i but incorporates progressive scanning and allows fewer motion artifacts as well as no visible flicker.
- 1080i—This HDTV system traces 1080 scan lines from top to bottom in $\frac{1}{60}$th of a second to prevent flicker. Each scan line is 1280 pixels long, for a maximum screen/frame size of 1230 × 720.
- 720p—This HDTV system incorporates 720 lines scanned progressively from top to bottom in the same $\frac{1}{60}$th of a second.

Because the eye sees the same amount of detail in the given time, the 720p and the 1080i are considered equal in image quality. At the time of writing, CBS, NBC, and their affiliates have adopted the 1080i system whereas ABC and affiliates have opted for 720p. PBS has gone with 1080i multicasting, whereas Fox and WB currently broadcast digital in the 480p format.

Interlaced and Progressive Video

Analog and digital moving images can be captured as interlaced or as progressive (noninterlaced) video. Video programming recorded in the NTSC, PAL, and SECAM standards are known as interlaced, where each frame is composed of two consecutive fields. The scan lines in the fields interleave like your clasped fingers when you intertwine them, creating a frame from the two fields. Each field carries every other horizontal line in a frame. The video display, or raster, displays the initial field of alternating scan lines over the entire screen, then shows the second field to create a synthesized frame. When you pause on an interlaced video image, you will likely see a single field of low resolution rather than a complete frame.

The progressive, or noninterlaced, frame rate is one of the defining qualities of film. Professional and consumer video cameras have adopted this mode of frame sampling to imitate the film look. In fact, George Lucas's greatest triumph in recent years may not be the *Star Wars* episodes he has directed but rather his championing of the 24-fps progressive frame video camera for shooting the entire *Attack of the Clones* adventure. If you do shoot progressive scan video, keep in mind that the video will still have to be interlaced in order to play on NTSC or PAL systems.

Ideally, art should not be confined to terms dictated by limitations of a medium conceived not to create but merely to exhibit and distribute. This might be akin to cutting down paintings to 12 × 16 inches because frames are only available in that size. But such are the realities of digital distribution. One trades off versatility and, in many cases, maximum quality in an effort to reach the largest audience possible. When your content has been edited and completed as a theatrical or documentary motion picture, it may not make sense to edit it down or otherwise alter it simply to make it available to a Web audience. If you are creating content with the Web in mind, however, and dissemination of information is more important than visual art, you may do well to craft your film or video with these limitations in mind.

Targeting Your QuickTime Content

Motion picture production, whether film or video, always requires greater capital expenditure that other visual arts such as drawing, painting, and photography. Thus, the filmmaker must target his or her audience to ensure the greatest success. To paraphrase an old aphorism: you can reach some of the people all of the time, or all of the people some of the time, but you can't reach all of the people all of the time. If you have film or video that you want to deliver over the Web, you must take several factors into consideration.

Think of the traditional analog distribution options. When you make a film, you think about the various venues where the picture will screen:

- Multiplex
- Single-screen movie house

- Cable TV
- VHS
- DVD
- Broadcast television
- Public access TV

You may plan to release on one, two, several, or all of the above modes of delivery. There are certainly advantages and disadvantages to each. The single-screen movie house may offer the best viewing experience to your audience, who will not have to endure distracting noise rumbling through the walls from the screening room next door. Each mode of exhibition may reach a different segment of your target audience. The single-screen cinema may attract a more sophisticated and attentive audience than the multiplex, though the trade-off is that audience numbers in the former will be far smaller than those of the latter. The same holds true when you deliver your content digitally. You want to reach the widest possible audience. If you are delivering to the Web, that means many of your potential viewers will be receiving their Web data over 56k modems. If you want them to be able to view the movie as a progressive download, you will have to compress your movie drastically for it to play as it loads. Another option is simply to allow viewers to download the entire movie in all its gargantuan glory and then let them view it later. You may also wish to aim a larger, higher-quality, less-compressed movie at viewers accessing the Web over fast cable modems and T1 connections.

The conventional approach to tailoring movies to various Web viewers has been to optimize versions of the movie for specific user groups: one for QuickTime fat pipe users, one for moderate Integrated Services Digital Network (ISDN) and cable users, and one for low-bandwidth dial-up modem users. QuickTime has a feature known as the *reference movie* that lets you as a content provider post a movie that acts as a traffic cop, directing the user to the appropriate version of the movie based on the user's own QuickTime self-entered settings. Content providers who wish to reach the widest possible audience routinely make content available in versions readable by Windows Media Player (WMP) and Real Player as well as QuickTime. The need to make these different movie versions may disappear with the adoption of MPEG-4 (newly featured in QuickTime 6), which promises to change all this with its scalable "encode once" standard architecture that should be readable by Real Player and ultimately even WMP.

Getting the Film Look with Video

The controversy still rages: which is superior, film or video? Whereas film retains its romantic aura, video is cheaper and more convenient to shoot, and this will likely influence any decision on what media to use. There are a number of

Continued

applications such as CineLook that promise to add film-like artifacts such as scratches and jumpy sprocket effects to video footage in an effort to make it look more filmic. This discussion, however, will address the technique of making video approximate the look of film as it appears when transferred to video.

Film and video images differ in regard to sampling (frame rate), image resolution, color rendition, and inherent depth of field.

Sampling refers to how many frames are shot per second. Film is traditionally shot at 24 fps, at a shutter speed of approximately $\frac{1}{48}$ second, with a rotating shutter having an angle of 180°. NTSC video is captured at a rate of 30 frames (60 interlaced fields) with an approximate shutter speed of $\frac{1}{60}$ second. One might suspect that the higher sampling rate makes for superior viewing, but it is the slower shutter speed of film—creating more blur in each separate image—that we see as a lifelike and fluid motion effect. Each video frame, on the other hand, depicts a much sharper image due to the fact that it is captured at a higher shutter speed. PAL video, used widely outside North America and Japan, uses a 25-fps rate and is much closer to film in this regard than NTSC video.

Some insist that progressive video scan cameras are much better at replicating the film look than standard interlaced video. Cameras, such as Canon's XL1, capture 30 actual frames a second in a noninterlaced mode, whereas standard video cameras shoot 60 interlaced fields or half-frames a second. This results in a higher sample rate and, thus, an "edgier" video look.

Image resolution is much higher in 35 mm film than video, but once film is transferred, its maximum resolution becomes the same as video (i.e., 720 × 486 pixels). Thus, resolution does not play a crucial role for capturing a film look.

Color rendition, or the way colors are reproduced in each medium, matters a great deal. Film captures a much smaller range, or gamut, of color than we can discern with our eyes; video can reproduce even fewer colors. Saturation (pureness of hue) and brightness are adjustable to a large degree in video, whereas these are fixed in a film print and cannot be adjusted in the presentation (projection) stage. Video tends to show much greater contrast than film, which typically has more latitude (midrange contrast).

Depth of Field

If you look closely at close-up shots when you watch movies, you may notice something that subtly but surely contributes to our perception of a filmic effect: shallow depth of field. Yet when you try to emulate this or a dramatic "rack focus" shot

(shifting focus from foreground to background or the opposite) in video, you may find that the image stays uniformly sharp and well focused. This is due to the fact that video cameras have a smaller image-gathering area (called the video target) than does 35 mm or 16 mm film. Thus, lenses for video cameras are shorter in length generally. The three factors that affect depth of field are lens length, aperture size, and the distance between your focus point and your camera. If you want shallow depth of field in video, you may need to dim the light or focus on a subject that is close to the camera.

Softening the Video Edge

Because video imaging is limited by the number of scan lines the system can handle (such as NTSC), images can be low in resolution. Thus, video was designed to apply an artificial-edge enhancement to produce the appearance of sharp images. This edge enhancement can be adjusted down in DV cameras such as the Sony VX2000 and PD150 to give a less electronic look. Videographers have also been softening video images for years using everything from diffusion filters such as Tiffen's Promist to actually stretching pantyhose over the internal video target. Although this takes the edge off somewhat, the jury is still out as to whether this can actually make video look like film.

Adding Warmth

Some videographers swear by warming up the video image by dialing in an orange or yellow cast in postproduction. Probably the best way to capture a film look is to emulate a film-shooting procedure, replete with a large camera crew and electrical unit that can help light the production along the lines of a professional film shoot.

Optimizing Your Movie in Preproduction, Production, and Postproduction

As a filmmaker, you are familiar with the workflow of preproduction, production, and post-production. Nearly all of our discussion of QuickTime lies in the traditional postproduction phase, but when you know your target audience will be viewing your films via the Internet, CD-ROM, or hard drive, you can tailor your production style to suit the parameters of the medium.

Many filmmakers and videographers seek to produce their movies according to their own aesthetic and commercial requirements and then use the Web as an additional means of distribution. The considerations of compressing and downsizing their films do not even enter into the creative and logistic process of production. When the filmmaker later wants to deploy the movie on the Web, however, he or she finds that there are a number of factors that influence the quality and accessibility of the movie. If you as a filmmaker know in advance that Web deployment will play a key role in distribution, then it will benefit you to pay attention to some simple facts that will affect how your movie plays on the Internet. These affect the way you make your film from preproduction to post, including the photography and editing.

Storyboards

Most filmmakers are familiar with storyboards, as nowadays they guide all but the most amateur productions. Indeed, beginning filmmakers and students are regularly advised to prepare storyboards as a way to better visualize their productions, facilitate communication among various crew and cast members, and save time and money in production. The planning and preparation of storyboards is vital for productions that will ultimately screen over the Web. While you prepare and edit your storyboards, keep the following in mind to ensure optimal Web viewing:

Do I really need to do storyboards?

As independent filmmaker Jim Jarmusch observed, "I never used a storyboard, because I like to be thinking on my feet" (www.miaminewtimes.com/issues/2000-03-23/film.html). Won't storyboards just limit you? Believe it or not, you will work much faster on a set if you can communicate your ideas visually to your crew. You can always deviate from the storyboards you make. But when you are running around on automatic mode, storyboards are often the only way to ensure that your ideas are realized as you envisioned them.

What if I can't draw?

Of course, the optimum way to go is to hire a professional storyboard artist. But if you are a true independent, you probably cannot afford this luxury. But you absolutely do not have to be an accomplished artist to generate good working storyboards. Even if you can afford a storyboard artist, it is always best to start out with sketches you knock out yourself, quickly and inexpensively. You can experiment and try out different compositions, blocking (posi-

tioning of your actors), and camera angles this way. Many of the great directors, including Hitchcock and Spielberg, have created their own storyboards, often with no artistic ability at all. And if your film is to be truly cinematic, you will find that there is really no substitute for storyboarding, which is essentially the only way to envision and plan complex visual sequences, special effects, and creative framing. The films by the Coen brothers are as visually rich as any you will see, and much of this is no doubt due to their meticulous storyboarding.

How are static pictures supposed to represent a motion picture?

You may also ask why written scripts are so important for fully formed movies. The storyboard is supposed to be a sketch, not a finished film in itself. As stated earlier, it is to help you think visually.

How to make an effective storyboard

The language of storyboards owes much to the cartoon strip. In fact, the best cartoon strips are very cinematic in composition and juxtaposition of their component frames. You can help communicate and save yourself lots of tedious work by adopting some shorthand rules in your storyboards:

1. Use arrows. Let's say you want to dolly into a scene, or suggest a character's movement within a frame. How do you draw this into a storyboard? Simply draw arrows in your drawings showing the direction of the movement. You might be surprised at how much these little symbols can say in terms of your camera movements.

2. Inset frames. Inset frames float within a larger frame to show the ultimate close-up of a dolly-in or zoom-in shot.

3. Use varying camera angles for interest.

4. Use index cards. Draw your frames (each representing a shot) on blank index cards so you can shuffle and edit them. Often the best way to visualize the flow of your film is to pin your card sequence on the wall and stand back. But make sure you number your cards!

5. Use a pencil for quick scribbling and easy erasing. Pencils and paper are always cheaper than film or videotape or hard drives. They will also save on your most precious commodity of all: time.

6. Experiment with a camera. If you are totally opposed to drawing, you can take a camera along to your various locations when you scout them, or block some friends in the actors' positions and photograph them, using the snapshots for the pictures of your storyboard.

Photography for Web deployment

If you do not have access to a DV camera, you can of course capture your footage with any film or video camera. If you shoot film, you must first have it transferred to video in

a telecine session. Most filmmakers are already familiar with this process, but if you are new to filmmaking and video transfer, you should keep in mind that you will have more control over the ultimate look of your footage if you supervise the telecine session yourself. Be sure your telecine house uses a high-resolution transfer process, and have your footage transferred to a high-quality medium such as digital Beta or Beta superior performance (SP). If you do not have access to Beta machines for capturing the video into your computer, then have the telecine house make a DV tape of the footage as well, if they are set up to do so.

You can also shoot with almost any analog video camera and transfer the video into your computer using an analog-to-digital card (e.g., a Targa or Matrox card). Such cards can run into the thousands of dollars, however, and do degrade the video image to some extent, depending largely on the quality (and expense) of the card.

Cinematographers spend a long time perfecting their craft. We often associate various techniques with famous directors of photography. Classic films are often known for their trademark cinematic styles. Who could imagine *The Godfather* films without their honey-amber scenes of harsh down light? Try to imagine an Oliver Stone film without the nervous mix of various film formats within the same picture. And who could separate the constant camera movement from the pictures of Robert Altman, Martin Scorsese, or Stanley Kubrick? On the other hand, if you are shooting content for Web exhibition, be advised that it is best to keep your shots as simple and straightforward as possible if you wish to have the cleanest, smallest, and trouble-free movie files.

Shot size

The cinematic language grants a wide range of shot sizes to the filmmaker: the long shot, the full shot, the medium shot, the close-up, the extreme close-up, and others. Experienced video producers know, however, that the small screen does not provide enough area and detail to do justice to long and wide shots that look breathtakingly beautiful on the cinema screen. Conversely, the close-up and extreme close-up are practically made for the television and computer screen, as they provide abundant information without overpowering the viewer.

Avoid busy backgrounds

Compression protocols do not like busy picture detail in movies (Figure 2.1), especially moving elements such as tree foliage undulating in the wind or moving traffic. Therefore when you are planning shots in the storyboards, remember that the less-detailed background you include around your main subjects in a shot (Figure 2.2), the easier it will be to optimize it for the Web.

Hand-held camera shots can provide a sense of spontaneity, vivacity, and immediacy to the look of a film. Tracking and Steadicam shots can put the viewer in the picture, moving around the scene with the subjects. Pans and tilts can give new meaning to shots and provide opportunities for smooth editing transitions. If you want to ensure optimal compression, however, you will want to avoid or minimize your use of these techniques. That is because the more pixels change in a picture, the more difficult it is for the codec

Figure 2.1 Avoid busy backgrounds in close up shots.

to use its prime tool in squeezing the movie down to a manageable size, assuming that much of the picture area consists of redundant and therefore dispensable information.

The primary limitation in optimizing video files for Internet exhibition is bandwidth. Internet bandwidth constraints impede the flow of large media files. When media files are compressed to a smaller size, they may be sent through the Internet pipeline more efficiently, which means they arrive at their destination in much less time. However, in the real world compression exacts a price on the quality and fidelity of the compressed movie.

Use a tripod, even if you think you can hold the camera perfectly still. Every infinitesimal movement has a negative effect in terms of compressing, and this is literally magnified further with a telephoto lens. When you shoot with a tripod, the amount of movement effectively decreases, allowing the codec to work on the subject and not on the constantly shifting details of the background.

Figure 2.2 Strive for uncluttered backgrounds when you shoot close ups.

QuickTime movies, like their MPEG cousins, are composed of squares (a phenomenon that can be seen when compressed video scenes containing lots of camera or subject motion break down into a grid work of blocky artifacts). Compression schemes save space in movie files by comparing areas of a given frame (often the first frame of a shot or scene) and discarding squares in subsequent frames that the compressor judges indistinguishable from squares in the initial frame of a scene or shot. In a shot of a subject seated before a static backdrop shot with a stationary camera, only squares that need to be copied across one frame to the next are moving features of the subject, namely the mouth and eyes. But because only squares are carried across from one frame to the next, you get squares rather than a complete picture. These frames, composed of partial squares of information, are known as *delta frames*. In order to keep things straight, a frame containing the entire picture from a scene is inserted every so often to hold a reference; these are known as *key frames*. Uncompressed video has a key frame practically 30 times per second and all the frames are key frames, which makes the files much too big to flow easily through Internet routers.

Thus, when you perform a tracking shot of an actor walking and speaking to the camera, you are creating a streaming file consisting solely of key frames. When this footage is compressed, the codec attempts to abbreviate the constantly changing information and the result is a jerky, blocky sequence of delta and key frames (Figure 2.3). If you sit the actor down in front of a solid color wall and shoot him or her from a camera mounted on a tripod, you will have a sequence that will compress nicely and stream smoothly across the Web. Why? When you minimize camera and subject movement, delta frame size is minimized because information in the static areas of a scene do not appear to change. On the other hand, when the camera tracks, pans, or zooms, or the subject is in constant flux, the background changes from frame to frame, and delta frames become the size of key frames. Thus, the quality of the streaming video at low bandwidths depends on adherence to relatively static shots. There is a reason for those "boring" talking head shots after all.

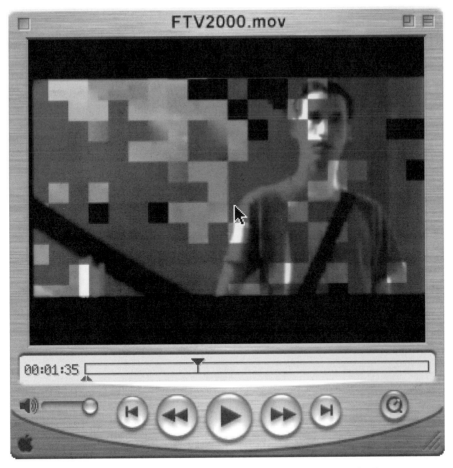

Figure 2.3 Excessive motion in a movie may result in blockiness when the show is compressed.

Lighting

Much has been written on the aesthetics and craft of lighting for motion pictures and television productions, and knowledge and practice of aesthetic lighting techniques is a matter of pride for many directors of photography. In fact, the most visible differences between film and video stem from the quality of lighting (or lack thereof) used to produce programs in each medium. Film, particularly theatrically screened film, is still unsurpassed when it comes to showing detail in high-contrast scenes such as nighttime exteriors and other low-key lit scenes. Luckily for the Web video producer, many rules of traditional video production apply as well when shooting for the Web. The low-key lighting (with a preponderance of dark shadows and high contrast between dark and lighted portions of scenes) that defines the tone of many films does not play as well on traditional video due to an inherent inability to resolve adjacent areas of high contrast. Unfortunately, such scenes fare even more poorly with compressors. In general, the best lighting for Web applications is high-key lighting, characterized by bright overall lighting with few shadows or other areas of darkness and relatively low contrast.

Lighting for Compressed Video

Often the best way to get a film look is to emulate the professional lighting techniques used in feature-length movies. Having said this, it should be noted that those techniques that give a theatrical film style and verve—high-contrast lighting, strong back- or side-lighting, saturated color, and constant camera movement—are often the very thing to avoid when you seek to produce quality video meant for Web or CD deployment. Alas, the compression process necessary to make a digital video file small enough to travel efficiently through phone lines and over computer networks does not work well with many feature film production techniques.

So how do you go about lighting video (or film) for compression? Here are some guidelines and basic setup procedures to help you in your mission:

As most filmmakers know, lighting is often one of the most overlooked and neglected aspects of shooting video. Blame it on the lighting's fast setup time, the miniaturized equipment, and the relative low prices of videotapes. Video's ease of use and low cost has led to a lot of quick-and-dirty production. "Good enough for video" is no excuse for schlocky production values.

Avoid the "Film Noir" Look

In general, work with light levels as high as you can manage with the lighting instruments available to you. That said, the fewer sources you actually have on a set, the more naturalistic and appealing your lighting will be. Lighting that is too dim will force cameras to increase gain levels (amplifying the video signals they produce) and lead to excessive noise (also known as "snow" or "grain"). Areas of high contrast between shadows and highlights can create dramatic "chiaroscuro" (Italian for "light/dark") in painting and 35 mm film but are best avoided with video, particularly video that will be compressed.

Resolving Light Sources and Color Temperature

In real life, we are surrounded by light sources that emphasize different colors of the spectrum. Daylight is predominantly blue, tungsten light bulbs predominantly yellow, and fluorescent lamps predominantly green or orange. These differences are very obvious to video cameras, and light disparities our eyes ignore become obtrusive and ugly on video or film. The simplest solution is to eliminate fluorescents and discharge sources (like outdoor streetlights and industrial lighting in large warehouses) from your set. Fluorescent light sources, apart from professional Kino-flo type lights (available as tungsten- or daylight-balanced), may be one of six different color types, whereas industrial discharge lights lack a complete spectrum and cannot be filtered successfully. Be aware also that tungsten lamps, whether the quartz halogen (3200 K color temperature) or standard household (2800–2900 K), are much warmer in color than daylight (5600 K). If you do not want the color disparity to show in scenes where tungsten light and daylight appear, be sure to filter one or the other. Daylight will take on a tungsten warmth when filtered with color temperature orange (CTO) or #85 filter gels (often placed over windows in the form of sheets to filter incoming daylight to match indoor tungsten light). It may be easier to filter your individual tungsten sources with color temperature blue (CTB) or #80 filters, but beware that these densely colored gels will cut your light sources by about 70%. This means that a 200-watt lamp with blue filtration will become a 60-watt lamp. But for all these alternatives, the best solution may be to simply limit your lighting to one type of source. Mismatched light sources cannot be "fixed in postproduction."

Modified Lighting Formulas

Lighting formulas followed too rigidly can result in generic lighting effects, but at best they offer starting points that ensure professional results. The most time-honored of these is the three-point lighting setup for lighting a single subject. Three-point lighting consists of a main (key) light, a fill light to bring up the illumination of shadows, and a backlight to create an illuminated edge and separate a subject from a background. A fourth source, the background light, is often used to lighten the backdrop behind the subject. Three-point setups are traditionally illustrated by surrounding a subject with three identical sources, two in front and one directly behind, with fill and key positioned on either side of a subject's face and angled 90° to each other. This is not the best way to achieve a visually interesting lighting scheme.

The best way to use three-point lighting is to light a subject so that it does not look lit. Look at the prevailing light in a scene and then try to emulate it in a way that looks pleasing on camera. The key light can be a small spotlight or soft-light. If you use an open-face lighting fixture, without a built-in lens, then try to diffuse the light by aiming through a translucent diffusion gel held in front of the source. You can hang the sheet from a C-stand arm or clothespin it to the barn doors of the fixture (assuming you have barn doors for the fixture). This will take the edge off the light. Start with a position at about 30° to 45° in front of the subject, to the side of the camera.

The fill light is placed on the other side of the subject, often quite close to the camera. Its job is to decrease contrast in the scene by lightening the dark shadows. The fill should never cast visible shadows of its own. The best fill is a large soft-light (a fixture that casts light with a large reflector but no direct light from the bulb itself). A reflector card, such as a white foamcore sheet, makes an excellent fill, either as a reflector for the key light or with a lamp dedicated as a bounce light. Foamcore is cheap and easily found at most art and office supply stores.

Separation light, also called the backlight, is the third important light used in most lighting setups. The backlight adds a glistening, 3D quality to the subject. Without it, high-key scenes may look flat and dull, and in low-key and night scenes, the subject tends to fade away into the background. Despite their popularity in feature films, it is best to avoid contrast rim or kicker lighting because these will create problems in the encoding process.

Two-shots are often best shot using a crosskey arrangement. Cross lighting is a very efficient lighting tool that keeps setups simple, allowing the use of fewer lights. Begin by drawing an imaginary line from the camera to the actor (from 6 to 12 o'clock if you think of a horizontal clock face). Then you form the "cross" with two more lines (one from 4:30 to 10:30 and another from 2:30 to 8:30)

intersecting on the actor. Put a key light on 8:30 or 4:30 for nice 3/4 illumination on the actor's face or on 10:30 or 2:30. The light will appear to be coming from a practical source behind the actors and wrapping around their faces while giving a backlight to each. When we do the reverse or "over-the-shoulder" shot the lights, with additional softness, are already in the very pleasing 8:30 position for one actor and in the 4:30 position for the other, plus giving each a nice rim light. Shoot the two-shot with a higher ratio such as a 4:1, 6:1, or 8:1. You should have a large fill source near the camera, such as a large silk or white card.

It is a good idea to light the background separately rather than let the key and fill spill onto the background. If possible, block the spill using a flag (a black cloth sheet affixed to a metal frame and held with a C-stand). Often in film lighting, backlighting is filtered through a cut-out pattern to create a mottled lighting effect; it is always better, however, to create a smoothly lit surface for QuickTime video. Limit the illumination of the key on the subject to no more than four times the overall fill illumination; this is known as a 4:1 ratio. If you have an incident light meter for measuring lighting ratios, use it. Although this may seem overly conservative, it will yield superior QuickTime quality.

In general, always light the subject. Avoid using too many sources and keep all sources color consistent. Avoid high-contrast situations; hot highlights and dark shadows make ugly QuickTime video. Make sure your lighting matches from shot to shot.

Subdue contrast and hot colors

If you can control aspects of your shoot such as the color of clothing worn by talent, by all means do so. A solid dark-colored shirt is a much better option than a very light or patterned garment. Shirts with pinstripes or other patterns are especially problematic, as are white shirts worn by dark-complected subjects. Hot colors such as bright blues, yellows, whites, and especially reds will create unwanted noise in your picture. Ask actors to wear solid dark-colored shirts.

Sound concerns

Because film production nearly always employs a double system (with a sound recorder running independently of the camera) when it comes to sound filming, the audio quality of such productions tends to be considerably higher than that of the lone videographer who records audio with the built-in microphone of the video camera. Always record with the highest quality microphone you have available, and place the microphone as close to the sound source as possible. This may mean clipping a lapel or lavaliere mike to an interview subject, or employing a skilled crew member to hold and aim a boom-mounted

shotgun microphone at the sound source. The primary goal of sound recording for nearly any medium, of course, is 1) to maximize desired sound levels and minimize background noise by actively turning off noisy appliances, closing windows, and miking closely, and 2) to record as "flatly" as possible, without introducing reverberations, signal processing, or equalization into the production tracks. If you want to ensure correct audio levels, the person in charge of sound recording should monitor the sound recording both visually (using the peak program, modulometer, or volume unit (VU) meter if the recording machine has one) and with headphones to ensure that the recording is free from distortion and hum. Be sure to eliminate any AC hum that may be emanating from power cables. If possible, use a mixer to control the audio before it goes to the computer. All of these precautions should be taken in production, rather than attempting to "fix it in post" or trying to salvage poor sound during editing or encoding.

Postproduction tips

As with production, you can take steps in the postproduction or editing process to ensure that your movie compresses as optimally as possible.

Straight cuts versus transitions

When it comes to transitions, use straight cuts. There are a lot of reasons to avoid dissolves: they tend to soften the impact of cuts, and they can slow down the pace of a film considerably. Wipes tend to look gimmicky and artificial. There are more compelling reasons to avoid optical transitions when it comes to codecs, and for the same reasons you should avoid camera movement and busy backgrounds: It is very difficult for the codec to keep up with the constantly changing pixel distribution of shots dissolving or wiping together. This also holds true for dynamic special effects such as superimpositions. Even straight cuts can be problematic when they follow one another in close succession, therefore, try to avoid very active montage sequences and minimize scene changes if you can, as they make for inefficient compression.

Rolling titles

In general, when a movie is compressed, the original titles and credits become small and pixilated and consequently fairly illegible. In fact, it is often much better to cut out the text and replace it with a text track (see Chapter 7) that is vector-based and not subject to the degradations of compression. In any case, you should definitely eliminate any crawling or rolling text you may have, as the constant changes in detail are difficult to encode.

Color and gamma compensation

Video has a tendency to look darker when viewed on a computer screen, especially if the frame size has been reduced significantly. Gamma, or the difference between the brightness range of an image displayed by one computer/display and the same range displayed by another, varies across computer platforms as well. PCs display higher gamma than Macs, resulting in darker renditions of normal-looking Macintosh images. Conversely,

Macintoshes display PC graphics considerably lighter than PCs. You will need to boost the gamma if you are authoring on a Mac and want the image to have the proper density when viewed on a PC. You can increase the gamma of your movie using the gamma filter in Discreet Cleaner or by applying a gamma change in the filters in Movie Properties when you use QuickTime Pro.

3 The QuickTime Player and Plug-in

"The QuickTime team came up with a revolutionary notion—the ability to capture video in real time using inexpensive video-capture hardware and edit it right on the Macintosh. It brought the power of movie creation to the masses."

—**Dawn C. Chmielewski**[3]

QuickTime has two primary playing components: the QuickTime Player and the QuickTime Plug-in (in addition, an ActiveX component comes into play for Internet Explorer 5.5 and above on the Windows platform; see Chapter 8 for more details). These components are placed on your hard drive at the time of installation. The QuickTime Plug-in will install itself automatically into any browser you have installed, such as Internet Explorer or Netscape Navigator. The Player is a stand-alone application that plays movies by itself without the aid of a browser. The plug-in, on the other hand, plays content through your browser but it is not essential for playing content on the Web; the Player itself will also play content from the Web. The Player has many more functions, however, and you can even go to QuickTime content on the Web and play media through the Player alone.

You can do many of the same things with the QuickTime Plug-in as you can with the Player. For example if you have your browser open, you can simply drag a QuickTime movie or other compatible media file to the browser window and the QuickTime window will open.

The QuickTime Controller Bar

You will find the QuickTime controls in the Controller bar (Figure 3.1). Among these controls are the "Time Line Slider," the "Play" button, the "Step Forward," "Step Reverse," "Audio Level," and the "Info" buttons. When you press "Play," the movie plays forward at normal speed whereas the button itself becomes a "Pause" button that will stop the movie at that point, without resetting it to the beginning. If you double-click anywhere in the movie window, the movie will also play; a single-click in the window will pause the movie. Other ways to start and stop the movie are:

- Pressing the space bar.
- Hitting the "Return" (Mac) or "Enter" (Windows) key.

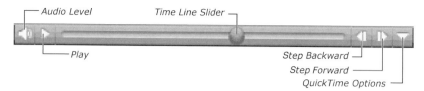

Figure 3.1 The QuickTime Plug-In controller bar.

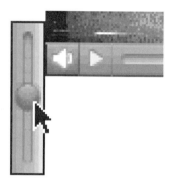

Figure 3.2 Control sound levels by clicking your pointer on the speaker icon.

- Holding down the "Control" key (Windows) or the "Command" key (Mac) while pressing the right arrow key to start the movie; conversely, you may reverse the film by Control-clicking (or Command-clicking) the left arrow key; hit "Enter" (Windows) or "Return" (Mac) to stop.

The "Step Forward" and "Step Back" buttons allow you to advance or reverse the movie one frame at a time. You can also go straight to the end of the movie by pressing "Alt/Option" simultaneously with the right arrow key. You can go directly to the start of the movie by pressing "Alt/Option" and the left arrow key.

Controlling sound in the QuickTime Plug-in and Player

It is safe to say that sound is half of film and video, and it plays a large role in QuickTime as well. You can control sound levels with the speaker icon button in the far left-hand corner of the control bar (Figure 3.2). Hold down the "Option" key (Mac) or the "Control" and "Alt" keys (Windows) while clicking the speaker icon; you will see that the icon changes to reflect a mute speaker, with no "waves" emitting forth. You can reverse this by repeating the same step, and the sound returns. When you click and hold on the speaker icon,

a pop-up menu emerges to show a sound volume level slider where you can adjust the sound level.

Master volume control

The Plug-in offers a feature that the Player lacks: if you hold the "Shift" key and click and hold the "Speaker" button, you will see a slider appear etched with hash marks at approximately the one-third and the two-thirds positions. This feature acts as a kind of master volume slider, where the one-third position represents 100% of the potential audio level and the two-thirds marking denotes 200% of the normal volume. These indications give a rough idea of when you may be overdriving the sound and might hear distortion and noise. Rather than using this as a method of gaining the maximum volume level, you would be better off adjusting this master level at the speaker volume knobs of the computer or amplifier. This feature may be useful, however, to laptop users who do not normally have the luxury of external speakers.

Speed control slider

The elegance of the QuickTime Controller owes much to the clean interface that appears to offer only the most basic features but actually hides many more controls that reveal themselves with various keyboard commands. Such is the case with the variable speed control slider that lets you slow down or speed up the playing of both the visual and audio information of a movie.

The variable speed controller appears when you hold the "Control" (Mac) or "Alt" (Windows) keys and click and hold your pointer on the control bar between the step forward and step back. You will see and hear your movie play at $2\frac{1}{2}$ times the normal speed when you push this slider to the extreme right, while you can play the movie in reverse at the same 250%. This slider lets you scrub or shuttle through a movie or simply watch in fast or slow motion, forward or reverse.

QuickTime chapters

QuickTime movies can contain chapter names that reveal themselves to the user as the movie plays. If the QuickTime movie has been designed with chapters, you will see chapter names appear and change in a space between the time line slider and the step buttons. Further, if you click and hold on the chapter name showing, you will bring up a pop-up list showing all the chapters available. This feature also lets you select any chapter showing in the list and the movie will go to that chapter. This is a convenient way to allow the user to go directly to preselected points in the movie.

Saving QuickTime movies

You can save many of the QuickTime movies that you see on the Web if you click and hold on the small triangular arrow button located on the far-right side of the controller of the movie you wish to keep. While holding on the button, you will see a pop-up menu (Figure 3.3) displaying a list of options. You can either "Save as Source" or "Save as Movie." You will want to choose the latter option to get the complete self-contained movie. A familiar dialog box will appear asking you to name and choose a folder you wish to save the movie in. Please note that the "Save" option shows up only when the movie has finished downloading. You can see its progress as a dark line that extends along the time line slider as the movie downloads; when the dark line reaches the end of the timeline, the movie has downloaded completely.

Keep in mind that you will find movies on the Web that will not allow you to save them; in this case you will see the "Save" options appear to be grayed out. This is due to the fact that some content providers disable this ability to deter users from keeping copies of their movies. You can also disable the saving properties in your own movies that you put on the Web. Just be aware that many individuals are clever enough to know how to circumvent this safeguard by snatching the movies out of the browser cache that temporarily stores files on the hard drives of their computers.

The QuickTime Player

The QuickTime Player shares many features with the Plug-in. You will soon see, however, that the wealth of features to be found in the menu bar really sets the Player apart. And

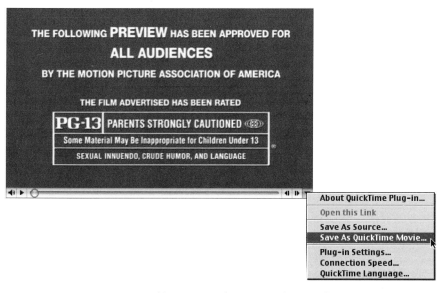

Figure 3.3 You can save QuickTime movies by going to the "QuickTime Options" menu.

with QuickTime, as with so many other applications, the "Shift," "Alt/Option," and "Control/Command" keys may be used in unison to perform numerous tasks.

Setting your QuickTime preferences

You will want to set your QuickTime preferences before you get too far into exploring some of the QuickTime Player's features and functions. In Windows and Mac OS 9, you will find the preferences in the menu bar under "Edit/Preferences/Player Preferences" in the form of a flyout menu. Mac OS X users will want to go to the menu bar under "Quick-Time Player/Preferences/Player Preferences."

Note the four categories in the dialog box: "Movies," "Sound," "Favorites," and "Hot Picks," with options to check boxes:

Movies
- Automatically play movies when opened. When this box is checked, any movie will automatically begin playing as soon as it is opened. Generally, this box will be unchecked by default.
- Open movies in new player. When this box is unchecked, a newly opened movie will take the place of any movie currently open on the desktop. To allow multiple movies to open on the desktop, make sure this box is unchecked.

Sound
- Play sound in background. This allows you to hear the audio of a movie even when it plays behind other applications. This is useful, for instance, when you want to hear MP3 files playing while you work with other programs.
- Only front movie plays sound. You may wish to leave this checked if you do not want to hear the sound from several movies you have playing commingle and create a cacophony. If you wish to hear all movies playing, however, go ahead and uncheck this box.

Favorites
- Ask before replacing favorites. This is simply a safeguard to prevent you from losing any favorites you have selected.

Hot picks
- Show "Hot Picks" movie automatically. When this box is checked, a movie from QuickTime's selected "Hot Picks" will play when the Player is opened.

An easy way to open mov files you have on your hard drive or removable media is simply to click on the file and the movie will open in QuickTime. You can also go to the menu bar, to "File/Open Movie in New Player," and browse for the file in the dialog box that appears. Alternately, you can "Command/Control + O" to bring up the same dialog box.

The Player has three large round buttons flanked by two smaller round buttons to perform the following functions:

- "Play/Pause" (center button). This lets you stop or start the movie.
- "Fast Forward" and "Rewind" (two large buttons flanking the "Play/Pause"). These let you zip through the movie forward or backward at $2\frac{1}{2}$ times the normal rate as long as you press the button.
- "Go to End" and "Go to Start" (the smallest buttons flanking the larger three). Pressing these will take you to the end or the beginning of the movie. These are not the step buttons you find in the Plug-in; when you want to step by single frames, you can hit the arrow keys: right arrow for step forward and left arrow for step in reverse.

Playback options with the QuickTime Player

You can set a number of options regarding the playback of a QuickTime movie. You will find them by going to the "Menu" bar, under "Movie":

- "Loop." This allows you to play the movie as an "endless" loop, constantly repeating itself from beginning to end. ("Control/Command + L")
- "Loop Back and Forth." This is an odd variation on the loop, playing the movie from start to finish, finish to start, over and over again. This is also known as palindrome mode, named after the special words that read the same forward and backward, such as "kayak."
- "Half Size." This shrinks the Player window to one half the original saved window size of the movie. ("Control/Command + 0")
- "Normal Size." Plays the movie at its intended window size. ("Control/Command + 1")
- "Double Size." This allows the movie to play at twice its normal size. It does this by doubling the pixels of the movie, and in some cases interpolating or creating pixels to make the movie play at a bigger screen size. This has the unwanted effect and grain as well as the picture. ("Control/Command + 2")

Note: You can resize a movie by clicking the lower right-hand corner of the Player and dragging up or down (Figure 3.4); you cannot change the proportions of the frame—the movie's original aspect ratio will remain constant. If you want the movie to play in a "long and squashed" or "tall and skinny" aspect ratio, drag the lower right-hand corner of the Player frame while holding down the "Alt/Option" key. If you want to play the movie at one of several predetermined optimum sizes (with original aspect ratio intact), then press the "Shift" key while dragging the corner of the Player. These optimal sizes use central processing unit (CPU) power most efficiently.

- "Full Screen." Allows the movie to play using the entire computer screen. This is a useful option when you want to show a movie without the distractions of background clutter. ("Control/Command + F")

Figure 3.4 You can resize a movie by clicking the lower right-hand corner of the Player and dragging up or down; you cannot change the proportions of the frame—the movie's original aspect ratio will remain constant.

- "Present Movie." This option brings up a dialog box that allows you to set a movie size (as previously stated), lets you play it as a movie or a slide show (frame by frame), and gives you a schematic of the screen configuration and the position of the movie within the screen. When the "Present Movie" option is selected, a neutral gray or black background appears on the screen for the movie to play in, a handy feature when you want to present it before an audience. When "Present Movie" is selected as the play option, keyboard commands such as step forward and reverse are temporarily deactivated; to return to the desktop, press the "Escape" key. ("Command/Control + M")

- "Show Sound Controls." When this option is selected, basic equalization controls will appear in place of the progress slider. These controls allow adjustments to speaker balance (left and right), bass, and treble.

- "Show (Hide) Video Controls." When this option is selected, an adjustment panel will appear in the movie frame to facilitate a number of adjustments to color, brightness, contrast, and tint. Only one adjustment is allowed at a time, but you

may shuttle through the four adjustment states by clicking on the "Up" or "Down" arrow icons in the adjustment bar directly to the right of the category title (color, brightness, and so on) or by simply using the "Up" and "Down" arrow keys on your keyboard. You can make each of these four adjustments by clicking and dragging on the small division between the wide and narrow striped bars (Figure 3.5), or by using the left and right arrow keys. ("Control/Command + K")

- ■ "Get Movie Properties." This option brings up a dialog box allowing you to see and set the movie's various properties. We will cover this feature in greater detail in later chapters.
- ■ "Play All Frames." When you are using a slow computer, you may experience *dropped frames*. The "Play All Frames" option lets you play each frame, but because the playback may slow down to accommodate this with a slow computer or slow connection, you will not hear the sound track.

Adjusting sound on the Player

There are several ways you can adjust sound quality and amplitude:

Volume controls

You can make simple sound-level adjustments by grabbing the small round knob on the volume slider and dragging to the right (louder) or left (softer), though it may be even easier to use the "Up" and "Down" arrow keys for the same thing. You can make a clip play silently if you hold the "Control" (Mac) or "Alt" (Windows) keys while clicking the "Play" button. Curiously, you can save any balance and volume settings you wish, but not

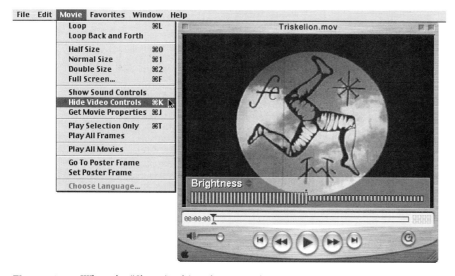

Figure 3.5 When the "Show (Hide) Video Controls" option is selected, an adjustment panel will appear in the movie frame to facilitate a number of adjustments to color, brightness, contrast, and tint.

bass or treble, which will return to their original defaults when a new copy of the movie is opened.

Tone controls

You can reveal tone and balance controls if you go the menu bar and select "Movie/Show Sound Controls." After this option is selected, basic equalization controls will appear in place of the progress slider. These controls allow adjustments to speaker balance (left and right), bass, and treble.

4 Basic Editing with QuickTime Pro

"You won't be up for an Oscar, but you'll do a decent job."

—**Arnie Keller**[4]

QuickTime is rightly famous for its multimedia playback abilities, but its editing capabilities remain largely unknown. In truth, there are more robust editing systems than QuickTime Pro when it comes to video postproduction, and serious editors would be well advised to stick with an application such as Apple's Final Cut Pro, Adobe Premiere, Avid Film Composer, DV Xpress, or even Apple's iMovie for editing content more than a few minutes long. Nonetheless, it is hard to beat QuickTime Pro's price and simplicity, and you may be surprised at the power that QuickTime packs when it comes to basic editing tasks.

Making Selections

Most editing programs, including QuickTime, use the word processor metaphor in their basic operation; that is, you rearrange, shorten or lengthen, and add or subtract frames and footage in much the same way you would edit letters, words, and sentences in a word processing document, through copying, cutting, and pasting. As with word processing, in order to edit, you need to learn how to make selections.

Open a movie clip you wish to edit and look at the QuickTime time line slider; at the start of the slider just under the black playback head arrow—the playback head—you will see a split gray arrow (Figure 4.1). The left half of this arrow represents the "In Selection Point," whereas the right half of the arrow denotes the "Out Selection Point." If you click and drag the "Out Selection" arrow out along the time line, you will see a gray bar appear over the time line between the "In" and "Out" points. Voila! You have just made a selection. You can also click and drag the "In Point Arrow" to trim the size of your selection. Notice that as you drag an "In" or "Out Point Arrow," you will see the picture change accordingly as you move your pointer across the time line. This indicates where you are in the movie so you know where to place in and out points of your selection; as soon as you release the point, the picture will return the frame of the movie to the position of the playback arrow. Any cutting or copying done now will affect only this area. You can fine-tune the "In" and "Out" points by highlighting one and incrementally nudging the point with the right (forward) or left (backward) arrow keys on your computer keyboard—you can

Figure 4.1 At the start of the slider just under the black playback head arrow—the playback head—you will see a split gray arrow.

tap or hold the key depending on how much you wish to nudge the point. Another way to set an "Out Point" is to scrub through the time line and when you arrive at the point where you would like to place the point, press the Shift key simultaneously with the right arrow before releasing your mouse button—your "Out Point" will jump to that place in the time line.

Note: If you use the mouse to make selections, your selection end point will be frame-accurate. That is, if you grab an "Out Point" and drag it back a couple of frames, then that is exactly the selection you will get—frame on. Conversely, if you use the time indicator and scrub to the last frame and use the Shift key + arrow key to set the end point, your selection will actually be one frame before what you are seeing on the screen. Although this is not a big issue, you will want to keep it in mind if you alternate between these two methods for setting end points.

Once you have made a selection, an easy way to move the time line playback indicator around is by holding down the Option key (Mac) or the Control + Alt (Windows) and using the arrow keys to make the playback indicator jump from point to point to start or end. For instance, if you have in and out points selected and your playback indicator is poised at the start of the movie, you can jump to the first point (in), to the second (out), to the end with Option or Control/Alt and right arrow clicking, or jump back through the out and in points to the movie start with Option or Control/Alt + left key clicking.

Copy-and-Paste Editing

You are ready to start editing when you have made a selection (see previous section). Perhaps the simplest form of cut-and-paste editing is taking a selected clip out of its context in the movie and placing it somewhere else.

Remove and replace a clip

- Select the segment of the movie you wish to place elsewhere, if you have not already.
- To cut the clip out of your movie, go to "Menu Bar/Edit/Cut" ("Control/ Command + X"). Note that the options under "Edit" are similar to the "Edit" options in any word processing program. The clip is now being held in the memory of the computer, waiting for the next step.
- To paste the clip, move the playback indicator to the point where you want to insert this clip, go to "Menu Bar/Edit/Paste" ("Control/Command + V") and insert the clip. Note that the clip appears in the movie as a grayed selection in case you want to further work with the clip.

Note: If you need to undo any step you have executed, you may do so by going to "Menu Bar/Edit/Undo" ("Control/Command + Z") and rescinding the last step you did. Unfortunately, QuickTime does not allow you to undo more than one step at any given time.

Trimming a clip to specific duration

The method described provides an easy way to edit clips visually. When you need to edit to a specific time length, however, you need to have a little more control. This is important if, say, you have to edit a clip to exactly 20 seconds long. To trim a clip to a given duration:

- Go to "Menu Bar/Movie/Get Movie Properties" ("Control/Command + J"), and you will see a "Properties" dialog box.
- In the "Properties" box, see that the left pull-down menu reads "Movie" and click on the right pull-down menu (it may be set to "Annotations" by default) and choose "Time."
- In the "Time" window, you will see four categories:
 - "Current Time": This shows the position of the playback indicator in hours:minutes:seconds:frames.
 - "Duration": This shows the length of the movie in hours:minutes: seconds:frames.
 - "Selection Start": This shows where the selection start is in hours:minutes: seconds:frames.
 - "Selection Duration": This shows where the selection end is in hours:minutes: seconds:frames.

When you go back to the Player, leave this dialog box open where you can see it. Then drag your in/out points across the time line slider according to the length you want, using the information in the "Selection Start" and "Duration."

Saving a Movie as a Self-contained File

In most cases, you will want to save a movie as a complete file. To do this, go to "Menu Bar/Save As" (rather than simply "Save"). At the bottom of the box you can see two choices: "Save Normally (allowing dependencies)" followed by a very small file size figure, and "Make Movie Self-Contained" followed by a large file size figure. As you save this file, be sure to check the option "Make Movie Self-Contained." This will save all of the film's components so that it will play in any context, rather than just within the directory where the movie currently resides. If you were to simply save the movie in the default "Save Normally (allowing dependencies)," the movie will play in its current state as long as all dependent files—meaning earlier versions or component elements used in editing the movie you are saving—remain in place. Think of these dependent files as components of a Web page, such as graphics and linked pages—the links of the Web page will function properly only as long as the links between it and its components remain intact. Therefore, the movie saved in this form will not play if it is moved or if the dependent files are moved or discarded. Saving the movie as a self-contained file will avoid this potential problem.

Editing Tracks

As we have seen, QuickTime movies are constructed of numerous tracks. You might think of tracks as layers if you are used to using image editing applications such as Adobe Photoshop. In general, the topmost video track at full opacity will obscure all underlying video tracks and thus they will not be seen. But audio tracks will play simultaneously unless they are disabled. So far, we have discussed editing QuickTime movies with a single video and audio track. But QuickTime is a multitrack editor, and you can put its ability to compile a movie from many tracks to good use.

For example, if you open a QuickTime movie, you can check the number of tracks it contains by going to "Menu Bar/Edit/Enable Tracks," where you will see a box listing the various tracks contained in the movie. If you have a movie with at least one video and one sound track and do a simple cut-and-paste edit, you switch out one portion of video and audio for another, essentially retaining two tracks. You can add new tracks to the existing tracks, however, by editing with the "Edit/Add" command. This action effectively stacks the new tracks on top of the existing tracks, preserving rather than writing over them. You will be able to hear two audio tracks when you play back the movie, even though only one video track will be apparent.

Track information in "Get Movie Properties"

You can learn a lot of useful information about the tracks in a QuickTime movie if you go to "Movie/Get Movie Properties." In the "Movie Properties" box you can pull down the left menu and see the various tracks in the movie; by selecting one of them, you can then go to the right menu and scroll down to any one of the following categories: "Alternate," "Annotations," "Files Format," "Frame Rate," "General," "Graphics Mode," "High Quality," "Layer," "Mask," "Preload," and "Size." When you select one of the audio tracks, you can choose from some of these same categories, including some extra ones such as "Preload" and "Volume."

Extracting tracks

The simple editing process described so far refers to what is known as assemble editing; that is, assembling clips with all tracks (e.g., video and audio) intact without regard to their component tracks. If you want to pull a single track from a movie, such as audio (or video) only, you can do so by extracting the track:

- Go to "Menu Bar/Edit/Extract."
- In the "Extract Tracks" box, select the track of your choice.
- Click "Extract" and a new movie appears that contains only the track just extracted. In this way you can add the sound from one movie to that of another (by going to "Edit/Add").

Replacing tracks

If you want a new track to take the place of an existing track, simply:

- Go to "Menu Bar/Edit/Delete Tracks" and a box appears showing the tracks contained in the movie.
- Select the track you wish to delete and press "Delete."

You have replaced one track with another, which you can verify by going to "Movie Properties" and checking under the left scroll menu.

Extracting multiple tracks

You can extract multiple tracks by doing the following:

- Go to "Menu Bar/Edit/Extract Tracks."
- "Command/Control" click on each of the tracks you wish to extract. (If you "Shift +" click, you can select all the items within the first- and second-selection click you made).
- Go to the movie where you want to add the tracks and select "Edit/Add," and the tracks will be added to the movie.

Turning tracks on and off

You can turn tracks on and off by going to "Menu Bar/Edit/Enable Tracks" and selecting the track(s) you wish to turn off. When you click on the track, you should see the green "On" button change to a red "Off" button. The track is still in the movie, but while it is turned off, it will not be visible or audible.

Stretching or compressing a track to fit a different movie

One cool feature is QuickTime's ability to let you stretch or compress a track you extract from a movie and insert into another movie to conform to that movie's length—this is known as scaling. Take, for example, an audio track from a one-minute movie using "Edit/Extract," select the audio track, and click "Extract." In the new audio-only movie select "Edit/Select All" and "Edit/Copy," and close the window without saving. Now if you go to the movie two minutes in length and select from the "Menu Bar Edit/Add Scaled," the track will stretch to fill the two-minute length of the movie. This will affect the speed of the video or audio track, of course, so you need to decide how much fast- or slow-motion effect you want in your scaled track (generally 5% to 10% is the maximum before the speed difference becomes really noticeable).

Scaled insert edits in QuickTime

You can also use this method for inserting scaled tracks from one movie into selected portions of another:

- You will want to specify the length of the track you intend to extract, so make a selection in the time slider of your source movie (see instructions on making selections if you forget how to do this). Now choose "Menu Bar Edit/Extract Tracks," selecting the track you wish to insert and clicking "Extract."
- In the new single-track movie that appears, select "Edit/Select All" and "Edit/Copy," and close the window without saving.
- Go to your second movie where you want to make your insert; make a selection in the time slider.
- Go to "Menu Bar/Edit/Add Scaled" and the clip you copied will insert into the selection where you want it. The clip you paste will expand or contract to fit the selected space.

Resizing and Repositioning a QuickTime Track

Changing the position and size of a QuickTime video track is a snap (note that these effects are not applicable to sound tracks).

- Go to "Menu Bar/Movie/Get Movie Properties" and select a video track from the "Movie" pull-down menu.

- With the "Movie Properties" window open, and "Video Track #" selected, go to the right pull-down menu and scroll down to "Size." You will see a number of controls to resize and position the video frame (Figure 4.2).
- In the lower half of the "Movie Properties" box, press the far-left button to "flop" the image horizontally; press the second-to-the-left button to "flop" the image vertically.
- In the lower half of the "Movie Properties" box, press the second button from the right to rotate the image clockwise in 90° increments; press the far-right button to rotate the image counterclockwise in 90° increments.

Figure 4.2 Options and controls in the "Movie Properties" window.

- You can rotate, scale, or skew the frame in varying degrees by clicking on the "Adjust" button. A red bounding box will appear around the frame with a red circle in the frame's center (Figure 4.3). "Handles" will appear at each corner of the frame and at the midpoint of each side. Grab one of the "handles" at the corner and pull to skew the picture or grab a corner and scale the picture to any proportion. If you click and drag from the center circle, a stretch handle will appear and allow you to pull the picture around, rotating it on the fly to any point you wish.

Note: QuickTime does not crop the frame when you perform these transformations; rather the movie canvas expands to contain the entire movie framed in its new position.

If you have two or more video tracks in the movie (you can add extra video tracks using the method described), you can move one of them within the frame:

- Open the "Movie Properties" window if it is not already open and select one of the video tracks from the left pull-down menu.
- Click on the "Adjust" button.
- Click within the bounding box that appears around the movie frame and drag the window; you will see that you are separating these video tracks and you can pull the picture up, down, or sideways. You can even drag down into the time slider and beyond; when you release the frame, you will see it in the position where you dragged it, increasing the size of the overall frame to accommodate both tracks. If you like the new configuration you just created, click "Done" in the "Movie Preferences" box; otherwise, you can restore the original dimensions if you click the "Normal" button in "Movie Preferences."

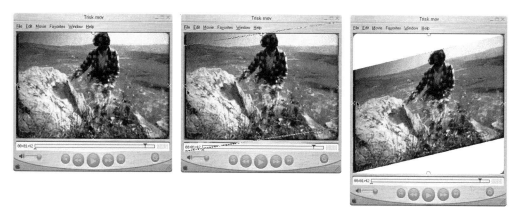

Figure 4.3 When you click on the "Adjust" button, you will see a red bounding box appear around the frame. Click on the bounding box and drag to change the frame size and shape.

Picture in a picture

You can get a simple but impressive picture-in-a-picture (PIAP) effect (Figure 4.4) by following this procedure:

- Extract a video track from an existing movie.
- In the extracted track, select "All" and "Copy" and close the extracted movie window without saving.
- Go to the movie where you want to create the PIAP effect and select "Edit/Add." This stacks the video track above the existing tracks.
- Go to "Movie/Get Movie Properties" and select the video track of your choice from the left pull-down menu; click "Adjust."
- A red bounding box should appear; click and drag a corner or edge of the bounding box to scale the track to a smaller size of your choice.
- Now move the track to the position you desire; the movie will play both the insert box and the underlying video track simultaneously.

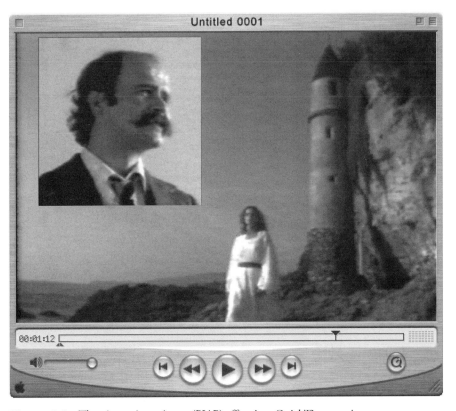

Figure 4.4 The picture-in-a-picture (PIAP) effect in a QuickTime movie.

Rearranging Video Tracks

You can reorder or layer your video tracks so the underlying obscured track becomes the visible track:

- You will want to see both video tracks, so go to the "Movie Properties" window ("Movie/Get Movie Properties"), choose "Video Track 2" from the left pull-down menu, choose "Size" from the right pull-down menu, and click on the "Adjust" button.
- Drag one track down so you can easily see both in the Player window. Click "Done."
- Now go to the right pull-down menu and select "Layer" (Figure 4.5).

Important: QuickTime tracks are numbered according to their layer order, so the higher the number of the layer, the farther down it sits in the layer stack.

- Change the number assigned to "Video Track 2" and click on the "Down" arrow until it becomes a number less than the overlying layer, such as "−1."

Figure 4.5 You can reorder or layer video tracks when you select a video track in the "Movie Properties" dialog and select "Layer" in the right-hand pull-down menu.

Using Masks

QuickTime Player lets you apply a mask to video tracks in a movie so it can play in a frame shape that is not necessarily rectangular. It is easy to create a mask, which is nothing more than a black and white graphic of a blob or patch in the shape you would like to act as the window of your movie. Here is how you put a simple mask in a QuickTime movie:

- Make a mask using a graphics program such as Adobe Photoshop or Adobe Illustrator. The mask should be black where you want your video to show through (and preferably extend to the edges of the document), and the rest white. Masks are most effective when they do not incorporate gradients, or soft edges. Be sure to make the mask document the same size of the playback size of the QuickTime movie, or the mask may be distorted as QuickTime scales the mask to fit the Player.
- In the movie you wish to mask, go to "Movie/Movie Properties" and select the video track in the left pull-down menu.
- From the right pull-down menu, select "Mask" and in the box that appears click on the "Set" button.
- From here you can browse for the mask you made and click "Open." The frame of your movie will now play in the shape of the mask you made.
- If you do not like the mask effect, you can go back to "Movie Properties," scroll to "Mask" in the right pull-down menu, and in the box that appears, click on the "Clear" button. You can try another mask if you like.
- Masks with soft edges or blends may render with unpredictable results as Quick-Time attempts to dither the soft edges (much like a GIF file). What's more, soft-edge masks will take more CPU time to render and make your file size much larger than if you had used a hard-edge mask.

Video Effects Using QuickTime's Graphics Mode

QuickTime will let you add all kinds of visual effects to your movie in the "Graphics Mode" property, including blended video tracks, keyed-in graphics, and alpha channels.

Blended video tracks

You can apply layer blends to your video tracks, much like you can blend with layer modes in Adobe Photoshop. You will need a movie with two video tracks; in this tutorial we will add a scaled video track to an existing movie and save it as a new file:

- Open the two movie files found in the "Ch04/Blend/" folder of the CD: nuages1.mov and orb.mov (Figure 4.6). With the orb.mov movie open, select "All" and copy.
- Open the nuages1.mov file (Figure 4.7), and select "Edit/Add Scaled" to add the orb as a second video track.

Figure 4.6 With the orb.mov movie open, select "All" and copy.

- Now go to "Movie/Get Movie Properties." In the "Movie" menu, select a video track from the left pull-down menu and "Graphics Mode" from the right pull-down menu.
- In the "Graphics Mode" box that appears, you will see a list of properties. From the "Graphics Mode" properties, select "Blend" and you will see the top video layer become transparent (Figure 4.8).

To vary the opacity and hue (transparency) of the video track, click on the "Color" button and a "Color Settings" box will appear (Figure 4.9). Click and drag on the slider to add or subtract transparency; the more black the color circle becomes, the greater the transparency in the video track. You can also vary the overall hue of the track by clicking in the appropriate area of color in the color circle and thereby tinting the video track.

Figure 4.7 Open the nuages1.mov file and select "Edit/Add Scaled" to add the orb as a second video track.

Keyed graphics with transparent colors

You can key graphics such as titles or logos over a video track by importing the graphics and making one color transparent. This effect is most successful with images containing solid areas of flat color.

- Start with a graphic containing a color you would like to become transparent (transparent areas will show video).
- Open your graphic in the QuickTime Player by going to "File/Import."
- Navigate to the desired graphic file and open the graphic as a QuickTime movie within the Player.
- With this movie selected, go to "Edit/Select All" and "Edit/Copy" to copy the track.
- Go to the movie where you want to add the graphic, select "Edit/Select All" and "Edit/Add Scaled" if you want to reduce the size of this graphic.

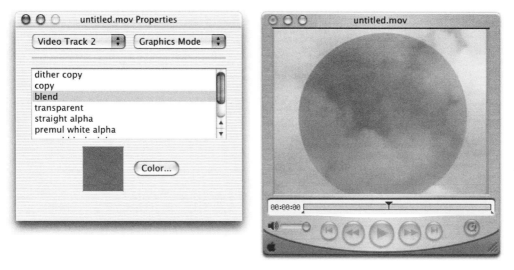

Figure 4.8 When you select "Blend" from "Graphics Mode Properties," you will see through the track to the ones below it.

Figure 4.9 To vary the opacity and hue (transparency) of the video track, click on the "Color" button and a "Color Settings" box will appear.

- Go to "Movie/Get Movie Properties" and from the left pull-down menu, select the video track of the graphic (Track 2 in this case) and choose "Graphics Mode" from the right pull-down menu.
- Scroll down in the right pull-down menu to "Transparent."
- Click the "Color" button and you see the "Colors" dialog box appear. Click on the "Magnifying Glass" icon in the upper right-hand corner of the "Colors" box and you will see a large magnifier appear (Figure 4.10); then choose a color in the image area you want to make transparent by clicking in the appropriate area of the graphic. Click "OK" and the color will become transparent.
- You can scale and reposition the graphic if you like (see "Resizing and Repositioning a QuickTime Track").
- Save the file with a name of your choosing.

Alpha channels

Many graphics programs such as Adobe Photoshop can be used to create files to contain hidden alpha channels allowing transparent and gradient effects. Alpha channels go a step

Figure 4.10 Click on the "Magnifying Glass" icon in the upper right-hand corner of the "Colors" box and you will see a large magnifier appear.

further than masks in that they can incorporate pixels in a wide range of opacity, allowing for much more sophisticated composite effects. They tell QuickTime what to show and how much should be transparent in the image.

- If you create an image with Adobe Photoshop, you can save a selection of an area in your image and that becomes an alpha channel. In an alpha channel, the whiter areas are more transparent than darker ones. Be sure to save the image in a format that preserves alpha channels such as TIFF, PNG, TGA, or other 32-bit formats.
- In QuickTime Player, open or import the graphic with the alpha channel and add it to your QuickTime in the form of a video track.

In the "Graphics Mode" window, select one of the alpha channel modes in the scrolling menu. In most cases, you will want to select "straight alpha." If your graphic was created with a premultiplied alpha channel, however, you will want to select "premul white alpha" for images created on a white background, or "premul black alpha" for images incorporating a black background.

Note: Straight alpha channels store the alpha channel separately from the RGB image (video) content. Adobe After Effects provides straight alpha channels, whereas Adobe Photoshop provides premultiplied alpha channels, where the RGB and alpha channel information are intermingled on a pixel-by-pixel basis and the alpha channel has to be subtracted out of the RGB information before either can be processed.

Making a composite movie using alpha channels

In this tutorial, we will combine the orb with the cloudy sky again, but rather than blending it as a transparent image, we will "float" the orb as a solid body in the heavens. In order to use alpha channels, however, we will need to use source files saved as Photoshop TIFFs with saved selections of the white background (alpha channels). For this we can import a series of TIFFs and build a movie from them.

- In QuickTime Pro, select "File/Open Image Sequence" and browse to the CD to "Ch04/Alpha." Note that the TIFF files within are named numerically so that they will line up in the proper sequence. Select the first file, orb01.tif (Figure 4.11). QuickTime Pro will automatically import all the files within the folder. Click "Open" to import the images.
- A dialog box, "Image Sequence Settings," will appear. Since we are importing this series as frames to integrate with another QuickTime movie, select 30 fps (Figure 4.12).
- In the movie you have just made, select all and copy.
- Open the nuages1.mov file from the CD and select "File/Add Scaled." The orb movie will appear as the topmost track in the frame, completely obscuring the clouds track behind it.
- Go to "Movie/Get Movie Properties"; in the left pull-down menu, select "Video Track 2." Now go to the right pull-down menu and select "Graphics Mode." Click on "straight alpha" in the list of "Graphics Mode" options; though straight alpha

Figure 4.11 Select "File/Open Image Sequence" and browse to the CD to "Ch04/Alpha." Select the first file, orb01.

Figure 4.12 A dialog box, "Image Sequence Settings," will appear. Since we are importing this series as frames to integrate with another QuickTime movie, select 30 fps.

is probably the best choice, you can try some of the other alpha settings to see how they look, if you like. You should see the orb floating as an opaque ball against the background (see Figure 4.13 on the next page). The alpha channel in each of the Photoshop TIFFs has let us create a movie with alpha channels to achieve a matte-like special effect.

Other Graphics Modes

You have probably noticed that there are other options available as part of the QuickTime "Graphics Modes." Here are the others in a nutshell:

Figure 4.13 You should see the orb floating as an opaque ball against the background.

- "Dither Copy." This adjusts the hue of adjacent pixels, approximating the original image color when the user's display is set to a lower bit depth such as a 256-color display. If you desire a higher quality (though this occurs at the expense of speed), set this mode and go to "High Quality" in the same pull-down menu (one down from "Graphics Mode") and check the box labeled "High Quality Enabled."
- "Copy." If your image has lots of solid color, you may opt against a dithered appearance; if so, select this rather than "Dither Copy."
- "Transparent." As it says, this makes a selected hue in the chosen video track transparent. This does not work well with images with graduated tones and hues—like photographic imagery—but does yield good results with solid colors and tones.

5 A Filmmaker's Guide to Compression

"Everybody says, 'If you just gave me the settings you used for *Star Wars*, then I'd be set.' Well, unfortunately, that setting worked for that clip, but I didn't even use the same settings for another clip they sent me two weeks later . . ."

—**Doug Werner**[5]

You have a completed film, and it is time to deliver it to your audience. Although theatrical exhibition is still the ultimate goal of most filmmakers, it remains one of the most elusive goals for many independents. CD and DVD distribution are a more realistic alternative for most, though cost factors may still loom large for reaching the potential of sizable audiences. Thus, Web delivery has emerged as one of the best ways to reach large audiences at little cost. Web exhibition is not the ideal medium, however, for several reasons. Bandwidth still dictates small files, often at less-than-ideal frame rates. A computer screen is not the first choice of exhibition venues for most filmmakers. And, like it or not, downloaded movies often become the property of the user. Thus, it may be appropriate to reevaluate the function of the QuickTime movie on the Web. A good example of QuickTime being perfectly suited to distribution is the movie trailer. In most cases, these are advertisements for full-length films that film distributors hope users will copy and replay and even send to friends. In this case, the QuickTime movie is just a part of a film's overall promotion.

Depending on which avenue of delivery you wish to pursue with your QuickTime movie, you must compress the movie in order to squeeze it through the narrow pipe of the Internet. And whereas disc delivery such as CD-ROMs and hard drives require much less compression for playback, they still require that you apply moderate compression to ensure trouble-free playback. Compressing a movie encompasses choosing the physical frame dimensions, the frame rate, and the mode of compression. And some compression schemes let you pick target data rate, color depth, image quality, and number of key frames. Whatever is compressed must be expanded, or decompressed, once again in order for the user to read or play that file. Hence, we must use a specific COmpressor/DECompressor, or codec, designed for the route of delivery we will use to distribute our movie, whether via CD, DVD, or the Web.

Many professionals use specialized software such as discreet cleaner to compress batches of video. You can, however, do a respectable job of compressing using the QuickTime Pro Player itself, simply by choosing "Export" from the "File" menu, and then selecting "Movie

to QuickTime Movie" from the pop-up menu. In this menu, click the "Options" button
to bring up a list of compressors and choose your codec.

QuickTime has often been described as a Swiss army knife of compression features,
many of which go unused but add to the overall versatility and attractiveness of the package.
Thus, whereas the vast majority of codecs QuickTime offers for encoding and decoding
may not all prove indispensable to the filmmaker/videographer, they nonetheless increase
the versatility of the QuickTime architecture.

Compressing Time-based Video and Audio

If picture files tend to be large, moving picture files tend to be gargantuan in size, con-
suming lots of bandwidth. Full-screen 30-fps NTSC video chews through about
30 MB/second, which far exceeds the capacity of network lines and hard-drive delivery
speeds. Thus, all video must be compressed, and the rate and mode of compression is largely
dictated by the delivery mode you wish to use. There are codecs designed especially for
video, audio, and different types of still image files. There are codecs optimized for Web
and CD delivery. Most codecs compress files by discarding information considered super-
fluous or imperceptible to most people, and these are referred to as "lossy." There also exist
a small number of "loss-less" codecs that do not discard file information; most of these are
limited in their compression abilities, however, and do not provide files small enough for
Web deployment.

QuickTime allows the use of a multitude of different codecs all designed for specific
uses that allow for great versatility in choosing and honing a compression method for a
specific application. Indeed, the uninitiated filmmaker can be confused by the vast array
of codecs available, most of which are for very limited use only. Thankfully, you can accom-
plish most common compression and deployment tasks with the use of a few select codecs.
The number of applications that provide compression tools vary in sophistication, from
Apple's basic QuickTime Pro, to nonlinear editing applications such as Final Cut Pro and
Adobe Premiere, to other specialized programs such as Totally Hip's HipFlics, Sorenson
Squeeze, and discreet cleaner.

Although it is often a good idea to encode video/audio files within their native Quick-
Time .mov format, it may be wise to encode in a different format depending on the movie's
deployment. For example, although the MPEG-4 standard has been touted as a scalable,
versatile protocol for presenting and storing media for the Internet, you may also want to
encode your files in a format such as Kinoma movie for the Palm OS to gain maximum
exposure. Below is a discussion of the various types of standards that QuickTime supports.

The MPEG Codecs

The Motion Picture Experts Group (MPEG) protocols—MPEG-1, MPEG-2, and MPEG-
4—were developed as standards for disc and Internet digital media. MPEG, which unveiled
its first eponymous codec for compressed digital video in 1991, has been around as long

as QuickTime. The codec found widespread use in CD-ROM multimedia and video CDs. The video CD format made a big splash in Asia, where it became an alternative to VHS for marketing cheap copies of feature films (and, in fact, fueled a wave of bootlegged movies there). MPEG-1 never caught on in the United States as a feature film distribution format but found use as a video format for CD-ROM multimedia content and Web-based files in the mid-1990s. QuickTime supported the MPEG-1 format early on.

MPEG-1 video compression works by essentially removing the spatial redundancy—referring to portions of video frames of a given scene or shot often repeated—within a video frame (much like JPEG), and reducing the amount of temporal redundancy—the similarity of picture detail within a sequence of frames—between video frames. Temporal redundancy occurs when successive frames of a video sequence exhibit nearly identical images of a common scene, as with the static backdrop of a talking head subject. The system works on the principle that images in a video sequence do not change dramatically over short periods of time. Each video frame is encoded specifically in relation to other frames that precede and follow it. Thus, the term "spatial" refers to compression involving a single frame, whereas temporal compression recognizes the differences between frames and stores those differences only, leaving unchanged areas to be repeated from previous frames.

Video is digitized in a standard RGB format, 24 bits per pixel (8 bits for each primary color). A frame of video in digital format is essentially a mosaic of pixels measuring 720 × 480 pixels in NTSC (720 × 576 pixels in PAL). A pixel, like a grain particle in film, is the basic building block and smallest discrete element within a picture. Each pixel carries information relating to the intensity of each of the three additive primary colors—red, green, and blue—in one byte of data per color. A byte contains 8 bits, thus, 24 bits are necessary for full color. We refer to a system that sets the order and relationship of colors to one another as color space; examples are RGB (red, green, blue) and CMYK (cyan, magenta, yellow, black). Digital video uses the YUV color space, which recognizes the luminance or brightness (Y) and chrominance or hue (U and V) components of the image. MPEG forms of compression also use the YUV color space and tend to discard more color information than luminance information, as the human eye is less sensitive to chrominance. MPEG-1 compresses the chrominance in video on a ratio of 4:1, whereas the most widely used chrominance compression ratio in MPEG-2 schemes is 2:1.

MPEG-1 was designed to work with images measuring 352 × 288 or less, at 14–30 fps at bit rates not exceeding 1.5 MB/second. The popular MP3 audio format is actually based on the MPEG-1 protocol (MPEG-1, Layer 3).

The need for a broadcast-quality digital format spurred the development of a more robust codec, MPEG-2. The format of digital cable transmission and storage, MPEG-2, which can be streamed over intranets, was used as a compression and storage protocol for the newly developed digital versatile disc, or DVD. MPEG-2 enables the employment of encryption that protects content against unapproved copying. Whereas QuickTime is able to play unencrypted content (such as DVD content burned on discs by home users), encrypted MPEG-2 is a highly guarded format that QuickTime is unfortunately unable to play. And unlike QuickTime's contiguous sampling mode of formatting content, MPEG-2 programming is fragmented in a way that impedes unauthorized copying.

The group originally planned an MPEG-3 (not to be confused with MP3, which is MPEG-1, Layer 3) format for HDTV but determined that the quality of MPEG-2 was good enough for this format. Thus, MPEG-3 was dropped as a standard.

The next step was the creation of a high-quality video compression standard for Web media, MPEG-4, the successor to MPEG-1 and MPEG-2. The idea behind the MPEG-4 protocol, a media architecture in its own right, was the creation of an open standard to encourage swift adoption and ready compatibility. Open-source protocols (e.g., the Linux operating system) reassure programmers and content producers because they can encode files without the fear of certain obsolescence. MPEG-4 incorporates scalability, meaning that producers will encode once for all formats and bandwidths rather than create multiple versions of the same file. MPEG-4 also supports an audio codec known as AAC that allows for much greater compression while preserving much higher fidelity than the MP3 standard. Despite the promise, however, MPEG-4 has come up short in some comparisons with newer codecs, and hurdles loom in the road to complete acceptance for MPEG-4 (see sideboard).

What's with MPEG-4?

"It's all about standards."

—**Frank Casanova**, director of QuickTime product marketing, Apple Computer

It makes a lot of sense. MPEG-1 is the standard for video CD content. MPEG-2 is the standard for DVD content. So why not a standard for Internet media, so that we can all receive streaming and downloadable media encoded and played with one technology? Why do we still need three different mutually exclusive players (Real, WMP, and QuickTime) to play all forms of Internet media? Chalk it up to licensing and proprietary dominance—the corporation whose technology vanquishes the others becomes the de facto standard, and stands to make billions as a consequence. Don't believe it? Just look at what happened with JVC's VHS home videorecording protocol—its proprietary format became the only half-inch videotape recording system that mattered. The problem with proprietary schemes is that usually the scheme remains closed—that is, not available for tinkering and improvement by independent programmers and others. You need to simply follow the corporation and hope that the scheme continues to improve and remain relevant.

The Windows Media Player threatens to become the de facto industry standard for Internet media—and Microsoft's set of WMP 9 series products looks good indeed. The main problem is that Windows products are proprietary—closed—so the faithful have to follow Windows where the corporation sees fit to

lead them. Thus, the Microsoft Windows Media Player does not support MPEG-4 or its standards. In fact Microsoft continues to assert that its WMP MP4-V3 codec is superior in quality, despite the fact that the technology is based in part on the MPEG-4 protocol.

The MPEG-4 standard is made up of eight parts, some still under development, that handle video and audio encoding and rendition, file format selection, and transfer protocols. Much of the MPEG-4 standard was established back in 1999, with various improvements and additions added over the years. The protocol got a big boost in late 2001 when Real offered to support the MPEG-4 architecture, combined with the founding of the Internet Streaming Media Alliance (ISMA)—a group that both RealNetworks and Microsoft have so far refused to join. Indeed, the ISMA has staked its hopes that MPEG-4's AAC protocol will supplant MP3 as an audio format. Hoping to circumvent the kind of out-of-control peer-to-peer file sharing that occurred with the MP3 codec, a consortium formed to hammer out patent and licensing issues. In fact the inability of a key group—the MPEG-LA—to agree on such issues held up the official release of QuickTime 6 for nearly six months in the summer of 2002 after its originally planned unveiling at the 2002 QuickTime Live! Conference in February. The final version was released the day the MPEG-LA officially announced MPEG-4 licensing fees.

If this belated debut has not hurt the reception of MPEG-4 in the Internet media community enough, there is the repeated allegations, echoed in a February 2003 *DV Magazine* article, that QuickTime 6 and its implementation of MPEG-4 are inferior to its rivals. So where does this leave the standard carriers for Quick-Time and MPEG-4?

Many claim that Sorenson Video® 3 (SV3)—available to QuickTime users—is a higher-quality codec than MPEG-4; Sorenson also has released a version of the MPEG-4 codec said to be superior in nearly every way to Apple's MPEG-4. Two-pass variable bit technology available in cleaner, Sorenson Squeeze, and other compression/decompression technologies is not even available as part of the Quick-Time MPEG-4 package at the time of writing.

The future success of MPEG-4 may lie in a new extension of the MPEG-4 protocol known as Recommendation H.264, or MPEG-4 Part 10, finalized in December 2002. Its proponents have claimed that H.264 offers streaming video at DVD quality at much-reduced bandwidth and obviates any advantages attributed to Windows Media Player 9. The promise of H.264—still not a completed standard at time of writing—threatens to stop the slowly growing acceptance of MPEG-4's Advanced Simple Profile dead in its tracks as firms wait for the finalization of the new protocol.

The hope among MPEG-4 proponents is that H.264 can be included into a rich feature set with the MPEG-4 standard. In the meantime, QuickTime users have access to an array of basic and add-on codecs, including SV3, Envivio, Streambox, and ZyGoVideo.

QuickTime Codecs

Making an informed choice on what codec to use will be based mostly on where your media is going to screen and how it is going to get there. QuickTime movies destined for CD-ROM delivery can be saved with much less compression than those meant for the Web. In addition, some codecs such as DV are designed for authoring media, whereas others such as Sorenson Video are strictly delivery codecs.

Compressing Your Movie with QuickTime Pro

Compressing your QuickTime movie is practically as easy as saving it as a new media file.

1. If it is not open already, open your movie in QuickTime Pro.
2. Go to "File/Export" to open the "Export" box.
3. When the "Export" dialog box appears, choose "Movie to QuickTime Movie," located toward the bottom of the dialogue box (Figure 5.1). There are numerous

Figure 5.1 When the "Export" dialog box appears, choose "Movie to QuickTime Movie," located toward the bottom of the dialog box.

formats you can save to, but in general, it is a good idea to use the "Movie to QuickTime Movie" option.

Hint: At this point you could go to the next pull-down menu just beneath the "Movie to QuickTime Movie" and pull up one of several presets (Figure 5.2) It is always preferable to compress your movie to your own specifications, however, so go on to the next step.

4. Click the "Options" button.
5. In the "Movie Settings" box that appears, make sure the "Video" check box at the top of the box is checked (Figure 5.3) and click on the "Settings" button.

Figure 5.2 At this point you could go to the next pull-down menu just beneath the "Movie to QuickTime Movie" and pull up one of several presets. It is always preferable to compress your movie to your own specifications.

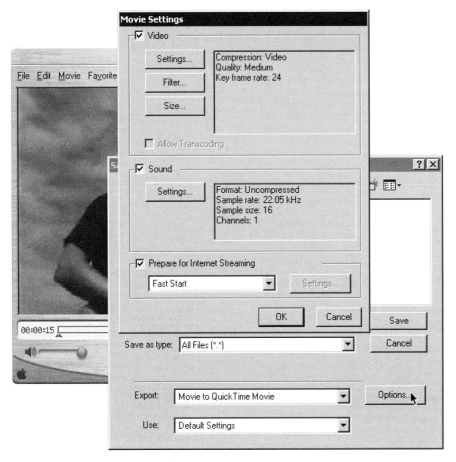

Figure 5.3 Be sure to select "Fast Start—Compressed Header" for all movies except those meant to stream from a streaming server.

6. Consult the listings and following discussion of the various video and audio codecs available to select the best codec setting and movie size for your delivery need, and click "OK" to set the codec and return to "Movie Settings."

7. Make sure the box "Prepare for Internet Streaming" is checked and select "Fast Start—Compressed Header." This is the recommended choice for all movies except those that will be handled by a streaming server (see Chapter 8 for more about streaming). Selecting "Fast-Start—Compressed Header" will ensure that the movie loads quickly. Other choices are:

 ■ "Fast-Start Movie." This is a good choice for movies available through hypertext transfer protocol (HTTP). It is adequate for movies that have a hint track.

■ "Hinted Streaming Movie." Choose this option if you are putting the exported file on a streaming server. Hinting refers to a process for adding information to the movie that the streaming server uses to package media data to be sent out over the Internet. The file will not stream without a hint track for each track in the movie (see Chapter 8 for more information regarding hinted movies).

8. Click "OK" to close the "Movie Settings" box.

9. Give your movie a new name and browse to or otherwise specify the location where the movie will be saved. Click "Save."

You can see numerous codecs available for saving files in the QuickTime format (Figure 5.4). Depending on your ultimate deployment venue—CD-ROM, Web, DV, or other— the process is pretty much the same. The following is a detailed explanation of the various codecs available as part of QuickTime Pro.

Figure 5.4 QuickTime provides a number of codecs for encoding movies.

Animation

Useful for two-dimensional (2D) animations

As the name implies, the Animation codec is best suited to compressing clips composed of large areas of solid color such as animated cartoons. The settings determine how lossy the compression will ultimately be; 100% quality is essentially lossless, making this an attractive editing codec for storing title sequences and other motion graphics. Although files encoded with the Animation codec may be quite large, they will still be made smaller than those made by choosing "None" for compression. It has some applications for CD-ROM delivery at its lower-quality settings but is suitable for the Web only for slide shows and other mostly still-image programming. Recommended key frame setting is one per second for moving images, blank for slideshows. Data-rate limits cannot be specified with this codec. The Animation codec uses an Apple compression algorithm based on RLE.

BMP

The BMP codec renders a series of Windows bitmap (.bmp) images, and like the Animation codec, yields the best results with clips having large areas of solid color. Because it does not provide any temporal compression, data rates increase with the frame rate. Thus, it is not suitable for Web or CD delivery, and frankly, there are better codec choices for DVD delivery. BMP allows for 2-bit, 4-bit, 8-bit, and 24-bit color. This codec will come into play by default if you open a series of BMP frames into QuickTime, but you will likely never have use for it as an exporting compressor.

Cinepak

Useful for CD-ROM files where backwards compatibility is an issue

In the early days of multimedia before the World Wide Web explosion, Cinepak was the prevailing QuickTime codec. Indeed, it was designed for compressing 24-bit video for CD-ROM discs and found use in compressing downloadable video files. QuickTime video files compressed with Cinepak can play on older versions of Windows Media Player, as well as any version of QuickTime on all supported platforms. Cinepak reaches higher compression ratios and faster playback speeds than other codecs, such as the Video Codec, but though it decompresses quickly, its compression speed is very slow. Notably, it does not work well at less than 30 KB/second. Image quality generally is not up to the standards of other codecs. In fact there are better codecs these days, notably Sorenson, so there are not a lot of compelling reasons to use Cinepak, other than the fact that files encoded with it might play better on slow computers. Use one key fps for motion video; for slideshows and still images, use the Animation, Graphics, or Photo-JPEG codec instead.

Component video

Capture and archiving codec

This codec, used in Sony Beta videorecording technology, finds many uses as a capture and storage format. Its low compression ratio of 3:2 yields high quality at the expense of large file sizes that consume large amounts of disc space. This codec is best for digitizing live video from an analog source for streaming broadcasts, where content is immediately discarded or otherwise compressed again with another codec for storage. It is not good as a delivery format.

Digital video (DV NTSC and DV PAL, DVC PRO PAL)

Capture, edit, and storage codec

DV, the codec used by digital camcorders, has become the consumer motion-picture medium of choice. Supported by NTSC and PAL, DV can provide interlaced as well as progressive scanning. DV does not, however, let the user vary the rate of compression (as does Motion-JPEG). This codec provides compression to the tune of 5:1, with a maximum video data rate of 25 MB/second. One minute of DV displaces about 200 MB of hard disc space. Thus, although the DV codec facilitates generally high-quality transfers, the compression and decompression afforded are CPU-intensive, making this a poor candidate for Web delivery. A key advantage of DV is its ability to be captured directly from camcorder to computer with Firewire (IEEE 1394) connections. DV material may be shot, edited, and duplicated with little degradation or generation loss. The primary drawback to DV lies in its resolution and sampling regarding color, such as 4:1:1 NTSC or 4:2:0, which do not work well for effects such as blue- or green-screen matting.

DV is a good format for editing, as evidenced by its adoption as a standard in popular nonlinear editing programs such as Final Cut Pro and Avid Xpress. DV-encoded video can also be recompressed as MPEG-2 with little degradation, and thus may be easily incorporated into a DVD using authoring software such as iDVD or DVD Studio Pro.

Graphics

Good for 2D animation
Delivery: hard disc

The Graphics protocol uses a compression scheme not dissimilar to the animated GIF. It generates a compressed image one half the size of the same image as compressed by the Animation codec. The trade-off is its decompression rate, which is slower than the Animation codec. The codec may not always produce the smoothest-playing videos, but it will not place strain on the processor in the same fashion as certain other codecs. Because the Graphics codec accommodates only 8-bit color or grayscale, this could be a good alternative to the Animation codec if your file does not need the extra color depth; it is not generally a good idea to convert a 16- or 24-bit file to 8-bit for this purpose, however, as the

image may be degraded significantly. Because this codec does not achieve high video compression ratios, it is suitable for playback from hard disk but not from CD-ROM. Only slideshows or very small movies will perform well with this codec at Web data rates.

H.261

Streaming video

This is an old codec originally designed for ISDN videoconferencing, thus it delivers very poor image quality. It has been superseded by its upgraded version, H.263, and hence offers little of interest to the filmmaker or videographer.

H.263

Streaming video

The successor to the H.261 protocol, H.263 allows for greater image quality at similar data rates. It was designed for low bit-rate communication, of less than 64 KB/second, used on slower machines for high bandwidth streams that cannot handle encoding such CPU-intensive codecs, such as—SV3, on the fly. Indeed, with current fast Macs and PCs, it is easy to live encode even SV3, and therefore H.263 is no longer widely used.

Intel Indeo® Video 4.4

CD-ROM

QuickTime still lists this codec as "Intel Indeo," though the license was sold to Ligos, Inc. some years ago. It provides high-quality images but requires a fast Pentium processor for compression and decompression. This codec is available for Macintosh OS 9 as an extra download component but is incompatible with OS X.

JPEG-2000

Still images, photographs

This is the latest development in the Joint Photographic Experts Group (JPEG) codec, available only on Mac OS X. It delivers superior encoding for still images while dispensing with much of the lossiness of previous JPEG versions and compresses files into much smaller file sizes even while retaining higher quality.

Motion-JPEG

Video editing

This codec is an extension of the popular JPEG standard for compressing and storing still digital images. Using compression algorithms virtually identical to photo JPEG, Motion-JPEG (M-JPEG) imposes no temporal compression, so the data rate increases

proportionally to the frame rate. Also like Photo-JPEG, M-JPEG supports 24-bit color or 8-bit grayscale. QuickTime offers the codec in two versions: M-JPEG A and M-JPEG B; they are virtually identical. QuickTime can handle both versions, which are basically different implementations of the same codec, differing from one another only by unique placement of file markers in each. M-JPEG video does not use interframe coding, thus every frame is a key frame; this makes it easier to edit in a nonlinear editing system than full MPEG-encoded video.

M-JPEG accommodates interlaced and progressive content alike, and like the JPEG format for still images, it allows various degrees of compression. A good use for M-JPEG is for encoding files that will go from one application to another; for instance, if you edit material with Final Cut Pro or Premiere and wish to take it to a special effects editor such as Adobe After Effects, you can save it in M-JPEG without too much degradation in overall quality.

MPEG-4 video

Internet

Introduced to QuickTime with Version 6, MPEG-4 was designed to approach MPEG-2 quality video at lower data rates and smaller file sizes. MPEG-4 offers better quality than MPEG-2 at bit rates below 1M-bit, making it a good codec for high-quality Web delivery. MPEG-4 promises to create interoperability for video delivered over the Internet and other distribution channels, as well as play back on many different devices, from satellite television to wireless devices. Apple's MPEG-4 video codec provides the highest quality results across a wide spectrum of data rates—from narrowband to broadband—ensuring that content providers only need encode once, rather than specifically for each venue (Quick-Time, Real, CD-ROM). The codec is said to offer compression times and video quality that rival those of the best proprietary codecs available, yet it provides true interoperability with other MPEG-4 players and devices.

The QuickTime MPEG-4 codec also provides rate control—the encoder can be set to a target data rate that ensures playback at the appropriate data rate for a particular delivery mechanism, and it can use a single-pass variable bit rate (VBR) controller either to maximize accuracy for the highest-quality output or to maximize encoding speed. That said, if MPEG-4 lives up to the hype, this codec *may* make all others obsolete. The general acceptance of MPEG-4 has been hampered somewhat by haggling over licensing implementations (see sideboard "What's with MPEG-4?").

Photo-JPEG

Delivery and storage codec
Use for still images with gradations (e.g., photographs), QTVR

This codec is best for still images that do not contain lots of sharp edges or detail. As a JPEG format, Photo-JPEG is lossy, but the compression can be set to preserve much of the original quality of the file. Using standard JPEG compression, this codec uses YUV

color and can provide high-quality results so long as it is used with progressive rather than interlaced video. Like M-JPEG, it makes for a good intermediate codec. Photo-JPEG is the most widely used codec for QTVR movies.

Planar RGB (also known as Photoshop)

Still photographs

This codec is useful for importing photographic graphics with an alpha channel, such as when you have an image that you want to composite with video.

Video (also known as Apple Video)

Real-time video capture

This offers very fast compressing and decompressing of video and has good compression ratios. Use it for real-time capture of video, particularly when hard disk space is at a premium, or for testing clips. It is also OK to use for hard disk playback but image quality is poor when compressing enough for CD-ROM playback.

Sorenson Video

Web and CD-ROM

Sorenson Video (Version 2) has enjoyed a reputation for being the best all-around delivery codec for QuickTime linear movies since it was introduced in 1998 for exclusive inclusion in QuickTime 3. Apple did not develop Sorenson but licensed the rights to incorporate it into the QuickTime Player. You can access the standard version (Figure 5.5) through the "Compression Settings" in QuickTime Pro, though you will not have access to Sorenson's VBR (see next section) and other functions unless you purchase the Pro version. The Standard edition gives good results for what Sorenson terms "average video content at moderate data rates (50 KB or above)." Sorenson is ideal for low bit-rate movies, and although it compresses slowly, it allows for more efficient use of disc space than almost any other similar codec.

Sorenson 3 Web and CD-ROM

SV3 uses much-improved technology, yielding twice as much compression speed and better color saturation and video ($4:2:0$ rather than YUV-9 color space) than Sorenson 2 at half the bit rate. Many consider Sorenson 3 to deliver the best quality and some of the smallest file sizes of any codec available for QuickTime, besting even MPEG-4. Its features include data rate tracking, automatic key frame sensitivity control, and bidirectional prediction (using "B-frames" that reference both past and future pictures and provide very high compression rates). SV3 also features video watermarks, QuickTime streaming

Figure 5.5 The basic Sorenson Video codec in QuickTime allows limited compression options.

support, and video masking. One downside to SV3, however, is its incompatibility with QuickTime versions preceding QuickTime 5.

When used in conjunction with discreet cleaner, Sorenson's most important feature is its ability to use VBR when encoding video and audio files. The SV3 Pro version of the software functions as an upgrade (www.sorenson.com, $299) to the basic version included in QuickTime. The robust SV3 is an asymmetrical codec, meaning that encoding is more time-consuming than decoding, which is advantageous for the user. After installing SV3 you may access the codec in QuickTime's "Compression Settings" dialog box by setting the top pull-down to SV3. Click on the "Options" button (Figure 5.6) to bring up the Sorenson Video "Settings" box. If you have SV3 installed, you will see tabs for "Summary," "Encode," "Playback," "Streaming," "Masking," and "Watermark":

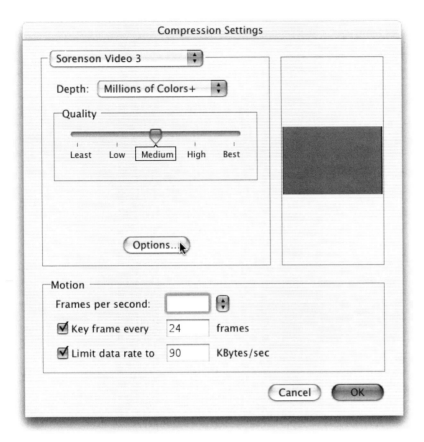

Figure 5.6 Click on the "Options" button to bring up the "Sorenson Video Settings" box.

1. The "Summary" window (Figure 5.7) shows how the SV3 settings are configured and may be changed in SV3 in the other tab windows.
2. The "Encode" window (Figure 5.8) includes SV3's most important compression settings:
 a. "Quick Compress"—If this box is checked, compression time is cut by about 20% with little loss in quality.
 b. Leave the "Bidirectional Prediction" pull-down to "Allow" for greater compression efficiency. The "Force for Playback Scalability" turns "Bidirectional Prediction" on at all times and allows for playback scalability. Leave this setting off if you are compressing with two-pass VBR (not an available option in QuickTime Pro) or fixed quality at 15 fps or lower.
 c. "Automatic Key Frames" monitors the differences between frames and inserts a new key frame when the difference reaches predetermined settings. This setting lets you choose how frequently you wish such key frames to be inserted. For maximum compression efficiency, the fewer key frames, the better; it is

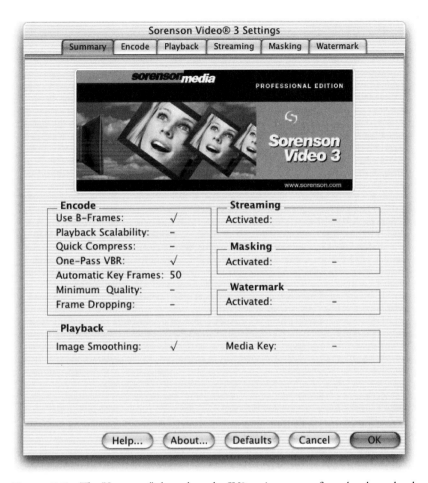

Figure 5.7 The "Summary" shows how the SV3 settings are configured and may be changed in SV3 in the other tab windows.

best if you can get away with a setting that inserts just one frame at the beginning of each scene. Sequences with lots of motion usually require more key frames. In general, the default value of 50 is fine for most purposes; Sorenson recommends keeping settings between 35 and 65 for optimum results. You may need to compress several times to achieve the ideal setting.

d. Finally, you have the option of one of the following three choices:

e. "One-Pass VBR." Leave this box checked. Sorenson touts this feature as producing video quality close to two-pass VBR in the time it takes to encode non-VBR. Unlike two-pass VBR, it does not require cleaner or Sorenson Squeeze and can be used in QuickTime Pro.

f. "Minimum Quality" lets you sacrifice data rate or frame rate to achieve a certain quality of image. It forces SV3 to keep the video picture quality at a

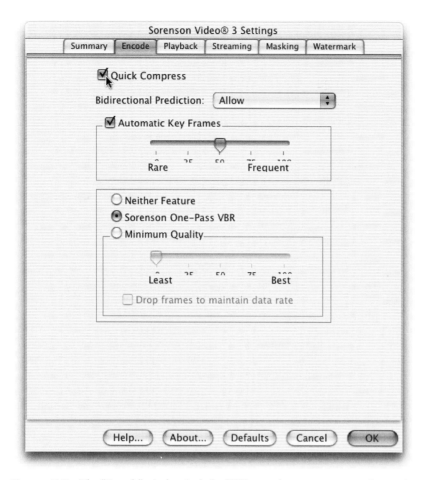

Figure 5.8 The "Encode" window includes SV3's most important compression settings.

certain level or higher, increasing the data rate as required to maintain quality. If you do not want the data rate to increase, check the "Drop Frames" box. Thus, picture quality is saved at the expense of dropping frames.

 g. "Neither Feature."

3. The "Playback" window (Figure 5.9).

 a. "Image Smoothing." This setting, when checked, reduces the blocky edges that occur in the low data rates used for Web video. Uncheck this box when you are encoding for high-quality video.

 b. "Media Key." Adding a media key can prevent unauthorized persons from viewing a video. To add a media key to the compressed video, type a password of your choice into the "Media Key" text box. Be sure to keep a record of this password in a safe place. Make sure you uncheck this box next time if you do not want to include this key—the setting will remain until you change it.

Figure 5.9 The "Playback" tab.

Figure 5.10 The "Streaming" window.

4. The "Streaming" window (Figure 5.10). If you are encoding for Web streaming media, check the "Streaming" box. You can leave the default settings for "Slice Picture . . ." and "Force Block Refresh . . ." as they are for most instances.

5. The "Masking" window (Figure 5.11) gives you the option of adding chroma-key like effects similar to those seen in news broadcasts, superimposing a foreground subject over another background.

6. The "Watermark" window (Figure 5.12) lets you add your own watermark, or logo, to a video, with adjustments available for position and transparency. The most notable feature about the Sorenson watermark is that the video will no longer play if the watermark is tampered with.

SOME GENERAL TIPS ABOUT SORENSON VIDEO

When setting data rates, the following formula is a good starting point:

Data rate = Width × Height × FPS/48000

Figure 5.11 The "Masking" window.

Thus, if your movie has a size of 320 × 240 at 30 fps, a general data rate would be 48 KB/second. Shots with little movement such as an interview could be successfully compressed at a rate as low as 24 KB/second, whereas an action sequence might require as high as 96 KB/second to look nice. Of course, higher bit rates demand more bandwidth and place more demand on the user's computer processor. You could also reduce the frame rate or the frame size if you did not want to decrease the data rate.

SOME SV3 TIPS

- The codec works best if both the height and width dimensions of the video are divisible by four.
- Sorenson likes a key frame every 10 seconds for motion video and can also designate additional key frames automatically when needed.

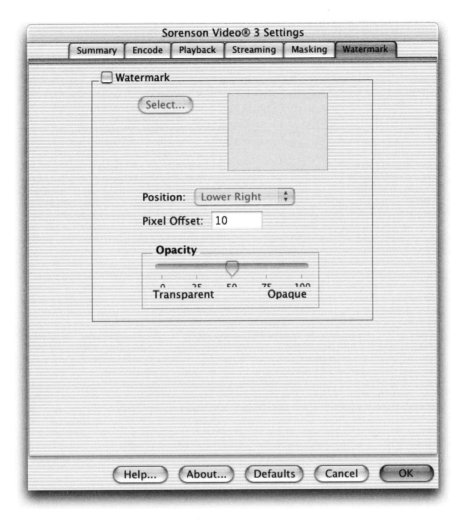

Figure 5.12 The "Watermark" window.

- You can specify data rate limits. It is best to be conservative here, particularly in the case of streaming video.
- Do not set the key frame rate too high, which can create stuttering playback. High data rates may spur frame dropping, particularly at rates exceeding 200 KB/second, thus only the fastest computers can decompress Sorenson at these rates.
- Compress at half the height and width you want, and then double the size for playback. This preserves an optimum data rate for movies that will play at full-screen settings. You can increase the data rate by about 10% to make sure video retains sharpness when scaled up.

Additional Codecs for QuickTime

There are a number of useful codecs supported by QuickTime not included in the standard QuickTime Pro compressor array. Most of these are proprietary codecs that you purchase and download to your hard drive.

VP3

This open-source codec once distributed by On2 gives impressive results when compressing video at Web or CD-ROM data rates, comparing favorably with SV3. One problem with the VP3 codec is that the user needs to have the codec installed. This means that the user will be prompted to download a plug-in in order to play the movie, if he or she does not already have this installed. This inconvenience might be enough to discourage potential viewers, so you may want to weigh this very real disadvantage with the benefits of the VP3 codec.

MPEG-2 Playback codec

Released in conjunction with QuickTime 6, the optional QuickTime 6 MPEG-2 Playback component allows the ability to import and play back MPEG-2 content, albeit for a price: the component costs $19.95 and is downloadable from the Apple QuickTime Products site. Although the QuickTime MPEG-2 component lets you play back MPEG-2 program streams, it will not play encrypted DVDs—including nearly all movies commercially released on DVD—nor will it act as a compressor for MPEG-2 (you need a DVD-burning application such as iDVD or a general media-encoding application such as discreet cleaner for that).

3ivx D4

Currently in Version 4.0.4, 3ivx Delta D4 is based on the MPEG-4 architecture and plays many of its variants. According to the distributor, the decoder available for QuickTime "produces noticeably higher quality video than other decoders due to its high-quality post-processing filters . . . and maintains a record-breaking decode speed." On the other hand, compressionist extraordinaire Ben Waggoner opined that the 3.5 version of this codec offered "mediocre image quality at best" ("Web Video Codecs Compared: An In-depth Examination of the Leading Web Video Codecs," by Ben Waggoner).

QuickTime Components

QuickTime can take advantage of numerous components designed and marketed by third-party developers that add increased functionality and versatility to the basic QuickTime architecture.

You can get many of the available QuickTime components through the Quick-Time "Automatic Update." If you go to the "Control Panel" in Windows or the "System Preferences" panel in Mac OS X, click on the "Update" tab and click the button or check box labeled "Install new 3rd party QuickTime software." Click on the "Update Now" button and the panel will call up the QuickTime server to check for new updated software. At this point you may see a pop-up (Figure 5.13) with the following message: "All of the QuickTime software you have installed is up to date. No update is necessary. Click Custom to select additional items to install." This may seem somewhat contradictory, but press the "Custom" button as the pop-up suggests. The next pop-up should show you a list of components available for you to download (Figure 5.14). Simply check the box of each component you desire and the QuickTime panel will begin downloading them. Some of the components are simple decoders rather than codecs, which means you can only play files—not compress them.

Figure 5.13 The "QuickTime Components" box. Click on the "Update Now" button and the panel will call up the QuickTime server to check for new updated software.

Continued

Figure 5.14 This shows a list of components available for you to download. Simply check the box of each component you desire and the QuickTime panel will begin downloading them.

Some of the components available for download that you may see are:

- Microcosm. A 32-bit codec for high-quality compression with alpha channels.
- Axel is a 3D component that, according to distributor MindAvenue, "plays in QuickTime with Axel's interaction effects intact. For Mac OS 9, OS X, and Windows, Axel's QuickTime component truly hands over the 3D, with meaningful interactivity, to QuickTime users and viewers."
- On2. According to the manufacturer, this codec "offers TV-quality video compression and streaming capabilities with support for multiple bit rates within a single file." See VP3 mentioned previously.
- Streambox. A codec for compressing video into small high-quality streams that can be served over broadband networks.
- Zoomify. This component allows images to stream, thus allowing on-demand viewing when a user zooms into a still image, as in a QTVR panorama or object. Instead of getting an increasingly pixilated image, the user can zoom in to see high-resolution views of an image.
- ZyGoVideo. A codec for real-time compression of video for broadcast, allowing multiple simultaneous video streams and Extensible Markup Language (XML) information within streams, as well as excellent results at low bandwidths.

Audio Codecs

Much of the same criteria apply to audio production as does to film and video production when it comes to compression: start with the highest-quality track possible. If you are pulling the audio directly from a CD, try to transfer the file digitally rather than through the sound jack of your computer. If you need to record from an analog source, use the highest-quality microphone and sound card possible. Be sure in particular that the input signal does not overmodulate, creating distortion. Monitor the input level via a level meter in your mixer or audio recording application. A good rule of thumb for setting audio input levels is about 2 dB below the full input load levels. Minimizing noise is not only good sound recording practice—absence of background noise and hiss will also result in smaller file sizes when you compress.

Digital audio is recorded by sampling a sound source a given number of times per second. Sound for CD recording is sampled at a rate of 44,100 Hz (cycles per second), or 44.1 kHz. This translates roughly to a data rate of approximately 150 KB/second—generally too high for most multimedia uses such as the Web and CD. In addition, CD-quality sound displaces 11 MB of storage space for each minute of sound. Music sounds best at 44.1, but is OK at half that. On the other hand, 22 kHz is more than sufficient for speech, which can sound reasonably good at 11 kHz. You should digitize audio at 16-bit at the very least (8-bit audio is not recommended for use with Sorenson and many other codecs).

QuickTime 6 supports a number of codecs you will see when you bring up the "Sound Settings" box in "Export" options (Figure 5.15). Some of the codecs described in the following section use a specific compression ratio (such as 2:1) listed after the codec name. In general, try to use a codec specifically designed for the type of audio in your program, such as speech, music, or multimedia. Avoid codecs intended for telephony (such as aLaw) unless your audio is almost exclusively speech to be delivered over low bit-rate media such as the Web. As with some video compressors such as MPEG-2, QuickTime retains the right to provide playback support for some codecs (like MP3) that it does not supply a compressor for due to licensing agreements. In general, it is always preferable to compress original uncompressed audio; in other words, avoid using previously compressed files such as MP3 files. You will gain double the compression power with a codec if you save the file in monaural rather than stereo, a difference that is not often noticed over the Internet.

Below is a rundown of each of the QuickTime audio codecs; the ones recommended by Sorenson are QDesign Music, Qualcomm PureVoice™, and IMA. A newer audio codec that looks promising is the MPEG-4 AAC Audio codec. You can access the various audio codecs by following these steps:

1. Make sure the movie you wish to encode is open in QuickTime Pro.
2. Select "File/Export" and click on the "Options" button. After inputting your video codec settings (see previous section), make sure the "Sound" check box is checked and click on the "Settings" button (Figure 5.16).

Figure 5.15 QuickTime 6 supports a number of codecs you will see when you bring up the "Sound Settings" box in "Export" options.

3. When the "Sound Settings" box appears, you select a codec from the pull-down, set the data rate, file size (whether 8- or 16-bit), and mono or stereo use (Figure 5.17). Some audio codecs, notably MPEG-4 Audio, QDesign Music 2, and Qualcomm PureVoice, allow access to more settings via an active "Options" button.

24-bit integer

32-bit integer
32-bit floating point
64-bit floating point
Uncompressed audio

Saving in these formats actually make the file larger, and hence are not good for Web compression. These protocols are useful if you intend to process or further work with the audio before ultimately compressing it for delivery. If you have sound editing applications that work with these formats, you might use them for signal processing and filtering, and then use QuickTime to compress to a more manageable file size for ultimate delivery.

Figure 5.16 To set an audio codec, make sure the "Sound" check box is checked and click on the "Settings" button.

aLaw 2:1

Voice compression

This codec was developed for digital telephony for cell phones in Europe and thus is useful primarily for human voice compression. It does not offer dramatic compression rates but can be used to compress speech with a minimum of distortion and audible artifacts. There are better codecs if you want to include music and sound effects.

Figure 5.17 The "Sound Settings" box.

IMA 4:1

CD and Intranet applications

A useful cross-platform audio codec for multimedia, this codec gives a 4:1 compression ratio, making it good for CD and local-area network (LAN) applications but less useful for Web delivery. IMA was the only audio encoding option for QuickTime before the unveiling of QuickTime 3. It endures because it does not put too much burden on older computers when decompressing files and thus can be decoded by nearly all users.

MACE 3:1

MACE 6:1

The Macintosh Audio Compression and Expansion codec, also known as MACE, is an old codec built into the Macintosh OS Sound Manager dating from the earliest days of the Mac. Avoid this for the most part unless you need to distribute audio that has been already compressed with MACE and you cannot get your hands on the original uncompressed audio.

MPEG-4 Audio (AAC)

Brand new with QuickTime 6, AAC—the audio component of the MPEG-4 standard (Figure 5.18)—is touted to offer improved compression with higher-quality results with smaller file sizes compressed with MP3. AAC also supports multichannel audio and can

Figure 5.18 The "MPEG-4 AAC Audio Compressor" control box.

provide up to 48 full-frequency channels and higher-resolution audio, yielding sampling rates up to 96 kHz. Finally, AAC provides improved decoding efficiency, requiring less processing power for decoding. AAC looks to be an extremely promising codec.

QDesign Music 2

The traditional first choice of QuickTime compressionists, QDesign (Figure 5.19) offers high-quality music compression particularly well-suited for Web distribution. It can deliver high-quality audio at low bit-rate, though not CD-quality audio, despite marketing claims to the contrary. It can handle 16-bit, 44.1 kHz audio over a 28.8 KB/second line. It boasts the same compression abilities as MP3—up to 10:1—with much better sound quality and is unparalleled as a lowbit-rate codec, making it exceptionally well suited for Web applications. QDesign is optimal for music but also offers respectable compression quality for sound effects and human voice recordings. It is a demanding codec in terms of CPU loads, although this can be mitigated somewhat by selecting a lower sampling rate or encoding as a mono rather than stereo track.

Qualcomm PureVoice

As the name suggests, this codec is best suited for speech and is attractive for its extremely low data rates that allow speech to stream over a 28.8 or even a 14.4 modem. Although good for compressing speech (at ratios of 9:1 and 19:1), this codec tends to make music and sound effects sound as if they are reverberating off corrugated sheet metal. Thus, avoid this codec for encoding anything other than "pure voice" sound sources.

Figure 5.19 QDesign Music 2 offers high-quality music compression particularly well suited for Web distribution.

MP3

The MPEG-1, Layer 3 codec for audio—also known as MP3—is not offered as a compression option in QuickTime due to licensing limitations, though Quick-Time retains the ability to play and edit MP3 files. The most popular digital audio format to date, MP3 took the music industry and the Web listenership by storm with help from the infamous file-sharing application Napster and changed the way millions of people acquired and listened to music. The codec features near-CD audio quality and compression ratios ranging from $5:1$ to $10:1$. Because of its proven propensity as a music-pirating format, the entire industry has been furiously at work developing audio codecs and protocols that would not allow unauthorized duplication and exchange of files. Although more music files (including

many obscure titles nearly impossible to find in any other format) have been encoded and made available in this format than any other, it does not mean that you should incorporate MP3 music files into your movie soundtracks. MP3 sound quality, depending on the bit rate used to encode files, is not up to the standards of CD digital recordings, or WAV or AIFF files (which are essentially uncompressed audio). Incorporating such files into a movie to be compressed will degrade them further, something you should avoid if at all possible. Therefore, for the sake of your productions, try to find high-quality CD or uncompressed digitized sound files for your QuickTime movies and you and your audience will be much happier with the results.

Professional Compression with Discreet Cleaner

Discreet cleaner, now available in Version 6 for Macintosh and Version XL for Windows, is possibly the most valuable tool available for compressing digital movies. It excels in batch processing in multiple formats, enabling the filmmaker to deploy movies in Real, Windows Media, and QuickTime streaming and downloadable files, as well as MPEG-1, MPEG-2, and MPEG-4, and digital video streams, as well as myriad audio and still-image file formats.

Cleaner incorporates all of the codecs available in QuickTime Pro and more. Cleaner also lets you crop movies to fit whatever aspect ratio you wish. The following tutorial should get you up to speed with cleaner and its many features for compressing and enhancing your movies. The terms compressing and encoding are used interchangeably throughout this tutorial.

You can download a demo version of discreet cleaner 6 for the Macintosh at www.discreet.com/products/cleaner6 and discreet cleaner XL for Windows at www.discreet.com/products/cleanerxl. Go to the Web site, click on the appropriate link, and you will receive email with instructions for downloading the program. Next download the appropriate installer and follow instructions for installation. The demo will be good for 30 days from the time you start using it; at that time or at any time before, you may purchase the software from Discreet.

"Batch" window

As you open cleaner, the "Batch" window appears, where you can add files by choosing "Batch/Add Files," or simply drag the QuickTime movies you wish to compress and optimize. Each movie you add will appear as a row with columns that designate project name, setting, destination, priority, and status (Figure 5.20).

Figure 5.20 The discreet cleaner "Batch" window.

The "Project" column shows the title of the source file plus a thumbnail, as well as any icons to indicate cropping, in/out points, settings, modifiers, and metadata. When you click twice on the name of your movie in the "Project" column, a "Project" window will appear (Figure 5.21), allowing you to make several adjustments to your movie.

"Settings" window

Double-clicking on this column entry brings up the "Settings" window, letting you choose presets such as QuickTime and MPEG (Figure 5.22). Cleaner offers a wide array of presets for compressing your movies. You can also modify existing presets to create custom presets by copying settings closest to your desired result and alternating between the various controls.

"Destination" window

The "Destination" window (Figure 5.23) lets you set the place wherein you wish to save your compressed movie. Here you can select a new folder or drive for each project.

Figure 5.21 The "Project" window.

Figure 5.22 The "Settings" window.

"Priority" window

This "Priority" window (Figure 5.24) shows you the priority of files to be compressed, the highest being the ones closest to the top of the window. You can bring up a pop-up menu that lets you pick a priority number between 1 and 10. This handy feature is useful for sorting projects so that higher-priority projects get processed first. You can click the "Priority" title bar to reorder the batch in numerical order.

"Status" window

This column indicates whether the compression is complete—when finished, the word "done" appears in this box. If a problem arises, the word "error" will appear. You can double-click this column to get additional information, including an error dialog box if problems occurred during compression.

Figure 5.23 The "Destination" window.

Tutorial 5.1: Batch encoding with cleaner

For this tutorial, go to the "Ch05" folder in the CD and find the QuickTime movie file titled "cleanerclip01.mov." We will start by setting up a batch process using cleaner's MPEG-4 preset feature:

1. Open up cleaner and drag the movie into the "Batch" window, then click on it to activate (shading the row in blue).
2. Cleaner will place each compressed file in a default folder—generally in your "Movies" folder on your hard drive—until you designate a different destination filter. Double-click on the word "Default" in the "Destination" cell to bring up the "Destination" dialog box. You can change the destination for your encoded files to a folder of your choice. If you check the "FTP Server" box (Figure 5.25),

Figure 5.24 The "Priority" window.

Figure 5.25 You can change the destination for your encoded files to a folder of your choice. If you check the "FTP Server" box, cleaner will also automatically upload files to your FTP server.

cleaner will also automatically upload files to your FTP server, placing them on the Web as soon as they are encoded.

3. Double-click in the "Settings" column of the "cleanerclip01.mov" row to open the "Settings" window and see all the presets available for encoding your movies.

Figure 5.26 If you want all possible options for the Web using MPEG-4, shift-select the last file in the "Film" folder, "ISMA Profile 1 384 streaming," and all of these options will appear in the "Settings" window ready for encoding.

Because this clip was shot in film and transferred to DV, select "MPEG/MPEG-4/Film/ISMA Profile 0 56K download." If you want all possible options for the Web using MPEG-4, shift-select the last file in the "Film" folder, "ISMA Profile 1 384 streaming," and all of these options will appear in the "Settings" window ready for encoding (Figure 5.26). If you encode your movie at all these settings, you will have a Web file ready for download by users with dial-up modems, ISDN accounts, cable modem connections, and high-speed T1 and T3 setups. This is the essence of batch encoding. Click on the green play arrow to begin the encoding process; cleaner will encode the clip at each of the selected settings and place the compressed files in your designated destination folder.

Watch Folders

A new feature in cleaner 6 lets you designate a watch folder—simply a folder you create that automatically encodes any file you drop into it. This greatly streamlines the compression process. To make a watch folder, select "Batch/Add Watch Folder," and select or create a new folder. The "Watch Folder" will show up in the "Batch" window where you can assign any setting to that folder just as you did with the single file. Now you have a location where you can export files from applications such as Final Cut Pro. Cleaner then begins encoding the file, leaving you free to work on another project.

Creating custom settings

As useful as the cleaner presets are, you will probably find it necessary to create custom settings to optimize your movie files. The most convenient way to do this is to modify an existing setting:

1. In the "Settings" window, select a setting that presents the most appropriate starting point. For instance, if you want to encode a movie for DVD deployment, select an MPEG-2 preset. In this case, we will encode this movie for Web deployment, so we will begin with a QuickTime file format and SV3 codec.
2. Click the "Duplicate" button.
3. Type a name for the new setting and drag it into the appropriate folder.

Now to create our custom settings in the important next phase: preprocessing.

Preprocessing for Custom Compression

Preprocessing refers to the process of optimizing a file before actual compression takes place. This includes cropping, noise reduction, deinterlacing, and adjusting gamma, brightness, and contrast to ensure the best possible picture and sound. Many filmmakers deride the computer display as a viewing device for video and film but the truth is that the computer monitor can deliver a much better picture than a television monitor ever could. It is capable of higher resolution, better color fidelity and wider color gamut, and deeper blacks and purer whites. The computer can show much more detail in a film or video than a TV set. On the other hand, it will also show any noise inherent in a video much more clearly as well, emphasizing the need for careful preprocessing. Another advantage of computer video is the ability to play back video at any frame rate; NTSC television is always limited to a playback of 30 (29.97) fps.

The fundamental steps for preprocessing are:

- Deinterlacing
- Inverse telecine
- Cropping
- Scaling
- Noise reduction
- Luminance (brightness) adjustment
- Chrominance (color) adjustment

Adaptive deinterlacing

As we saw in Chapter 2, traditional video cameras and imaging devices capture motion pictures by sampling scenes at 25 (PAL) or 30 (NTSC) fps. Each frame is composed of two interlacing fields. This creates some distracting artifacts, particularly in motion sequences or freeze-frames where cross-hatching interlace lines become obvious. Computer

video, on the other hand, plays video in progressive scan mode—in complete frames. The interlacing in conventional video must be removed for any video intended for computer display, otherwise well-defined horizontal interlace lines will become obvious and moving objects will display as two slightly misaligned images. The video you will be compressing will derive from one of three sources: interlaced video, telecined film (which is also interlaced video), and progressive scan video. The simplest way to deinterlace is to discard a field from every frame. The problem here is that you decrease your resolution by one half. Imagine you begin with NTSC DV video and 480 horizontal lines of resolution; after deinterlacing, however, you end up with a video resolution of 240 lines. Reducing resolution by 50% is, of course, unacceptable, but fortunately there is a better way: adaptive deinterlacing. Adaptive deinterlacing refers to selectively deinterlacing just those parts of the video comprising moving images, while leaving relatively static images intact. Cleaner provides an adaptive interlace filter expressly for this purpose.

Inverse telecine

If your content is film transferred to NTSC video, you will want to undo the telecine process that converted the original frame rate from 24 fps to 30 fps. The film-to-tape transfer adds six duplicate fps to the film transferred, mixing alternating combinations of three and two video fields. These pull-down frames created by blending frames from the original source in a specific pattern creates what is known as 3:2 pull-down [only NTSC video uses this 3:2 pattern, as European PAL video rolls at 25 fps and requires a different solution for this problem (24:1 pull-down)]. This pull-down can create some very annoying stuttering effects in long slow pans and other camera movements. Inverse telecine removes these superfluous unwanted frames, yielding full resolution of 23.976 fps. This invariably adds more resolution and smoother motion. This is one reason why Apple's QuickTime Movie Trailers look so good: preprocessed with inverse telecine, they boast a full 480 × 720 resolution. *Intelecine* is the name of cleaner's primary tool for inverse telecine. Inverse telecine is a nonissue in PAL video, as its frame rate is virtually the same as that of film and requires no pull-down in the transfer process.

Cropping

Video often exhibits rough edges and noise around the periphery of the frame, which goes unseen due to the overscanning playback monitors. Cropping removes the noise and can also serve to tighten up video by cutting away extraneous frame detail, giving you a smaller file. By design, the typical television set overscans the video raster by 10% or more; that is, the TV automatically crops out the messy edges of the video frame the way that a window matte overlays and obscures the edges of a framed photograph. On the other hand, computer displays generally show the entire image area of a video, including the edge blanking (sync info), black edge lines, and general noise. Cropping this peripheral area out of the video picture will greatly improve compression and file size. In cases where you want to encode a movie with a small frame size, say 180 × 240 pixels, you may want to crop

well into the image area to enlarge the picture for easier viewing. In fact, in a 720 × 460 image, you can easily crop in 32 pixels on both the left and right sides, 24 pixels top and bottom for action safe video, and twice that for title safe video. You will also want to crop out any black bars that exist in the video image as a result of letterboxing.

Scaling

Scaling means decreasing the size of the video frame of a movie (increasing the frame size yields inferior image quality and is not advised). That said, the aspect ratio of your scaled movie should match the proportions of the video source file. A 720 × 480 video image (remember, NTSC and PAL video images are captured with non-square or rectangular pixels) has a 4:3 aspect ratio, therefore you should always crop to a 4:3 aspect ratio. For example, 320 × 240 would be an appropriate crop size; 360 × 240 would not. HD, with a native aspect ratio of 16:9, would crop nicely to a size of 432 × 240. In general, you should avoid cropping to a size that exceeds 240 pixels in height, otherwise you will be scaling up (remember, any deinterlacing reduces your maximum vertical resolution to 240 lines or pixels). Thus, in general, the more you crop a video image, the smaller the video frame size should be. If you want your video frame to be 320 × 240 or larger, minimize cropping and use adaptive interlacing whenever possible.

Luminance adjustment

Luminance includes all non-color information adjustments, including brightness, gamma, contrast, black restore, and white restore. Whereas computers can use a graduated tonal scale from 0 to 255, video embraces a reduced range from about 16 to 235. This means that video black is more a dirty gray whereas video white is an off-white value. When you reset the black to 0 and white to 255, you extend the tonal range of the image. Setting video black levels to mathematical black (0) greatly enhances the look of video and makes it blend more seamlessly into the surrounding background of a black Web page, for example.

- Gamma. As we saw in Chapter 2, gamma—the relative contrast of the middle range of an image—is different on a Windows computer than it is on a Macintosh. Middle tones will always display brighter on a Mac than on a PC. Because there are more PCs out there than Macs, many Mac-based content providers adjust gamma to read correctly on Windows. Perhaps the best option is to create QuickTime alternate or reference movies (see Chapter 8) for Windows and Macintosh platforms to download to the proper user platforms.
- Brightness. Adjusting brightness is often a matter of personal preference. Increasing the level of luminance will brighten an image, but often at the expense of higher noise levels and weaker blacks. Lower brightness, on the other hand, will yield rich blacks but might darken the overall image unacceptably.

- Contrast. Unlike gamma, contrast affects the extreme black-and-white portion of an image. High contrast accentuates the darkness of black levels and the brightness of the white levels, with no discernable effect on the middle range. When all is said and done, do not forget that, ultimately, contrast and brightness settings are subjective. There is not even a real consensus among the experts. Master compressionist Doug Werner, for example, favors high brightness settings but often leaves contrast levels intact, whereas compression guru Ben Waggoner leans toward higher contrast settings and low brightness settings.

- Black restore. This setting lets you set a floor for black values and pushes dark grays beyond the setting to black. For example, a black restore setting of 10 will render all values falling below that numerical value as straight black. This can be a great effect for letterbox bars and black backgrounds behind titles and credits. If you use this setting in video picture areas, however, be sure to set the accompanying smoothness filter to a value such as 5 to create a transition between the blacks and the dark shadows. Be careful, or you will likely get blocked-up shadows in the darker areas.

- White restore. This setting allows you to set a ceiling for white values, where any value exceeding the number you set will render as white. Although less useful than black restore, you may find some instances to use this setting where a strong white graphic effect is desired.

- Hue and saturation.

Noise reduction

Noise in video (sometimes known as "snow") places more demand on the codec and creates larger file sizes, all while degrading the image. Shooting video under very low light levels with gain set high produces the noisiest video and is best avoided. It is always advisable to start with the cleanest, noise-free video possible. Cleaner offers a noise reduction filter that attempts to remove noise while leaving other image information alone. The trade-off here is that noise reduction filters introduce blurring. Noise reduction is at best a quick fix that makes bad video into OK video—it cannot work miracles with really noisy images. Cleaner's "Adaptive Noise Reduction" setting is a good solution overall to cleaning up noisy video. The temporal processing filter is available under cleaner's "Adaptive Noise Reduction"—it custom compares pixels in a frame with those before and after to distinguish noise from the rest of the video image. This process puts a big hit on processor power and speed, lengthening encoding times, and can garble areas of fine detail such as small text.

Preprocessing audio

The audio in your movie should be already mixed and equalized so that all elements are clear and modulated properly. In that case, your tweaking will be minimal. Nonetheless, you will want to optimize the audio in preprocessing with the following in mind:

- Normalization. Find the loudest point in your audio and set the volume for this point; it should be about the same level as the given computer beep. The volume normalization filter in cleaner maximizes audio volume without introducing distortion by scanning the movie to find the loudest passage and pegging the maximum volume to this portion; normalizing to 90% is often best for Web video compression.

- Sweetening. Cleaner allows a number of audio sweetening and other filters; in general, it is best if you begin with an audio track that is already mixed properly, though you may find the low and high pass, noise removal, dynamic range, reverb, and noise gate filters useful on occasion. The notch filter cuts out sound at a specific frequency, useful for reducing AC hum.

Tutorial: Custom compressing a film clip

Now let's compress a film clip for the Web using SV3. We will encode this for progressive download in three different file output sizes: a small file for 56 K dial-up modem users, a medium-size file for DSL users, and a large, high-quality file for cable modem and T1 connections. Let's start with the large file first:

1. If it is not open already, open up cleaner. Go to the CD, to "Ch06/cleaner-clip02.mov" and drag it into cleaner's "Batch" window. With the clip appearing in the top row of the "Batch" window, double-click on the icon in the "Project" column to bring up the "Project" window.

In the "Project" window, you will see the film clip—you can scrub through or play the clip to see the various shots that make up this sequence. This clip, from a Chapman University School of Film and Television Location Filmmaking project titled *Black Wedding*, is a good example of a motion picture designed and shot for theatrical exhibition. Like many neo-noir feature-length films, this clip boasts saturated colors, bold contrast lighting, and a wide aspect ratio. It is going to take some custom compression to bring out the best in this movie. Let's crop this clip to start off:

2. Cropping. This clip is letterboxed, so let's remove the black bars so we can have a true widescreen aspect ratio in our frame. In the QuickTime tab of the "Preview" window, leave the "Display aspect ratio" pull-down alone at 4:3 and change the "Crop aspect ratio" pull-down to "Custom." In the "Aspect" box that appears (Figure 5.27), type in a width of 444 and a height of 240. This conforms to the 1:1.85 aspect ratio of the original clip; be careful not to select a height exceeding 240 pixels, however, if you wish to avoid upscaling and degrading the image quality. (Note: Resist the urge to change the "Display aspect ratio" to a "Custom aspect ratio" as well; this results in squashing the whole existing 4:3 frame and distorting the image.) Now you may draw a bounding box that crops the black bars from the letterbox image, cropping in a little from the sides (Figure 5.28).

Figure 5.27 Selecting a custom aspect ratio in the "Aspect" box.

3. In the "Batch" window, double-click on the dash in the "Settings" column to open the "Settings" window. The "Settings" window contains an array of presets you may use as starting points for your compressions. We will start with a large download compressed with SV3. Open the "Film" folder within the QuickTime folder and double-click on "SV3FILM large download." Click on the "Duplicate" button to make a copy of this setting that we can modify to suit our clip.

4. Click on the "Output" button. Leave settings as they are, but put a check in the box labeled "Disable saving" (Figure 5.29). This will deter users from keeping copies of the movie when they download it from the Web.

5. Skip the "Tracks" button and click on the "Image" button. Settings should be as follows (Figure 5.30):

 a. "Crop" box checked, pull-down menu: "Manual."

 b. "Image Size" box checked. To preserve the original 1 : 1.85 aspect ratio of this clip, type in frame proportions as 444 × 240 (use a multiple of the aspect ratio with a vertical measurement not exceeding 240, otherwise you will be upscaling the QuickTime image). Set the pull-down menu "Custom . . . 444 × 240," "Display size: Normal."

Figure 5.28 Cropping the frame in the "Preview" window.

Figure 5.29 The "Output" window. Leave settings as they are, but put a check in the box labeled "Disable saving." This will deter users from keeping copies of the movie when they download it from the Web.

c. "Deinterlace" box is checked. Pull-down menu: "Intelecine." Intelecine is an inverse telecine 3:2 video pull-down removal option you should always use when working with film transferred to video and captured at full frame (640 × 480 or 720 × 486).

d. Do not check the "Shift Fields," "Telecine," "Blur," "Static Masks," or "Watermark" boxes, but leave the "Sharpen" checked with defaults as "Radius: 1.5" and "Amount: 50."

e. Leave the "Adaptive Noise Reduce" box checked, with the pull-down menu set to "Mild." You can try different settings of this and check them out on the "Dynamic Preview"; be careful though—this setting works by defocusing the image.

Figure 5.30 Settings in the "Image" window.

Dynamic Preview in Action

You can check the effects of any filter you try by bringing up the "Dynamic Preview" window (you must click on the "Apply" button at the bottom left-hand corner of the "Settings" window before cleaner will let you bring up the "Dynamic Preview"—and you can always apply your updated settings at any time as you go).

Figure 5.31 In this tracking shot, notice the obvious interlacing artifacts on the trailing edge of the headstone on the far right of the frame. This can be corrected with "Intelecine."

For example, if you scrub to a frame where the large headstone appears in the tracking shot, you will see some rather obvious interlacing artifacts on the trailing edge of the stone (Figure 5.31). With "Intelecine" checked, choose either the "Left/Right" slider or the "A/B" modes (click on either circle in the "Mode" box) to compare the picture before and after each setting you adjust; you will see the effect of the filter (Figure 5.32) before you commit to encoding. You can use the "Dynamic Preview" to see all filter adjustments in advance. For instance, if you want to try more or less sharpening, you can see the results of the filter before going ahead with the compression. Note: Discreet recommends using the "A/B" mode over the slider mode when compressing with SV3.

Continued

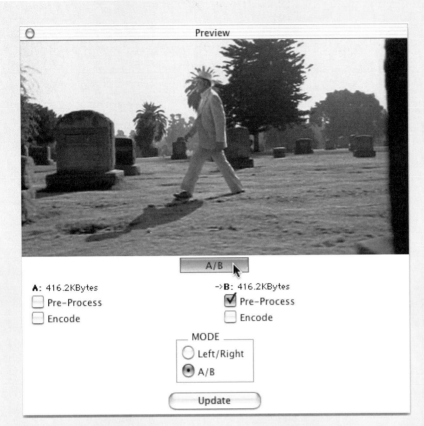

Figure 5.32 With "Intelecine" checked, choose either the "Left/Right" slider or the "A/B modes" (click on either circle in the "Mode" box) to compare the picture before and after each setting you adjust; you will see the effect of the filter before you commit to encoding. After applying the filter, the comb-like artifacts on the edge of the headstone have disappeared.

6. Click on the "Adjust" button. In this window you can adjust "Gamma," "Brightness," "Contrast," and other image settings (Figure 5.33). Because these settings are often subjective, feel free to try different settings and check them in the "Dynamic Preview."
 a. Check "Gamma": Set slider to 30.
 b. Check "Brightness": Leave slider at –5.
 c. Check "Contrast": Leave setting at 5.
 d. Leave the "Black and White Restore" boxes unchecked; these are best for deepening the blacks and whites in titles and graphics (for example, deepening the blacks of letterbox bars).
 e. Leave "Hue" unchecked.

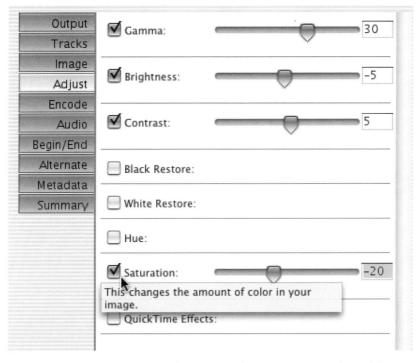

Figure 5.33 In the "Adjust" window you can adjust "Gamma," "Brightness," "Contrast," and other image settings. Because these settings are often subjective, feel free to try different settings and check them in the "Dynamic Preview."

 f. I found this clip oversaturated (especially for Web compression); check the "Saturation" box and adjust the slider to –15 to –20; check results in the "Dynamic Preview."

 g. Leave "QuickTime Effects" box unchecked.

 7. Click on the "Encode" button. Make sure settings are as follows (Figure 5.34):

 a. "Codec": Sorenson Video 3 Compressor

 b. "Bit Depth": Millions of colors

 c. "Frame Rate": 23.975 fps. This will give us smoothest motion but may yield motion artifacts at lower bit rates. When you prepare files at smaller sizes and lower bit rates, use 12 fps.

 d. "Keyframes": Every 240 frames. Ten times the frame rate is a good setting for the Sorenson codec.

 e. Leave "Compare Uncompressed Frames" box unchecked; this should not be used with live-action motion pictures.

 f. Check "Video Data Rate" box. Select "2-pass VBR" encoding from the pull-down if you have installed Sorenson Video. This greatly enhances encoding by using two passes and setting data rates accordingly. In the first pass, the movie is analyzed to identify difficult and easy segments to encode. On the

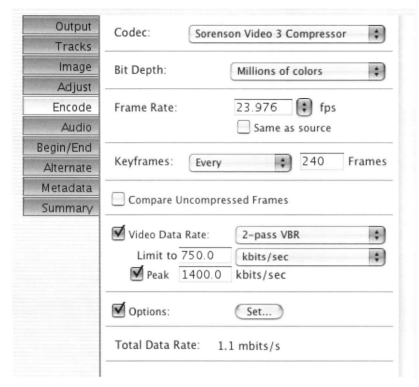

Figure 5.34 Settings in the "Encode" window.

second pass, cleaner ascribes lower data rates to the easy sections and higher average rates to the difficult portions. This method gives optimum compression results. Because this is a high-quality large-size movie, leave the "Limit to" at 750.0 K bits/second, check the "Peak" box, and make sure the "Peak" is set to 1400.0 K bits/second.

 g. Make sure the "Options" box is checked. The total date rate for this movie will be 1.1 M bits/second.

8. Click on the "Audio" button to bring up the "Audio" window, and use the following settings:

 a. "Codec": Because there is practically no music in this sequence, let's try using the IMA 4:1 codec. QDesign 2 would be a good choice if there were music, and AAC would be an excellent choice overall provided that all our users are using QuickTime 6 or better.

 b. For the "Sample Rate," let's try 22.050 kHz, because this clip is mostly dialog; this low sampling rate is less CPU-intensive than the usual 44.100 setting. In cases where there is music or overlapping dialog, however, we would need to use the higher sampling rate.

 c. "Depth" will default to 16-bit.

 d. "Channels": We could save bandwidth by checking the "Mono" box without losing much quality (provided the film soundtrack has been mixed to mono), but true "Stereo" sound is often the best choice when there is music and effects.

 e. Check "Volume" box and set the pull-down to "Normalize"; the slider should default to 90%.

 f. Check "Dynamic Range" and change the pull-down setting to "Limit to 90%," a good choice for Web video.

 g. Leave the other settings unchanged and click on the next button.

9. The "Begin/End" window (Figure 5.35) offers a number of options for the start and end frames of the video, important items to consider for optimization because the user sees the start frame first and the end frame is the one remaining on when the movie ends.

 a. For this clip, check the "Video Fades" and "Fade in" boxes, and leave the default settings from "Black at 0.5 seconds"; this will introduce the clip with a half-second fade-in.

 b. Check the "Audio Fades" and "Fade in" boxes as well, with the default of 0.5 seconds.

 c. Check the "High-Quality Frames" and "Last frame" boxes; change the pull-down to "JPEG track" and leave the slider at 50%. This setting ensures that

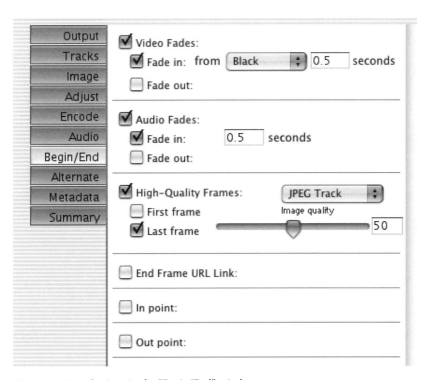

Figure 5.35 Settings in the "Begin/End" window.

the last frame is a high-quality image, a good idea because it will be the image that remains after the movie ends.

 d. If you want the last frame to become a clickable link to a URL, you could check the box "End Frame URL Link" and type a URL in the text box.

 e. Leave the other boxes unchecked.

10. You can click on the "Alternates" button to prepare alternate movies of different sizes and streaming characteristics. Skip this window for now.

11. In the "Metadata" window, you can type in various information regarding title, author, copyright, and so on.

12. The "Summary" window shows the settings you have created.

13. When you have finished making your settings, go to the "Batch" window and click on the green arrow to begin the encoding process. Cleaner will sound a bell when the encoding has completed.

Kinoma for PDA Video

The most recent development in Web-based video may well be the growing proliferation of hand-held electronic devices equipped to play full-color movies from the Web. The Kinoma movie format for Palm hand-held devices has emerged as a key protocol in this movement. The Kinoma Exporter transcends audio and video encoding, allowing control of video presentation such as background images, color, and layout. To encode using the Kinoma Exporter:

1. Open cleaner if it is not open and drag a movie of your choice to the "Batch" window. Choose the default setting in the "Settings" window.

2. In the "Output" tab, choose "Kinoma Movie for Palm OS" from the pull-down.

3. Check the "Options" box and click on the "Set" button to bring up the Kinoma "Advanced Settings" window.

4. The "Advanced Settings" window features an "Encoding" section that includes a pull-down to select the target device, a video settings box, an audio settings box, and a custom layout section (Figure 5.36).

 a. Select a target PDA or cell phone in the "Device" pull-down, in this case, "All color Palm OS devices."

 b. Set the "Video" encoding for:

 i. "Format": "Cinepak." The Cinepak Mobile is touted as the "most advanced video-encoding format" included in Kinoma, so that is what we will use. For black-and-white target devices, an appropriate codec would be "16 grays."

 ii. Set "frames per second" to "best."

 iii. "Size in pixels": 160 × 120

 iv. "Bit rate: 240 KB/second

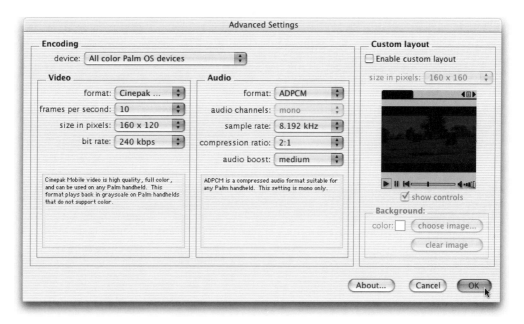

Figure 5.36 The Kinoma Movie "Advanced Settings" window.

c. Set "Audio" controls as follows:
i. "Format." There are three codecs to choose from, though no single format is common to all devices. Select "ADPCM" for greatest compatibility with all Palm units, "CLIÉ Audio" for stereo audio in units featuring Sony's Audio Adapter plug-in, or "Yamaha ADPCM" for units that include a Yamaha audio chip.
ii. "Audio channels." The choice of "stereo" or "mono" is available only with the CLIÉ Audio codec.
iii. "Sample rate." Leave this setting at 8.192 kHz. Increase this if you want to improve sound quality at the expense of greater processor load and larger file sizes.
iv. "Compression ratio." Choose 2:1 for best fidelity.
v. "Audio boost" is an option to increase volume for potentially better sound quality on Palm hand-helds. It can result in distortion, so be sure to test if you use this option.
d. The "Custom layout" lets you select screen resolution as well as background color and image selection. All Palm devices can display 160 × 160 images so we will leave this default as is. Click OK. Now you can go on to make adjustments in the "Image," "Adjust," "Audio," and "Begin/End" tabs before applying and encoding as you did in the last exercise.

These are just a few workflows you can use in cleaner—there are many more features that you will find as you explore this multifaceted application on your own. You can set up a

batch of different encoding settings to encode for streaming on Windows Media or Real servers, compression for MPEG-1 for CDs, MPEG-2 for DVD, MPEG-4 for the Web, and many other settings, depending on your deployment requirements.

As Doug Werner noted in the opening quote to this chapter, there are no magic formulas to achieve optimum results with every movie you compress. Though discreet cleaner provides presets to streamline the process, you will absolutely need to tweak and adjust settings yourself if you want movies that approach the quality of the Apple site trailers. The following is an example of some settings that can give you a starting point for your compression. First of all, remember the axiom you have undoubtedly heard time and again: Garbage in—garbage out.

So, begin with the highest quality video possible. If you are compressing actual film, with hope you will be getting your source transfer in the highest quality video available. The best quality source video to work from is DigiBeta, followed by BetaSP, and then DV. If you have DV source material and access to Apple's Final Cut Pro, capture the video using this application and save it in the uncompressed QuickTime format.

Compression Summary

Sorenson Video, currently in Version 3.1, remains the codec of choice for motion-picture compression in QuickTime, especially in files destined for the Web. Although the Standard Sorenson Video codec available in QuickTime Pro provides some limited compression abilities, professional compression calls for the Developer version of the software, which works exceptionally well in conjunction with discreet cleaner. The QDesign 2 Music Codec, Professional Edition has been the preferred compressor for audio with voice, music, and sound effects, whereas Qualcomm's codec is used when only speech appears on a soundtrack. The IMA 4 can also be used, especially when a less CPU-intensive audio codec is desired; the quality will not match what can be done with QDesign, however. With Quick-Time 6, and its embrace of MPEG-4 and AAC sound codecs, reliance on Sorenson Video may give way to these newer technologies.

Frame Size

Resizing is a necessity for the Web, and in fact all Web video comes to the user at lower frame resolutions than the original source. The key to clean resizing is to choose a size that is one-half to one-fourth the original size of the cropped movie. A good rule of thumb is to size at 160 × 120 pixels for movies intended to be downloaded over a modem; 240 × 180 pixels for DSL and ISDN speeds; and 320 × 240 for high bandwidth connections such as cable modems, T1 lines, and local networks. More and more, movies as big as 480 pixels wide are being offered as an option for very high-end users; high-quality movie trailers are regularly posted at sizes up to 640 pixels wide! In any case, you want to keep your frame proportions consistent with the original aspect ratio—in other words, do not squeeze

or smoosh the picture. If you expect your user to view at double the actual size, count on compressing at a higher data rate to preserve a sharp picture at larger scaled sizes.

Frame Rate

Reducing the frame rate will yield video that is much less demanding on bandwidth, and it is an essential part of compressing your movie. Change the frame rate of your movie to one that is one-half, one-third, or one-fourth the original rate. For film, this might be 12 or 8 fps. Video (NTSC) requires a 29.97, 15, 10, or 7.5 rate, whereas PAL video works best with 12.5 or 6.25. In most cases, lower bandwidth users require movies with lower frame rates.

Testing

Before you release anything to the Web or elsewhere, test and test again. Encoding generally takes time and often needs to be repeated with slight tweaks to get it right. Testing, though tedious, is not nearly as laborious as redoing your work when it is not up to par. A good way to go about your compressing is to compress the entire movie first and watch it, noting the most difficult areas where the most degraded picture quality and motion distortion occur most frequently. Now open your original movie in QuickTime Pro, select the area that compressed with the most degradation, and save it as a separate QuickTime movie with dependencies (if you forget how to select and save portions of movies, go back and review Chapter 4). Careful testing will yield Web and CD video that will give your content the quality it deserves.

6 Immersive Imaging with QTVR

"It's a blend of still imagery and motion pictures. The uniqueness is that it's nonlinear—so it seems to suspend the dimension of 'time.' It does this by giving the viewer the choice to look where they want but also 'when' they want."

—Janie Fitzgerald[6]

QuickTime's most remarkable and unique feature could very well be QTVR. QTVR uses a technique known as immersive imaging, allowing a viewer to pan around a given point to view a 360° panorama or see many sides of a photographed object. Moreover, Quick-Time is the only media technology that allows you to navigate from QTVR node to QTVR node, or jump to another URL on the Internet. Why is this of interest to a traditional film-maker? Because QTVR allows you to provide dynamic interactive content that easily augments and complements your traditional film or video programming. Creating QTVR panoramas and scenes of a location can add exponentially to the usefulness of location stills captured in preproduction. Numerous media producers have discovered the usefulness of QTVR content produced and posted on Web sites to augment information provided in the actual film or video program. For an example of dynamic complementary program information provided via QTVR, see the PBS Nova Web site on the Great Pyramid (www.pbs.org/wgbh/nova/pyramid/explore/khufuenter.html).

Panoramic and Immersive Imaging

Wide-angle dioramas have been popular with artists and museums for centuries, but Joseph Puchberger of Retz, Austria, devised the first panoramic camera in 1843. Puchberger's camera, which covered an area arc of 150°, used a hand crank to drive a swing lens and expose numerous daguerreotype plates. It was unwieldy to say the least, but inventors continued to evolve and refine the panoramic camera, leading up to the portable 35 mm Panon Widelux, one of the first compact panorama cameras to appear, and the 360° Roundshot, taking a complete panoramic image on a strip of 120 film. Virtual reality (VR) emerged during World War II as the United States government began developing apparatus for flight simulation. In the 1960s, 1970s, and 1980s computers became more powerful, and cumbersome and expensive head-mounted displays coupled with headphones and tactile gloves brought VR experiences to curious state fair and rock concert visitors with lots of disposable income to burn. VR was a very interesting but prohibitively expensive technology; it

was not until the invention of QTVR by Eric Chen in the early 1990s that VR showed itself in a somewhat different form and a viable medium on its own.

QTVR encompasses four distinct modes of VR: the panorama, the cube or Cubic VR, the object movie, and the scene. But before we delve into these various types, let's first look at the QuickTime controller bar of the QuickTime Player and Plug-in. You will note several differences between this and the linear movie controller (Figure 6.1). Because QTVR is not a time-based or sequential medium, there is no need for play, stop, forward, and reverse buttons. Instead, you will see buttons for zooming in and out of the panorama or object; this lets you magnify a portion of the scene right up to the very pixels, or pull back to see the maximum view of the panorama. You can also control these functions by hitting the "Shift" key for zooming in and the "Control" key for zooming out. When clicked, the button with the question mark will show the hot spots in the scene.

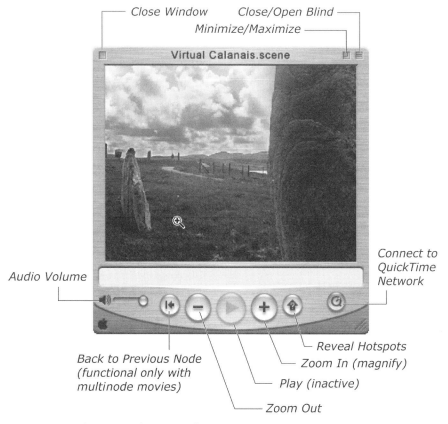

Figure 6.1 The QTVR player controller.

Cylindrical panoramas

The most widely recognized QTVR image is the cylindrical panorama, which comprises a continuous scene viewed from the same central point, usually stitched from a series of photographs shot sequentially around the point. From a central viewing point, known as a node, a viewer can pan right or left and zoom in or out of the panorama. It is as if the viewer was standing in the center of a large cylinder, where the 360° scene has been pasted; the viewer can turn to any point in the cylinder, tilt up or down to limited extent, look more closely, or draw back to view a larger field of view (Figure 6.2). It is possible to generate QTVR imagery using digital rendering applications and 3D software, however, the scope here is to keep within the realm of photographic imagery. The most common way to create an immersive panorama is to capture a series of images photographed in sequence around a preselected point in a landscape or interior location. Imagine you are standing in the center of an imaginary clock face on the ground or floor; you would shoot a photograph at 12 o'clock, turn the camera to 1 o'clock, and continue until you have shot 12 images 30° apart. If you use a traditional camera that shoots film, you need to digitize the photographs yourself or have them scanned at the time of processing. When you have your images in digital form, you then connect, or stitch the images together, to form a seamless 360° panorama. You may also create partial panoramas including any range of degrees for a more limited viewing experience.

The cubic VR or cube panorama

The making of QTVR cylindrical or cubic panoramas and object movies can be broken down into the following phases: 1) preproduction planning 2) image capture (and scanning,

Figure 6.2 The QuickTime VR cylindrical panorama.

if working with film), 3) stitching, 4) retouching, 5) final stitching 6) scene and hot spot preparation, and 7) delivery.

Capturing the component images

Yes, even QTVR panoramas require careful planning, especially if you have a multinode scene in mind. The QTVR field has spawned a cottage industry of technical tools and equipment for the use of photographers who wish to create QTVR content. Some of this apparatus can be highly specialized and, consequently, very expensive, but it is surprisingly easy to produce high-quality QTVR content using improvised tools. Much of the equipment you need can be adapted from traditional tools or otherwise improvised quite nicely.

One of the virtues of QTVR is that the authoring process was designed to allow photographers to use conventional equipment. The best choice is often a 35 mm single-lens reflex camera with manual exposure capabilities, particularly one with a wide-angle lens. In general, a focal length ranging from 20 mm to 35 mm is ideal for outdoor scenes, whereas interior locations necessitate the use of a wider lens, preferably a 14 mm or 15 mm lens. My typical setup is a Nikon FM2 with 20 mm lens for exterior shots and a 14 mm for interiors. A digital camera can be an excellent choice, as it captures in pixels and lets you skip the time-consuming and sometimes expensive processing and scanning steps, but it is advisable to use a camera with a sufficiently wide lens to capture a wide-enough area. Nikon makes an excellent wide-angle attachment (approximating a 24 mm lens in 35 mm still-photographic terms) for its popular Coolpix line of digital cameras.

Although it is technically possible to use almost any camera to capture QTVR component images, you will get the most satisfying results if you stick to cameras that offer the following:

1. A $\frac{1}{4}$-inch tripod screw socket on the bottom plate of the camera body (preferably centrally located on the plate) to affix the camera to a tripod or monopod head.
2. A single-lens reflex viewing system, or a through-the-lens digital LCD display.
3. A rectilinear lens, that is, one that creates images relatively free from barrel- or pincushion distortion. Many ultra-wide lenses produce images that appear to bow and bulge, which is especially pronounced when normally straight lines appear in the image area. Thus, fisheye lenses are not satisfactory for QTVR work due to their inherent distortion that defines the "wraparound" fisheye effect, unless spending an inordinate amount of time correcting this distortion appeals to you.

Although single-lens reflex is often the camera of choice for QTVR, it is also possible to use a video camera to capture source images for QTVR panoramas. In this case, simply use the camera to take still images around a pivot point for later stitching. A digital video camera is preferred, but you can digitize the still images captured by an analog video camera and save them as PICT or JPEG files. The main drawback of using video for capture is the inherent low resolution of NTSC or PAL video, still the predominant standards for most

of the world today. Because many videographers may have access to this equipment rather than single-lens reflex (SLR) cameras, they may be the only alternative and certainly can be used where low-resolution images are not entirely undesirable, as in dissemination through World Wide Web pages. Another method of capturing images uses a swing-lens panoramic camera (such as the Japanese Widelux, the Russian Horizon, or the fine German Noblex) to reduce the number of exposures needed. This type of camera uses a vertical slit shutter and a rotating lens to capture an arc of view of 140° or wider. Because of their highly specialized nature, swing-lens cameras are quite expensive. In addition to the advantage of capturing a great angle of view with fewer images, the swing-lens camera excels at photographing areas where people and vehicles move throughout the scene, as in a street or public area, because they can capture their panoramas at fast shutter speeds, thereby "freezing" action. The disadvantages are also considerable, however; this type of camera is expensive to purchase or rent, and the long images they create on film demand special scanning solutions, which can also be somewhat pricey.

QTVR IMAGE CAPTURE CONSIDERATIONS

As in all QuickTime media production and deployment, much depends on the chosen mode of distribution: How do you want to exhibit your QTVR content—by Web, by PowerPoint presentation, or by CD or DVD? As usual, bandwidth is the key factor here. Web distribution is by no means an equal proposition. Your viewers may be trying to view your content over a 56.6 KB/second modem, a 112 KB/second domain name server (DNS) hookup, a 500 KB/second cable modem, or a 1.5 MB/second T1 connection. Low bandwidth dictates small files, which in turn dictates low-resolution files. No matter what size you think your QTVR content will ultimately be, you should always originate at the highest possible resolution. Then it is a relatively simple and straightforward process to reduce the resolution and resize the image with an image-editing program such as Adobe Photoshop.

If you are using a digital camera, you may need to choose a resolution origination size based on other factors as well. The size of your memory will determine how many images at a given size you may store in the camera as you shoot. A bigger memory chip will allow you to capture more files, or larger files, or both. If you have access to a laptop or other computer in the field, you may be able to download your images via a universal serial bus (USB) or Firewire cable, erase the files from the camera, and continue. In any case, with a digital camera, you need to make decisions about the source image size before you begin shooting.

The high resolution of film still ensures it an unparalleled medium for recording and archiving images. A digital camera would need to capture in the range of 6 megapixels before it can offer similar detail. With a film camera, the only decision you need to make about image size when it comes to shooting depends on available light and the film speed you will use. A "fast" or very light-sensitive film with an International Standards Organisation rating (ISO) of 400, 800, or greater will yield grainier images than an ISO 100 or ISO 50 film. This grain factor has a direct impact on the optical resolution of the images. Another consideration is the decision to use negative or reversal (slide) film.

In general, negative film is more forgiving when it comes to exposure latitude and will yield good images that are as much as two stops over- or underexposed. Negative film also provides images that are relatively low in contrast when compared with reversal film images. Many photographers, especially those with experience in print media, however, prefer the immediacy and accuracy of reversal images, which can be evaluated directly from the original film without being printed (which introduces its own variations into the equation). In general, I use negative film for QTVR origination; even though I usually need to tweak the images more after digitizing to alter contrast and fix color imbalances, I appreciate the ability of the film to accept the wide variance in exposure that I cannot always avoid in the capture process.

Scanning and digitizing

Most producers and photographers use 35 mm to originate images for their QTVR panoramas and thus need to digitize these images to make them available for stitching. Kodak has evolved two major formats to provide scanned digital files on CD at the time of processing: PhotoCD and PictureCD.

PhotoCD, which appeared first in the mid-1980s, allowed you to drop off your 35 mm film at a select photo processor, who developed the film and digitized each image in five file sizes, each at 72 pixels per inch (ppi):

- 3072×2048 pixels (professional resolution, optimal for printing high-resolution graphics)
- 1536×1024 pixels (large-screen graphics)
- 768×512 pixels (approximately screen-size)
- 384×256 pixels (Web graphic)
- 192×128 pixels (thumbnail)

At the time of its inception, PhotoCD was a novel technology; since the World Wide Web was in its infancy and graphical interface browsers such as IE and Netscape were nonexistent, it was envisioned primarily as a method for home users to display photographic images on their TV receivers, using an expensive player marketed (and ultimately discontinued) by Kodak. Because PhotoCD offered a quick and easy way to obtain high-resolution scans at time of processing, it became a favorite of professionals seeking digital files of their photographs. Then, along came PictureCD.

When the Web and multimedia burgeoned in the mid-1990s, Kodak took another look at PhotoCD and created a digital CD solution that could be offered at 1-hour photo processors. The price came down, availability went up, and suddenly film digitizing was within the realm of the common consumer. The main drawback of PictureCD, as it came to be called, was the lower resolution of the files it provided, a maximum 1436×1024 ppi, approximately one-fourth the top resolution of PhotoCD or about 1.5 megapixels in digital camera parlance. PictureCD also stores its files in the JPEG format, which of course is lossy and may result in degraded images. Nonetheless, whereas the PhotoCD's top resolution cannot compare with that of today's best digital cameras (3 megapixels and

greater), you still get a film image and a resolution that is more than adequate for Web distribution.

SCANNING YOUR OWN IMAGES

The growth of the Web and the general explosion in the adoption of home computers by the general populace as more than simply word-processing and spreadsheet machines has dramatically driven down the cost of flatbed scanners for digitizing flat artwork. The scanner that can be found in innumerable homes and offices may also be used to scan photographs and prints for QTVR use. Although perfectly usable scans can be made from these machines, it is always preferable to scan directly from film—be it negative or slide film—to preserve the highest degree of resolution and provide the best contrast and color characteristics. Although film scanners—technically considered professional rather than consumer devices—have not enjoyed the same steep price discounts of flatbed scanners, they have come down in price enough to be considered a desirable option for the photographer wishing to scan and digitize his or her own film images. Today's scanners can scan from 2800 up to 4800 ppi, easily enough to capture the detail of the film image. The principal inherent drawback of large files, as noted earlier, is the fact that they displace more hard disk space and random-access memory (RAM) in the editing process. Because QTVR panoramas and object movies are invariably viewed over computer monitors, it is essential that the files conform to standard monitor resolution (72 ppi). If you wish to create the smallest, most data-packed source images possible, use a very wide-angle lens like a 20 mm. If you use a very wide-angle lens for exterior locations, however, distant objects will appear very small or even indistinguishable. Thus, it is important to have close vertical elements in a landscape physically close to the camera lens for maximum effect.

THE DIGITAL CAMERA

The digital camera has come a long way in the last few years to the point that this is the preferred method for creating photographic images intended to be viewed on a computer, as QTVR movies are. There are many advantages in using a digital camera for QTVR. The resolution of a 3- or even a 2-megapixel camera can produce perfectly satisfactory images for a QTVR movie, which, in most cases, will never be viewed at a resolution over 400 pixels in height. One big advantage of shooting digital stills is that you will never have to buy film or pay to have it processed. You do not have to have the images scanned or scan them yourself, and the images are ready to view and stitch as soon as you shoot them. Some digital cameras now come with software to let you shoot and stitch panoramas directly in the camera!

Making QTVR panoramas (cylindrical panoramas)

IMAGE CAPTURE: TECHNIQUE

You should keep in mind several points before you start shooting panorama source images. You need to keep the camera level while ensuring that you overlap each successive image by at least 30%, preferably 50%.

Equipment

A camera of some kind—whether digital, 35 mm SLR, or video—is essential for capturing images, of course. Although it is possible to shoot the component images by handholding the camera, it is always preferable to use some kind of external support. This is most often accomplished through the use of a tripod, preferably with a monoball head such as the Arca-Swiss B-1. A lightweight portable option is a monopod combined with a level and compass.

Tripod alternatives

Oftentimes, using a tripod is not convenient; you may find yourself in a location or on a shoot where you simply have not brought a tripod along with you. Many locations—especially historical sites, government facilities, and museums—enforce anti-tripod rules designed to discourage professional photographers. In this case, you have three choices: the tabletop or fencetop, the bipod, and the monopod.

The tabletop tripod is a boon to photographers with lightweight cameras who need to use long exposures in public places where a full-size tripod would be obtrusive or impractical. Tabletop tripods, although convenient, cannot support anything more than a very compact and lightweight camera, however. It is also very difficult to pan around a nodal point with any precision. You can also simply set the camera on a fence top or prop it on a small sandbag, and if you do not have much close foreground subject matter, this can be a workable alternative. A panoramic series of shots that include close foreground elements, however, will likely suffer from parallax and prove difficult to stitch together smoothly later on.

The bipod approach is simply to handhold the camera and visually level and overlap your exposures. This method works adequately for exterior locations where objects do not loom too closely, otherwise you may find yourself doing a lot of work trying to patch things together in the stitching phase.

The most reliable "no tripod" method is to use a monopod. Monopods can be the best of all possible solutions, as they are quick to set up and take down, they tend to go unnoticed in locations where tripods are frowned upon or banned, and they are lightweight and easily packed. For my Virtual Calanais shoot, I used only a monopod; it was much easier to maneuver in the high winds of the Hebrides and looked more like a walking stick than a serious piece of photographic equipment. And, it is much easier to level and rotate a monopod than it is to do the same with a tripod lacking a ball or specially designed panning head.

Nonetheless, although a monopod is often the perfect alternative, there are situations where the tripod is the better choice. Long exposures dictate a rock-steady mount, and the tripod has it over the monopod for these applications. Use a tripod if you are using a video camera to capture your images, as you will be shooting several seconds per shot. Balancing a heavy motor-driven or medium format camera can be tiring on a monopod, and likewise, you will want to use a tripod if your attention is divided or you want to proceed in

a more leisurely fashion. Finally, underwater panoramic photography is better accomplished using a tripod.

If you use a monopod to shoot your panoramas, you will still need to ensure that your compositions are level, and you will also need a way to keep track of your panning increments, that is, to make certain that you overlap each shot just the right amount. You can simply "eyeball" the scene and be sure to overlap each shot 30% to 50%, but it is difficult to keep the camera level if you lack a visual reference, such as an ocean horizon, for example. The easiest and most effective way to shoot accurate shots for stitching panoramas is to use a simple compass and a small bubble level. Any small compass such as one used for camping and hiking will work quite nicely.

I used the simple compass/level/monopod configuration in conjunction with a Stroboframe Vertaflip PHD L-bracket. In my configuration, the compass is fixed to the L-bracket by wedging the edge into the bracket (Figure 6.3).

It is crucial to overlap a sufficient amount to ensure smooth blends in the stitching process. Although it is not difficult to gauge this roughly while looking through the camera viewfinder, it is hard to do this while simultaneously keeping the camera level. The most workable solution is to use the hot shoe bubble level and tilt the monopod and camera until the bubble lines up dead center. When this is accomplished, then it is time to rotate the camera and monopod until the compass aligns to the north. Hold still, make sure your level position has held, and snap the picture. Now rotate the camera 20° or 30° (longer lenses require more exposures than a shorter lens, about 18 exposures for a 35 mm lens, and from 12 to 14 for a 24 mm or 20 mm lens) and shoot the next, and continue doing so until you come round back to north again. You have just shot the first node. You can shoot nodes quite rapidly using this procedure.

Before attempting any serious QTVR panoramic work, it is necessary to find the nodal point of your camera and lens configuration. The nodal point of a given lens is the point in the lens where the image becomes inverted before passing on to the film or video target. The notion of nodal point is simply Greek to many photographers because the term is practically never given even passing mention in photography or cinematography books or classes. Indeed, although camera lens manufacturers may etch in markings for focus, depth of field, and film plane information, as a rule they never included any reference to nodal point; you need to determine this for yourself. In sequential panoramic photography, your knowledge of nodal points is crucial for optimum results. If you shoot your pictures without rotating the camera around on its nodal point, you will incur varying degrees of motion parallax, the phenomenon that occurs when foreground, middle ground, and background elements move in relation to one another as the camera is panned, which will disrupt smooth blending later on in stitching. Thankfully, finding the nodal point involves a simple procedure. Through trial and error, you can determine this point by establishing a fixed straight edge of a foreground object and panning the camera slightly back and forth. If the foreground appears to shift in relation to the background, you are seeing motion parallax. You need to adjust the pivot anchoring point of the camera until you have eliminated this parallax; as you pan, foreground and background elements should be as one, as if you are

Figure 6.3 An improvised QTVR shooting rig.

looking at a panoramic photograph. If you wish to dispense with all this fuss and do not mind spending some cash, Kaidan makes a line of camera brackets specially designed for popular digital cameras such as Nikon's Coolpix series, where the nodal point has already been tested and incorporated into the design (Figure 6.4).

Once you have set the camera correctly to rotate around the nodal point, you are ready to begin shooting. As noted earlier, it is difficult or just about impossible to keep the camera level and peer into the viewfinder to take pictures. Luckily, once you have determined the location of your node and scoped out the initial shot, you should not need to keep looking

Figure 6.4 A Kaidan QTVR bracket for the Nikon Coolpix 990.

through the viewfinder, as the level and 20–30° rotation between each shot will pretty much determine the composition anyway.

Cubic VR

The cylindrical panorama, as beautiful as it is, often makes the viewer long for a total immersive experience, one where the viewer can look up and down as well as all around a landscape or interior. Until the release of QuickTime 5, the only way to create totally immersive "panoramas" was to make spherical panoramas (Figure 6.5). Unfortunately, producers had to choose between prohibitively expensive I-Pix license "keys" or the difficult-to-use Panorama Tools by Helmut Dersch (www.path.unimelb.edu.au/~dersch). With QuickTime 5, Apple unveiled the Cubic VR as its entry into the total immersive field.

Unlike spherical VR, Cubic VR panoramas are in fact cubes, with six inner "surfaces" (Figure 6.6). The capture and stitching process is a bit more complicated than simply shooting six square images, however. To construct convincing cubic panoramas, one must choose

Figure 6.5 Spherical panorama.

Figure 6.6 Cubic VR panorama.

between a procedure shooting two or three images with a fisheye lens or a multirow technique not unlike that used for shooting object movies. Multirow image capture demands a considerably more sophisticated rig than cylindrical panoramas.

Production

QTVR production requires some decisions regarding format and equipment.

A key decision in the production of any film, video, or QTVR is: what format? You can choose to work in 35 mm, digital, or video, depending on your requirements and what is available to you (Table 6.1). Keep in mind that 35 mm film will yield the best resolution (other formats such as 120 are not recommended unless you wish to output to large prints), though digital cameras can now generate high-quality images that require no scanning, a big plus. Traditional 35 mm SLR cameras still hold the edge in terms of overall image quality and resolution. In addition, 35 mm negative film is easily available the world over, and manual cameras do not consume batteries the way a digital or motor-driven camera can.

Table 6.1. Comparison of formats for QTVR panoramic photography

Form at	Pros	Cons	Recommendations
35 mm negative	Wide latitude, film can be relatively inexpensive, good choice for PhotoCD or PictureCD. Excellent resolution.	Not recommended if you do your own scanning. Difficult to read and judge color of raw negative.	Use if you are going to have the film scanned into PhotoCD or PictureCD.
35 mm transparency	Vivid color, easier to scan and gauge color than negative. Excellent resolution.	Relatively expensive processing. Narrow latitude necessitates bracketing. Not good for contrasty conditions.	Use if you are scanning film yourself, or if you need to ensure extremely accurate color fidelity.
Digital	No scanning required (a big plus). Inexpensive (apart from initial cost of camera, memory, batteries). Resolution ranges from mediocre to very good, depending on pixel count of particular camera (CCD).	Most cameras eat batteries at an alarming rate. Resolution does not compare with film (not a problem for the Web, though). Photographer must have access to computer download images to reuse memory or have several memory chips available.	May need lens attachment to take in very wide-angle views.
Digital video (such as MiniDV or Digital8)	Many filmmakers who do not have a still camera may already have a video camera. Camera may also be used to shoot traditional video footage at location.	Very poor resolution, even for the Web.	Use only as a last resort. May need lens attachment to take in very wide-angle views.

CCD, charge-coupled device.

START WITH A PLAN

There are essentially two ways to present QTVR movies: 1) individual movies unconnected or related to one another, and 2) multinode scenes interconnected via hot spots. There are lots of QTVR panoramas of the first category on the Web; they are always interesting and sometimes breathtaking but they do not truly capture a sense of navigating around an environment. This is the domain of the multinode scene. Indeed, you will find it very useful to conduct location scouting similar to any film shoot. Some things to be aware of as you plan your QTVR:

- Start with a map. Essential to the planning and visualization of a multinode scene is the map. It will prove invaluable when plotting out the position of your nodes. Many applications, including QuickTime VR Authoring Studio (QTVRAS), request that you load a copy of your map as a template as you lay out your nodes.
- Will the scene be interior, exterior, or a combination of both?
 - Choose your lens wisely. Interior scenes generally call for an extreme wide-angle lens, usually a 15 mm or shorter focal length, to fit in all of the walls. Exterior scenes can be photographed with anything from a 14 mm up to a 50 mm lens. A 24 mm or 28 mm lens should work fine with most outdoor locations; if you would like to bring background subjects closer into view, use a 35 mm. A 50 mm will give unimpressive results as it lacks the covering power of the wider-angle lenses.
 - Lighting. Outdoor scenes can be contrasty in sunny conditions. Shooting on a cloudy day (or best, a cloudy day with some blue sky for pictorial interest) can make blending go much more smoothly. You may wish to filter your shots but be aware that polarizers do not work well with panoramics. If you are shooting interiors, you may want to filter for any predominantly fluorescent or tungsten light. Digital cameras should have built-in circuitry for correcting color temperature—consult your manual. If you have nighttime or after-hours access to the facilities, you can even shoot time exposures and "paint" the interiors with a hand-held light.
 - Batteries. If you are shooting with a digital camera, be sure to bring extra batteries (or an AC adapter and extension cords if you have easy access to AC power). Most digital cameras eat batteries for lunch, so having extras cannot be overemphasized. Film cameras may also need batteries to operate motor drives or internal light meters.
 - Extra memory cards or a laptop computer with compatible cable for downloading. Depending on the size of your scene and the resolution of your shots, you will very likely need to change memory cards or download the shots and clear the memory for more shots.
 - Time of day. You may feel it prudent to shoot your panos at a time when there is the least movement of people and objects in the scene. The presence of people in landscapes always introduces uncertainty as to how the pictures will ultimately blend together.
 - Check the weather report (exteriors only, of course) for the day of your shoot.

Object Movies

A QTVR object movie is simply a panorama turned inside out. It allows a viewer to look at a given object and move around it to see its various sides, in contrast to the QTVR panorama where the spectator stands at the center of a scene and looks up, down, around, but always outward at the surroundings. As with the panorama, the viewer can use the

mouse or key commands to navigate, as well as zoom in to magnify or zoom out to reduce the size of the object. An object movie gives the spectator the feeling of turning an object around to inspect all angles, or the feeling of walking around the subject, craning one's neck to look down, crouching down to look up at the object from below. The object movie has been used extensively for virtual catalogs, manuals, and advertisements to show potential clients and customers items such as automobiles from numerous angles.

Making the object movie

Object movies generally require more sophisticated equipment than do panoramas. The simplest object movie can be made using a single-row method. For large objects, such as monuments, this could entail simply shooting a series of shots with the chosen object in the center of each composition as you move at regular intervals in a circle around the object's periphery. For smaller objects, you can exercise considerably more control and exactitude by placing the object on a lazy Susan (Figure 6.7) or turntable marked with a series of spoke-like increments to aid in rotating the object just the right amount for each exposure. The photos are then imported into a QTVR authoring application such as QuickTime VR Authoring Studio or VR Worx™.

To make simple single-row object movies, you will need a camera, lights, a backdrop, and a turntable for your object to turn on. If you wish to shoot additional rows allowing various degrees of overhead viewing of the object, you will need a sophisticated object VR rig. Depending on your chosen method of distribution, whether via Web or disc, you will need to decide how much resolution you will require. Bear in mind that although high-resolution files consume lots of disc space and hog bandwidth, they will yield the most detail when the viewer zooms in for a closer look at your object. Traditionally, the 35 mm SLR has been the camera of choice due to its ability to produce high-quality, high-resolution images still unmatched by affordable digital cameras. With the continual improvement in CCDs (at current time, up to 14 and more megapixels of resolution), however, digital still cameras are looking more attractive all the time. For most purposes, a good-quality digital camera such as the Nikon Coolpix, Olympus Camedia, and the Canon EOS D30 and D60 makes an excellent choice for just about all applications. You should have a lens with good telephoto and/or macro characteristics, as many of the built-in zoom lenses can offer nowadays. Besides the savings in film and processing, a digital camera fitted with a high-capacity memory chip or disc, or better yet, a direct Firewire or USB cable to a computer, will allow hundreds of exposures without having to change film rolls. If you like, the digital camera can also let you view your composition on a remote monitor (like those used with boom-mounted video cameras) so you do not have to man the camera precariously as it hangs over your object when it comes to photographing high-angle shots.

The background can be as simple as a flat-color wall or a seamless paper backdrop. Black velvet or duvetyne will betray no detail if you are photographing a light-colored object, and light gray or white will work if you have a darker object to photograph. You can also use a blue or green (or other color) backdrop and remove it later completely in Photoshop or other imaging software.

Figure 6.7 A lazy Susan can be employed as a turntable for shooting object movies.

One of the biggest differences between the object and panorama is that there is no blending between images in an object movie. This makes the sampling rate and the exactitude of camera placement a much greater factor in ensuring a smooth, non-jerky object movie. The more precisely placed camera angle shots you can use, the finer the quality of the ultimate object movie. And ultimately, if you want the top or bottom of your object, you will need to use the multirow method of shooting. The most common multirow technique involves shooting a ring of exposures above your initial single-row with the camera pointing down at a 45° angle to the subject. This is where the VR rig and massive turntables for large objects such as automobiles come in. These rigs, available from companies such as Kaidan and Peace River, make object movie production vastly easier and more precise. The most elaborate and desirable rig of all will align your camera vertically automatically and allow remote-control software to work directly with QuickTime VR

Authoring Studio or VR Worx. Of course, such equipment can be prohibitively expensive for the filmmaker or photographer who does not necessarily want to fund an entire full-time object movie production studio, though facilities such as eVox (www.evox.com) will rent you the studio space and gear for this kind of thing.

Tutorial: Stitching a Simple Object Movie Using Apple's QuickTime VR Authoring Studio

Object movies can be simple single-row constructions or become elaborate multirow affairs for greater range of viewing. We will focus on constructing a single-row movie in this tutorial. Unfortunately, the application is Macintosh only (System 9); it will also run in OS X Classic mode. At the time of writing, there is no demo available, and the application has not been updated since its release in 1998. The good news is that this software is quite robust and other than its lack of support for Cubic VR, it is still so powerful that many developers continue to use it. QTVRAS is available from Apple Computer (www.apple.com/quick-time/qtvr/authoringstudio/index.html) and other resellers.

1. Open QTVRAS and from the menu, select "New/Object Maker."
2. In the "Object Maker" window that appears (Figure 6.8), click on the "Define Object" button to bring up the "Define Object" dialog box

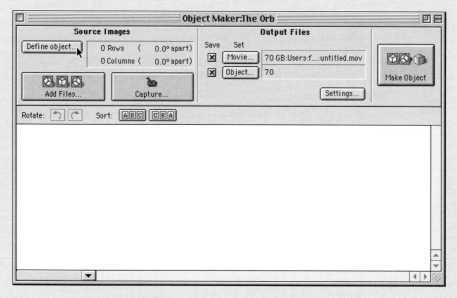

Figure 6.8 The QTVRAS "Object Maker" window.

(Figure 6.9). Because we have 30 images to stitch at 12° increments, type in 30 in the "Columns" box and 12 in the "Degrees Apart" box. Click "OK."

3. Click on "Add Files" and navigate to the CD to "Ch06/Object_Movie/ Images/." Click on the button "Add All" (Figure 6.10). Click "OK."

4. All the component elements from the "Image" file will line up in the "Object Maker" window (Figure 6.11). It is important to name the images in sequential order so that they line up in the proper sequence (usually this occurs as a matter of course as you photograph them, providing you rotate the object clockwise as you shoot the pictures). You can uncheck the "Movie" box if you do not want a linear movie of your object frames, otherwise, QTVRAS will make one along with the object movie.

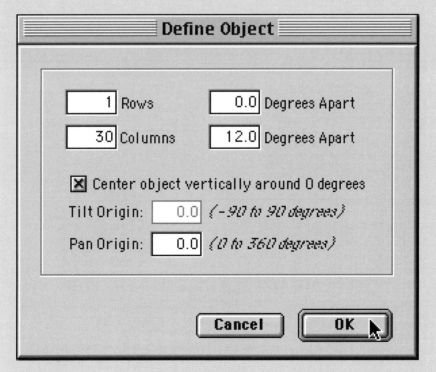

Figure 6.9 The QTVRAS "Define Object" box.

Continued

Figure 6.10 Click on the "Add All" button to gather all image files.

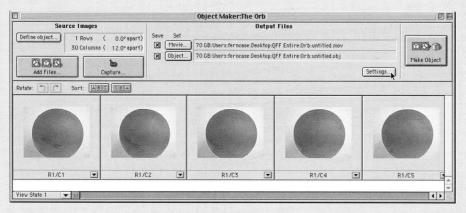

Figure 6.11 If the images are sequentially named or numbered, they will line up in proper order in the "Object Maker" window.

Click on the "Settings" button on the upper left-hand portion of the "Object Maker" window. In the first tab, "Compression," click on the "Settings" button. Change the codec to "Photo–JPEG, Best Depth," and set the "Quality" slider to "Medium" (Figure 6.12). In the "Playback" tab, change the "Object Viewing Size" to show a width of 320 and a height of 240 (Figure 6.13). The photographs are fairly large so this will make the movie a more manageable size. You can add extra information in the "File" tab if you like. Click "OK."

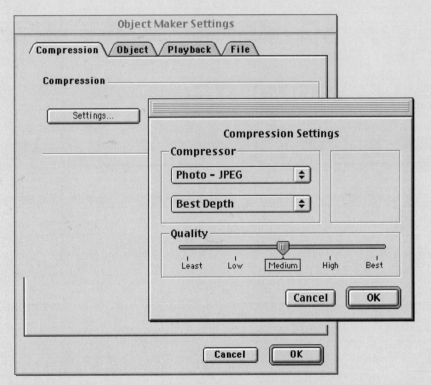

Figure 6.12 Be sure your QTVR codec is set to "Photo-JJPEG, Best Depth," and "Quality: Medium."

Continued

Object Maker Settings

Compression / Object / Playback / File

Object Viewing Size:

☐ Use Frame Size

Width: 320 Height: 240

Default Pan: 0.0

Default Tilt: 0.0

Default Zoom: 100.0 *(1 - 100%)*

Default View State: View State 1 ▼

Mouse Down View State: View State 1 ▼

Cancel OK

Figure 6.13 In the "Playback" tab, change the "Object Viewing Size" to show a width of 320 and a height of 240. The photographs are fairly large, so this will make the movie a more manageable size.

5. Click on the "Make Object" button and QTVRAS starts compiling your object movie before your eyes (Figure 6.14). Within minutes, the object movie will be completed.

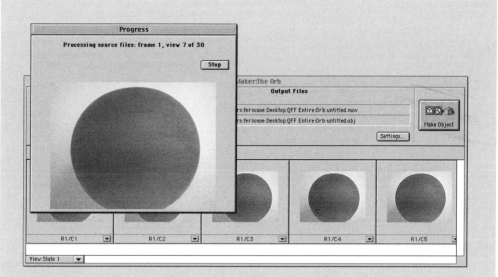

Figure 6.14 Click on the "Make Object" button and QTVRAS starts compiling your object movie before your eyes.

QTVR Scenes

You can combine QTVR panoramas and nodes and link them up to create an entire QTVR environment, sometimes referred to as the virtual tour. "Hot spots," or clickable areas, are embedded into each node within the QTVR scene to transport the viewer to a new node, a Web site, or bring up other data. Scenes are usually designed around a map, and a clickable map may also be part of the interactive experience as well. A good example of a scene can be viewed at my own Virtual Calanais site (http://www.ferncase.com/calanais); keep reading and you will learn the process I used in creating this QTVR world.

QTVR case study: Virtual Calanais

Many subjects do not seem, at first glance, to lend themselves to the traditional film or video media but nonetheless present worthy topics for documentaries. Ken Burns' landmark film *The Civil War* springs to mind. Here was a subject that seemingly could not be filmed without staging action. In Burns's case, he wisely opted against this shopworn approach and went with four primary elements: period photos of participants in the conflict, period photos of Civil War locations and personalities before and after conflicts, locations and documents filmed or photographed at the time the documentary was made, and voiceovers of documents and letters from the era. Although there was no traditional filmmaking at all in this production save the location footage, Burns was able to make a

compelling and important film. In the same vein, some subjects may be more convincing and powerful in the medium of QTVR.

For centuries, astronomers, archeologists, and common folk alike have speculated about the great standing stones and circles of the British Isles, told stories about them, and generally looked at them with wonder and amazement. There have been very few films made about them, possibly because the essence of the stones cannot really be conveyed through linear film. Even photographs fail to convey the majesty, mystery, and utter sense of "being there." Think of Stonehenge. You may have seen it many times in pictures, but only those who have visited the site can have an idea of the grandeur of these stones.

Although you would not know it from most of its photographs, Stonehenge has long been penned in with chain-link fences and blemished by a busy highway on its doorstep. I became interested in a little-known stone circle far away on the Hebridean Isle of Lewis (Figure 6.15). The majesty and mystery of these stones, which eluded a traditional photographic or filmic approach, presented a unique opportunity: a documentary in QTVR.

QTVR seemed like the obvious medium for this subject. I gathered research and pored over various scholarly writings about Callanish, which I will refer to by its recently given Gaelic-sounding name, Calanais. QTVR, served on the Web, was a much less-expensive method than traditional film or even video, and offered interactivity, key to the success of this project.

PREPRODUCTION

The first steps in creating the Virtual Calanais QTVR site meant visiting the site. This entailed flying from Inverness, Scotland, to Stornoway, Lewis, renting a car, and driving due north to the settlement of Calanais, a few miles from the stones. I shot pictures and some rudimentary panoramas as I strolled around the site. Remarkably, even walking around the stones themselves does not fully give one a sense of the grand scheme, as the stones are configured in a circle with multiple rows of stones radiating outward so as to form a giant cross; this becomes obvious only when the configuration is seen from a bird's-eye view. I bought some literature at a local shop and found a plan of the stones. This was instrumental in planning the next phase of the project.

Figure 6.15 The Callanish Stones on the Isle of Lewis, Greater Hebrides, Scotland.

When planning any QTVR multinode scene, it is crucial that you start with a map (Figure 6.16) so you can plan your node placement for the best interactive experience. In my case, I was lucky that the site had been mapped out already numerous times. You may have to draw your own map; by all means, do it! It will save you hours of aggravation later when you are adding hot spots to your panoramas. I wrote up some brief histories and speculative observations about the stones and drew up a grant proposal to raise some money to start the project.

Despite my careful mapmaking, I soon found it difficult to adhere to the node diagram I drew up, as changing weather and gusty wind conditions made it all but impossible to proceed photographing from the node coordinates I had laid out. I began shooting from positions I considered most interesting from a compositional standpoint and went about shooting at various points as long as the weather permitted. During the week of my visit to Calanais, I had sunny weather (albeit with lots of scattered clouds) for part of one day, and I made the most of it before rain resumed. I picked up some books and literature written about the site and its history at some local shops to aid in constructing a narrative about the site to accompany the QTVR scene.

I ended up shooting at least 18 complete nodes around the site, as well as several more nodes at some adjacent stone circles. After returning home from the trip, I proceeded to digitally capture the images with a film scanner, a time-consuming but necessary task. Although it is advisable to scan images at the highest possible resolution for archiving, I captured at about 1000 ppi and stitched the images together in QTVRAS to form one long rectangular panorama saved as a PICT or TIFF. After retouching defects, odd sightseers, and parked cars out of the image in Photoshop, I imported the panoramas back into QTVRAS to stitch the cylindrical panoramas.

Compression for QTVR

Most experienced QTVR producers agree the best codec in terms of preserving sharpness and clarity in QTVR images is Photo-JPEG (set at 50% as a rule of thumb). If you are after the smallest possible files for the Web, however, try Sorenson 3. I compressed low-bandwidth versions of my panoramas to 100 KB and less, but you definitely forfeit image detail when you do this. The resulting panoramas had an almost painterly texture, which may or may not suit the subject you wish to depict.

Making a QTVR Project

The following is a series of tutorials guiding you through the creation of a self-contained QuickTime movie that consists of a number of QTVR nodes all interconnected via hot spots and a clickable map. You will find the various elements for these tutorials in the CD in the "Ch06" folder. You will need to use an application that lets you stitch your photographs into panoramas, convert them to QTVR movies, designate hot spots within the

Callanish Nodes

CALANAIS
The Callanish Stones

Figure 6.16 It is important to begin any QTVR scene project with a map of your location. The numbers refer to points for shooting nodes.

movies interconnecting them, and combine them into multi-node scenes. You will find tutorials for VR Worx (for PC or Mac) as well as Apple's QTVRAS (Mac only).

Tutorial: QTVR panoramas and scenes with the VR Worx

The VR Worx is a robust QTVR authoring tool that creates panorama, object, and scene movies. It is available on both PC and Macintosh platforms, making it appealing to Windows as well as Mac users. You can download a demo version of VR Worx at www.vrtollbox.com.

Let's start with stitching the panoramas:

1. Open VR Worx and when the "Welcome to The VR Worx" box (Figure 6.17) appears, check the "Panorama" radio button under "Select document type." Click "OK."
2. Make sure the following settings in the "Panorama" dialog box that appears (Figure 6.18) are as follows:
 a. "Source Format": "Cylindrical Images"
 b. "Acquire From": "Image File"
 c. "Mechanism": "None"
 d. "Node Sweep": 360°
 e. "Max. Frames": 14
 f. "Lens Params": Check the "Length" button, and set the text box to 24 mm (35 mm equivalent).

Figure 6.17 When the "Welcome to The VR Worx" box appears, check the "Panorama" radio button.

Figure 6.18 The "Panorama" dialog box.

Figure 6.19 In the pull-down menu, select "Custom" and type in 480 for "Width" and 640 for "Height."

g. "Image Size": In the pull-down menu, select "Custom" and type in 480 for "Width" and 640 for "Height" (Figure 6.19).

h. "Frame Count" and "Overlap" are set automatically.

Save the document as "01_Memorial_Hall," and click "OK."

3. Click on the "Acquire" tab and notice a wheel (known as the "Frame Cylinder") with 14 spaces for your individual image files.

 a. You can add images singly or in groups. We will do the latter, so click on the "Multiple" button.

 b. In the "Add Frames to Panorama" dialog box that appears, navigate on the CD to "Ch07/01_Memorial_Hall/images." Click on "505 copy.jpg," hold "Shift," and click on "518 copy.jpg" (or click on the "Add 14" button if it appears) to select the images.

Change rotation to −90° to orient the images in portrait mode (Figure 6.20).

 c. Click on the "Select" button.

You should see the images aligned around the "Frame Cylinder" in the proper portrait orientation (Figure 6.21). At this point, you have the option of editing any selected image in the built-in image editor when you click on the "Edit" button in the "Tools" section of the box. You can remove any image from the "Frame Cylinder" if you select it first and click "Clear." You also have the option of reversing the image series order by going to "Menu Edit/Reverse Frames." We will not need to do any editing at this stage, so let's go to the next tab.

Figure 6.20 In the "Add Frames to Panorama" box, change rotation to −90° to orient the images in portrait mode.

Figure 6.21 When you see the images load around the "Frame Cylinder" in the proper portrait orientation, you can go the next step: Stitch.

4. The "Stitch" tab features an empty window for images to be stitched alongside a left-hand column of settings to help align the images for your panorama (Figure 6.22).

 a. Click on the "Stitch" button to add and stitch your component images in the "Stitch" window (Figure 6.23).

 b. The alignment should be OK if you used the settings given for the "Setup" tab. If images are inconsistent in density or were shot without a tripod, you may click on the "Tolerance" button and expand the tolerances with a vertical and a horizontal slider (Figure 6.24). This increases the stitching time but may offer more accurate alignment.

 c. "Options" group: If you check the "Transparency" box, you will be able to see through overlapping regions of stitched frames, making fine adjustments of images easier. Be sure to check "Hyper-stitch," a speedy blending setting.

 d. "Adjustment" group: If you need to fine-adjust the alignment of individual images, click on the desired image to select it and click on any of the four "Offset" buttons, these nudge the image one pixel at a time north, south, east, or west.

Figure 6.22 The "Stitch" window.

e. Correction: In most cases you can leave the "Auto" button checked and go ahead to the "Blend" tab. If you find, however, that you need to do more tweaking to the individual images, click "Manual" and play with the "H-Adj," "V-Adj," and "Keystone" adjustments; these let you make selected image shapes more or less convex, concave, or tapered.

5. Blending. Proceed on to the "Blend" tab to combine your stitched images into one seamless picture. Click on the "Blend" button to begin melding your images. When the blending is finished, you can inspect the panorama by scrolling horizontally (Figure 6.25). If it looks good, then skip the "Hot Spots" tab (we will make hot spots as part of our scene later) and go directly to the "Compress" tab. If you are not pleased with the blending results, try the following:

a. Effects: Min/Max Blend. If your images vary widely in density—that is, if some are much lighter or darker than others (this often occurs if images were shot on automatic exposure mode), you may want to adjust this slider (Figure 6.24), which extends the area of the blend effect.

b. Effects: Filters. VR Worx provides a number of filters including "Blur," "Sharpen," "Film Noise," and other effects you may want to experiment with.

6. "Hot Spots." Skip this tab—we will do the hot spots as part of the scene later.

Figure 6.23 Click on the "Stitch" button to add and stitch your component images in the "Stitch" window.

Figure 6.24 If images are inconsistent in density or were shot without a tripod, you may click on the "Tolerance" button and expand the tolerances with a vertical and a horizontal slider.

Figure 6.25 The "Blend" tab: When the blending is finished, you can inspect the panorama by scrolling horizontally.

Figure 6.26 The "Compress" tab. You can leave these settings as they are.

7. "Compress." In most cases, you can go with the default settings in this tab (Figure 6.26) and click on "Compress" to begin the encoding process. The default codec Photo-JPEG at normal (50%) quality is the best choice for most QTVR applications. You can leave the color depth at 24 bits and the tile array at 1 × 24 with

"Optimal Scaling" checked. The "Dual Resolution" box can be checked if you want to create a second low-resolution video track of the movie. The QuickTime VR media handler will try to access the standard high-resolution video track first, but in case of low computer memory, it will alternately attempt to open the lower resolution track instead. Do not bother with the "Default View Angles" adjustments here; they can be changed much more easily on the next tab.

8. "Playback." You have numerous options to control the look of your panorama in this final tab.

 a. "Movie Box." Here you can change the size and/or the aspect ratio of the panorama; it does not change the physical size of the movie but changes the size and dimensions of the window you see it through.

 b. "Attributes." With the exception of the "Annotate" boxes to input name, copyright, and descriptive information, most of these technical adjustments can be left on their default settings.

 c. "Constraints." Pan and zoom your movie to the point where the movie should open, and under "Initial," click the "Set" button to define exactly where a QTVR movie will open (Figure 6.27). You can also set the minimum and maximum zoom limits.

Figure 6.27 The "Playback" window offers numerous options to control the look of your panorama. After orienting your movie to its intended opening position, click the "Set" buttons under "Constraints" to define exactly where a QTVR movie will open.

d. When you finish with the settings, save your work in the appropriate folder. This is your VR Worx document, which you can go back and tweak anytime you want to make changes.

e. Click on the "Export Movie" button. VR Worx will ask you to name your movie, suggesting a ".mov" title based on the name of your project (Figure 6.28). If you intend to put this QTVR movie on the Web, make sure the "Optimize for Web Playback" box is checked.

f. Your QTVR panorama is finished! Follow this stitching procedure with the remaining four image folders—"02_Wilkenson_Hall," "03_Berlin_Wall," "04_Schweitzer_Mall," and "05_Panther"—or just use these panos already stitched and provided on the CD and go on to the next phase: making the multimode scene.

Figure 6.28 Click on the "Export Movie" button. VR Worx will ask you to name your movie, suggesting a ".mov" title based on the name of your project.

Tutorial: Making the scene in VR Worx

Once you have made individual QTVR panoramas, you can add the interactive element: adding hot spots and combining the separate panoramas into a single multinode movie or scene.

A QTVR scene consists of two or more QTVR movies connected by hot spots in a single self-contained movie. As we have seen, hot spots are preselected areas within a Quick-Time movie that link to other movies or launch Web pages when the user clicks on the spot. Hot spots may be designated as link, URL, or multipurpose "blob" hot spots that can link to a movie, a URL, or even trigger events in outside applications. We will work with link-type hot spots in this tutorial.

1. If VR Worx is not running on your computer, open it now. When the "Welcome" dialog box asks you to select document type, check the "Scene" circle and click "OK" (Figure 6.29). The "Scene" window appears, showing a number of tabs for "Setup," "Background," "Nodes," "Compose," and "Playback."

2. In the "Setup" tab (Figure 6.30), type in a name for your scene. You can leave the other defaults as they are. Click the "Background" tab.

3. Now to add a map in the "Background" tab. Maps are recommended whenever you are constructing a scene with more than three or four nodes. Click the "Add" button under "Commands." In the dialog box that appears, browse to the Quick-Time for Filmmakers CD on your desktop and open the "Ch07" folder. Open the "Scene_assets" folder, select "Chapman_map.pct," and click "Add." The map will appear in the "Background" window (Figure 6.31).

Figure 6.29 When the "Welcome" dialog box asks you to select document type, check the "Scene" circle and click "OK."

Figure 6.30 In the "Setup" tab, type in a name for your scene. You can leave the other defaults as they are.

4. Click on the "Nodes" tab. A node is a point in a QTVR scene where a QTVR panorama is placed—you will place five nodes in this scene.
 a. Click on the "Add" button under "Commands." When the "Add Node Media" box appears (Figure 6.32), select the file "01_memorial.pano" from the "Scene_assets" folder you accessed in step 3, and click "Add." Drag this to the numeral "1" on the map to position this node.
 b. Repeat step 4 with the remaining four numbered pano files in the "Scene_assets" folder, dragging them to their corresponding numbers on the map. Alternately, you can also drag the panorama files from the folder to the "Nodes" window.
 Now to link the nodes:
 c. Click on the double-headed arrow button from the "Tools" group and drag an arrow from node 1 (01_memorial.mov) to node 3 (03_wilkenson.mov). You should see a double-headed arrow spanning the two nodes when you finish (Figure 6.33).
 d. Select the "Arrow" from the "Tools" group and double-click on node 1 to bring up the "Node Browser." Click on the "Hot Spots" tab and scroll horizontally across the flat version of your panorama in the window until you find the

Figure 6.31 In the "Background" tab, click the "Add" button to find and insert a map.

transparent green rectangle representing the hot spot area (Figure 6.34). You should see a label on this rectangle identifying the node this will link to. Drag this rectangle to the correct place in the panorama where the hot spot should logically appear, in this case in the area directly to the left of the columned building. You may drag a corner of the rectangle to resize it (Figure 6.35). Once you move the rectangle, it will turn from green to red.

e. Double-click on the red rectangle to bring up the "Hot Spot Properties" box. In the "Name" text box, overwrite the existing name with something more descriptive, such as "Toward Wilkenson Hall." Click "OK" to return to the "Node Browser" (Figure 6.36). Save your project.

f. To test your link, click on the "Preview" tab to see your QTVR panorama; click and drag to the place where you put your hot spot. When you click on the question mark icon in the control bar of the QTVR movie, you can see the hot spot area shaded and your pointer will change into a flattened

Figure 6.32 The "Add Node Media" window appears to let you add nodes to the map.

Figure 6.33 Click on the double-headed arrow button from the "Tools" group and drag an arrow from a node. You should see a double-headed arrow spanning the two nodes when you finish.

Figure 6.34 Click on the "Hot Spots" tab and scroll horizontally across the flat version of your panorama in the window until you find the transparent green rectangle representing the hot spot area.

Figure 6.35 Drag this rectangle to the correct place in the panorama where the hot spot should logically appear, in this case in the area directly to the left of the columned building.

Figure 6.36 Double-click on the red rectangle to bring up the "Hot Spot Properties" box. In the "Name" text box, overwrite the existing name with something more descriptive.

upward-pointing arrow icon to show that you are on a hot spot (Figure 6.37); you will see the name of the hot spot that you typed in: "Toward Wilkenson Hall." Click on the hot spot and it should take you to the linked Wilkenson Hall panorama. The only thing wrong is that the point of view most likely does not match what the user would see if he or she were to "step" from node 1 (Memorial Hall lawn). To remedy this, click and drag around the Wilkenson (node 3) panorama until the view makes sense geographically from the point of view of our first node, the Memorial Hall lawn (Figure 6.38). Now you have correctly defined the entry angle for this hot spot. To ensure the new entry angle is indeed correct, click the lower left-hand button in the "Link View From" group (Figure 6.39). This will return you to the node you linked from: the Memorial Hall lawn. Try clicking on the hot spot again; it should take you to the correct entry angle in node 3. You have successfully defined a hot spot for node 1. Now close the "Node Browser" dialog box.

Now it is time to define hot spots for the remaining four nodes. Node 3 (Wilkenson Hall) lies between three nodes: node 1, node 2, and node 4.

Figure 6.37 The "Preview" tab: When you click on the question mark icon in the control bar of the QTVR movie, you can see the hot spot area shaded.

5. In the "Chapman Scene," "Nodes" window, choose the double arrow in the "Tools" group and draw links from node 3 to nodes 2 and 4 in addition to the link/hot spot you created for node 1 (Figure 6.40).

 a. Select the "Pointer" tool on the upper left-hand row of the "Tools" group and double-click on node 3. In the "Name" text box, type in a new name for the node: Wilkenson Hall.

 b. Click on the "Hot Spots" tab and when the panorama window appears, drag the hot spot rectangles to their proper positions. You can change the enlargement of the image and fit the entire panorama on your screen by clicking on one of the two small buttons just below the lower left-hand corner of the panorama (Figure 6.41). When you have correctly positioned all three hot spot rectangles, double-click on each to type in descriptive titles as you did in step 4(e). Your panorama with hot spots should resemble the image in Figure 6.42.

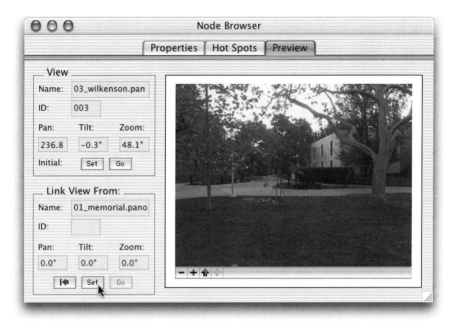

Figure 6.38 Click and drag around the Wilkenson (node 3) panorama until the view makes sense geographically from the point of view of node 1.

Figure 6.39 Click the lower left-hand button in the "Link View From" group to return you to the node you linked from.

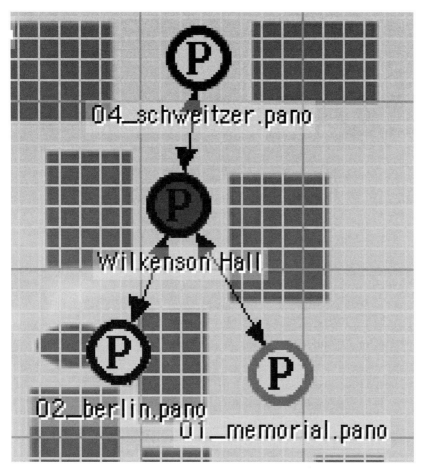

Figure 6.40 Choose the double arrow tool and draw links from node 3 to nodes 2 and 4 in addition to the link/hot spot you created for node 1.

Figure 6.41 Zoom in/zoom out buttons.

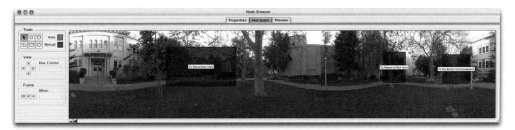

Figure 6.42 Node 3, with hot spots in proper position.

Note: You can define circular, elliptical, and polygonal hot spot shapes as well as rectangular shapes by using the appropriate tool in the "Tools" group in the "Hot Spots" window.

 c. Set the hot spots for these nodes as you did in steps 4(e) and 4(f) to finish adding hot spots to all remaining nodes. For reference, see the completed "Chapman Scene" in "Ch07" of the CD to try the hot spots and check the point-of-view positioning for each node. When you have competed all hot spots and positioning, go on to the next tab, "Compose."

 6. Select the "Compose" tab and click on the "Compose" button to create the scene with hot spots. Click on the "Playback" tab to bring up your completed scene. In this window you can add "Annotations" and change settings in the same way as when you created each panorama. You may change the initial point-of-view by navigating to the desired entry point and clicking the "Set" button in the "Initial Node" group near the bottom of the window.

 7. Try all the nodes and hot spots in the QTVR scene and if it all checks out, save this VR Worx document. Once you have saved your VR Worx file, click on the "Export" button. VR Worx will suggest the same name with the ".mov" extension when you export, and you may either go with this default or type in a new name. Congratulations, you have completed your scene!

Tutorial: QTVR panoramas and scenes with QTVRAS

Click on the QTVRAS application icon to open up QTVRAS; you will notice that no interface appears until you open a new or existing project.

 1. To open a new project, select "New/Panorama Stitcher." In the dialog box that appears, type in a name for your project, in this case "Memorial_Hall." Click "OK."

 2. The QTVRAS window will appear. Now to add the component images, click the button "Add Images . . ." In the dialog box that appears, navigate to the file named "Chapter_07/01_Memorial_Hall/images" and click on the button "Add All." Click the "Done" button.

Images "505 copy.jpg" through "513 copy.jpg" should appear in the window in sequential order. You will probably see only some of the images in the window unless you have a very large monitor. You can always click and drag an image to another place in the sequence, but in this case, the images should appear in the proper order. At this point, you will want to make sure that you have the correct lens selected; because these images were shot vertically with a 24 mm lens equivalent, set the "Lens:" pull-down to "24 mm Portrait." If any or all of the images appear upside down or sideways in the sequence, you can right them by selecting the images to correct and click the proper "Rotate" button (clockwise or counterclockwise). The "Sort" button lets you reverse the order of the sequence if you so desire.

The "Output Files" (Figure 6.43) show what formats are available for your final output. If you know that your panorama is going to need some touching up before making the QTVR panorama, then make sure the "PICT" box is checked. In fact, in most cases, you need only check this box. This ensures that you get a stitched panorama as a standard PICT (a Macintosh-only image file). If you want to make a QTVR panorama now, make sure that the "Tile" and "Pano" boxes are checked. For this tutorial, you may check all three boxes to see how each file looks.

Click on the "Settings" button to bring up the "Stitch Settings" dialog box, which contains tabs for "Image," "Compression," "Playback," "Imaging," and "File":

- "Image" tab (Figure 6.44)—Generally you can go with the default settings here, which are: "Blend," "Fill," and "Deskew" boxes checked; these enable blending and minor corrections. The pull-down menu below the "Blend" check box should be set to "Gaussian" for the best general blending. If you find that the resulting panorama shows smearing, you may want to go back and change the pull-down to "narrow" and try stitching again. Leave the "Crop" and "Auto Size" boxes checked. Click "OK."
- "Compression" tab (Figure 6.45)—In the "Tiles" portion of this dialog box, make sure the "Auto" box is checked. This will ensure that the QTVR movie will be composed of 24 tiles (tiles are the QTVR equivalent of frames). In the "Compression" portion of the box, click on the "Settings . . ." button. In the "Compression Settings" box that appears, make sure the "Compressor" pull-downs are set to "Photo-JPEG" and "Best Depth." (For some reason, the default for compression is often set to Cinepak, which you certainly do not want.) Set the

Figure 6.43 The "Output Files" show what formats are available for final output.

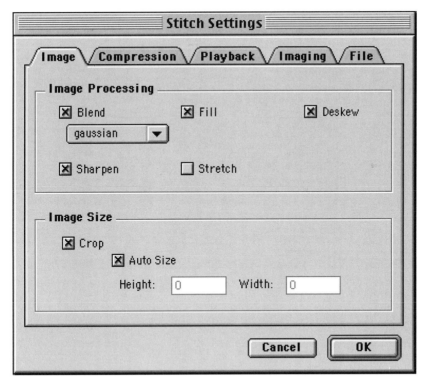

Figure 6.44 The "Stitch Settings" box—"Image" tab.

"Quality" slider to "Medium." These are regarded to be the best general settings for QTVR movies. Click "OK."

- "Playback" tab (Figure 6.46)—These settings determine the size of the panorama as well as the default starting horizontal (pan) and vertical (tilt) coordinates of your panorama. These are useful settings to adjust when your panorama is to be part of a multimode scene and you want the pano to open with a preset orientation. You can also change the range of the zoom function. Make sure the "Panorama Viewing Size" is set to "Width: 320" and "Height: 240." The other settings should be "Default Pan: 0.0," "Pan Range: Auto" checked, "Default Tilt 0.0," "Tilt Range Auto" checked, "Default Zoom 75," "Zoom Range: Min. 15, Max. 100." Click "OK."

- "Imaging" tab (Figure 6.47)—In the "Static" section of this dialog box, leave "Quality" set to "High," "Correction" set to "Full." In the "Motion" section, set "Quality" to "Normal" and "Correction" to "Full."

- "File" tab (Figure 6.48)—Be sure the "Flattening" box is checked. You may write in your name, copyright, and other information in these boxes if you wish. Click "OK."

Figure 6.45 The "Stitch Settings" box—"Compression" tab.

Figure 6.46 The "Stitch Settings" box—"Playback" tab.

Figure 6.47 The "Stitch Settings" box—"Imaging" tab.

Figure 6.48 The "Stitch Settings" box—"File" tab.

If you feel lucky, you can go ahead and click the "Stitch Pano" button to start the process of stitching. You will most likely find, however, that your panorama will show misaligned elements and ugly smears. Panoramas do not usually stitch seamlessly in QTVRAS without some adjustments to line up the images. The "Image Alignment" button just to the right of the "Add Images" button might seem like the logical place to start, and indeed, you can click on this to bring up the "Image Alignment" box (Figure 6.49). You can specify the "Degrees Between Alignment" if you wish; this is generally input automatically when you set the lens length, as we did earlier. In general, leave the settings on this box alone, and align each image manually. Click "OK."

Figure 6.49 The QTVRAS "Image Alignment" box displays information pertaining to the vertical and horizontal alignment of the images.

You can get information about any single image by clicking on the arrow button below the lower right-hand corner of the image. To align each image to the next, click on the small triangle between each image, starting with the first and second images in the sequence (Figure 6.50).

In the "Pair Alignment" box that appears, you will see the two images, one overlapping the other (Figure 6.51). At the top of the window, you can see information about the image regarding its relative position and size. You will need to click and drag the right-hand image until the overlapping portion of the right image coincides with the image underneath. This need only be approximate, as the distortion of most wide-angle lenses often makes perfect alignment impossible. To make more exact adjustments, you can nudge the image using the arrow keys.

It is generally best to try aligning the center of the overlapping area so that it looks clear and sharp. You can enlarge the images by clicking the tiny buttons bearing the images of a small and large mountain range; to the right of these buttons you can see the degree of image enlargement. When you finish aligning the images as best you can, click the "Next" button at the bottom left-hand corner (right of the "Previous" button) of the window. This will take you to the next pair of images. Continue aligning each pair, including the first and last in the series, using this method. When you have finished, click "OK."

Now it is time to start the blending process, so click the "Stitch Pano" button. You can watch the stitching, blending, deskewing, sharpening, and tiling process as it happens.

You may find that your panoramas need retouching to remove blemishes or unwanted elements in the images. In this case, open the PICT file that QTVRAS has generated and work on it in Photoshop or another image editor. (The PICT will open 90° sideways because PICTs can only offer limited horizontal dimensions—if you rotate it, be sure to rotate it back before final stitching!) When you have finished cleaning up the pano, be sure to save it again as a PICT. Open QTVRAS and select "New/Panorama Stitcher." The process for converting a flat panorama into a QTVR pano is much simpler than stitching 12 or 14 separate images—simply press the "Add Image" button and navigate to the appropriate PICT stitched and retouched earlier (Figure 6.52). When the image appears in the window, click the "Stitch Pano" button and QTVRAS does the rest. The resulting file will be a QuickTime movie, even though the extension is ".pano." Change this extension to ".mov."

Figure 6.50 Click on the small triangle between each image to bring up the "Pair Alignment" box.

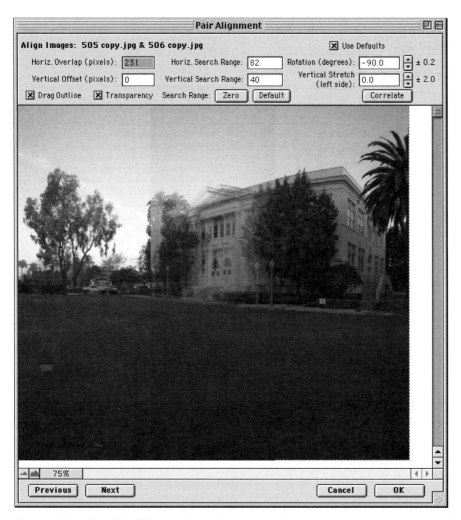

Figure 6.51 The "Pair Alignment" box displays two adjacent images, one overlapping the other.

Follow this stitching procedure with the remaining four image folders—"02_Wilkenson_Hall," "03_Berlin_Wall," "04_Schweitzer_Mall," and "05_Panther"—or just use these panos already stitched and provided on the CD and go on to the next phase: making the multimode scene.

Creating the multinode scene

Once you have made individual QTVR panoramas, you can add the interactive element: adding hot spots and combining the separate panos into a single scene.

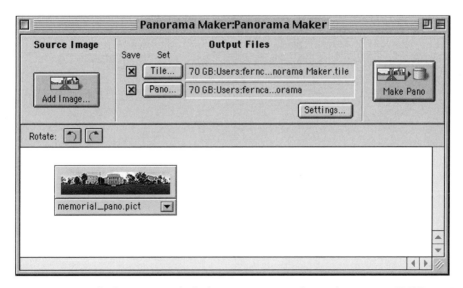

Figure 6.52 The "Panorama Maker" when you want to stitch a single panoramic PICT image into a QTVR movie.

As noted earlier, the best way to begin planning a scene is to start with a map. In this case the scene is to be a virtual tour of the Chapman University campus, so we will start with a simple map (chapmanmap.pct) of the area to be covered in the virtual scene (Figure 6.53) that you will find in "Ch06" of the CD. This map of the main Chapman University campus shows the main buildings. The numbers 1, 2, 3, 4, and 5 indicate the positions where the nodes were photographed. You will place these nodes in these designated positions and outfit them with interconnecting hot spots.

1. In QTVRAS, select "File/New/Scene Maker," and in the dialog box that appears, type a name for the scene: "Chapman_campus."
2. Click "Save" and the "Scene Maker" window will appear. Click on the "Add Map" button and in the dialog box that appears, browse to the file "campusmap.pct" in "Chapter 7/Campus_scene/" (you can also drag the map into the window). The map will appear in the "Scene Maker" window (Figure 6.54).
3. OPTIONAL STEP: If you would like the hot spots file or the scene file to have different names or be filed in other locations from the ones listed next to the "Hot Spots" and "Scene" buttons, click on each of those buttons and specify the new name and location of each.

You can create five different types of nodes in the "Scene Maker" by clicking on any of the buttons appearing to the right of "Create Nodes:" (Figure 6.55). These node buttons open windows for the "Panorama Stitcher," the "Panorama Maker," the "Object Maker," "URL" (for hyperlinks to Web pages), and the "Blob" (which allows undefined hot spots). At this time, unfortunately, QTVRAS does not support Cubic VR nodes.

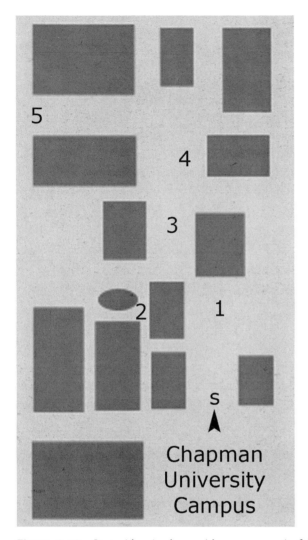

Figure 6.53 Start with a simple map (chapmanmap.pct) of the area to be covered in the virtual scene.

4. Because our panoramas have already been made, we can simply drag and drop each of the five panoramas to their appropriate numbered coordinates: "01_memorial.mov" to #1 on the map, "02_wilkenson.mov" to #2 on the map, and so on. Notice that each panorama changes into a circular icon when you drag it into the window (Figure 6.56). Notice that the first panorama icon you dragged onto the map will be bounded by two circular outlines, indicating this as your starting-point panorama.

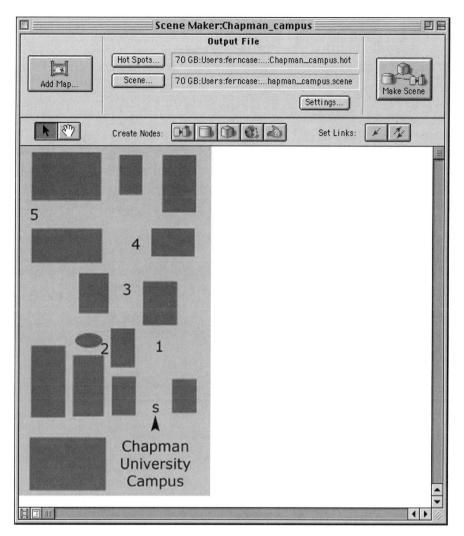

Figure 6.54 Click on the "Add Map" button or drag your map into the "Scene Maker" window.

Figure 6.55 You can create five different types of nodes in the "Scene Maker" by clicking on any of the "Create Nodes" buttons.

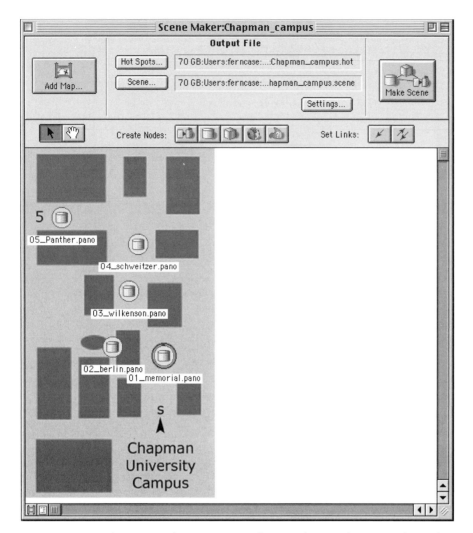

Figure 6.56 Each panorama changes into a circular icon when you drag it into the window.

If for any reason you want your map to disappear, click on the tiny button at the extreme left-hand corner of the window. You can also click on the button next to the map button to open a window with a list of your nodes (Figure 6.57).

Now it is time to set the links between the nodes:

5. At the top left-hand portion of the window below the "Make Scene" button, you will see two buttons for setting links; because we want our hot spots to link back and forth, click on the "Dual Link" button (Figure 6.58). Position your pointer over node 1 and drag to node 2 and release: a two-way link will appear in the form of two arrows going in opposite directions. Now link up all your nodes in the same fashion, but make sure that you do not link nodes that appear on oppo-

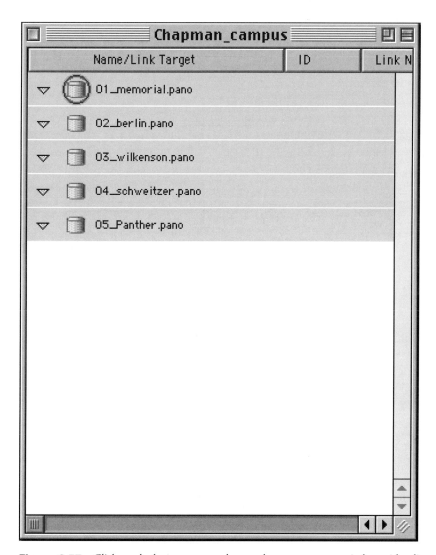

Figure 6.57 Click on the button next to the map button to open a window with a list of your nodes.

Figure 6.58 The "Dual Link" button lets you set hot spots that link back and forth between two nodes.

site sides of any buildings (indicated by the dark-gray rectangles). This is because there is no sight line connecting these nodes, and hot spots linking through obstructions would not make visual sense. If you need to adjust the positioning of any node, you may do so even when they are linked together. Your linked nodes should look like Figure 6.59.

6. You will want to set the opening view orientation of your scene, so that the scene will always open on the same view, by clicking on node 1 (in this case, "01_memorial.mov"). In the panorama that appears, click and drag to pan around the panorama until you find the place where you want the scene to open; you can also tilt and zoom to fine-tune the view (Figure 6.60). Click on the "Set Playback Settings" to lock in the visual coordinates you have selected.

Now it is time to define the hot spots:

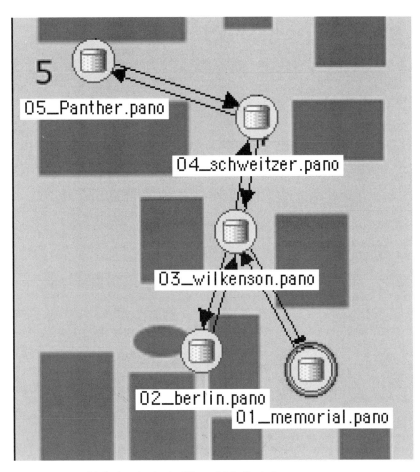

Figure 6.59　Linked nodes in the "Scene Maker" window.

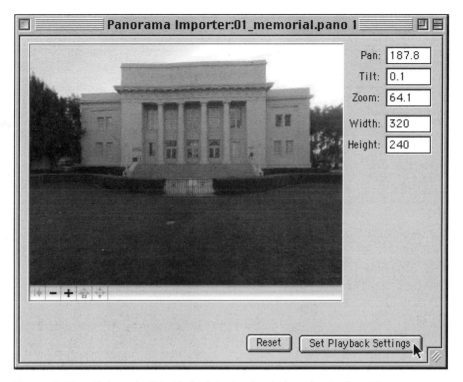

Figure 6.60 Click on the "Set Playback Settings" to lock in the visual coordinates.

7. Click and hold on node 1; choose "Edit Hot Spots" from the pop-up menu that appears (Figure 6.61). Two windows open simultaneously: the "Hot Spot Editor" (Figure 6.62) along with a window containing a flattened version of the panorama you are linking from (Figure 6.63). In the "Hot Spot Editor," you will see all the hot spot links you designated along with a randomly designated color and ID number (be sure to make a note of the individual ID numbers for later).

8. Find the area in the open panorama image where you would "see" the closest node—in this case the "02_wilkenson.mov" node situated in the mall just left of the columned Memorial Hall building. You can scroll back and forth horizontally to find the right place by clicking and dragging on the slider at the bottom of the window. Click on one of the colored hot spot buttons (Figure 6.64) to define a rectangular, elliptical, or polygonal patch where the clickable hot spot will be placed. It is best to choose a shape that best fits the area you want to define, so the rectangular button will work nicely. After selecting a button, go to the hot spot area and drag a hot spot patch and release it when you are satisfied with the hot spot; you can adjust the size of this afterward by clicking and drag-

Figure 6.61 Click and hold on node 1; choose "Edit Hot Spots" from the pop-up menu that appears.

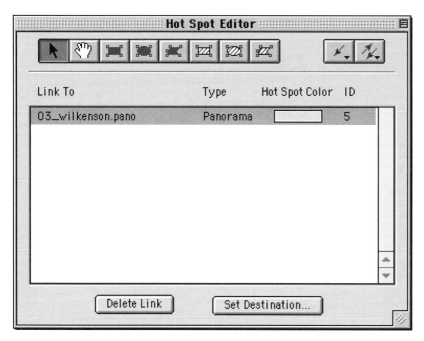

Figure 6.62 The "Hot Spot Editor."

Figure 6.63 Along with the "Hot Spot Editor," another window appears containing a flattened version of the panorama.

Figure 6.64 Click on one of the colored hot spot buttons to define a rectangular, elliptical, or polygonal patch where the clickable hot spot will be placed.

ging on any corner (Figure 6.65). The hot spot will be defined by a unique color to help you distinguish it from the many hot spots you may use—the colors will not appear in the final panorama. If you wish to slice away at any hot spot you have drawn, you can cut portions out using any of the three hot spot editing buttons to the right of the hot spot defining buttons (Figure 6.66). You can, for example, use the rectangular editing button to cut the flagpole out of this hot spot.

9. Now that you have drawn a hot spot, click on the "Set Destination" in the "Hot Spot Editor" window. A window with an image of the destination node will open.

Figure 6.65 After selecting a button, go to the hot spot area and drag a hot spot patch; you can adjust the size of this afterward by clicking and dragging on any corner.

Figure 6.66 The three hot spot editing buttons to the right of the hot spot defining buttons let you cut away and trim your hot spot areas.

Click on the "Set Destination" button located in the lower right-hand corner of this window. Select a view that matches the area from where the hot spot would be viewed (Figure 6.67).

10. Close the "Set Destination" window, and close the window of the node you are linking from. Your settings will be saved automatically and the "Hot Spot Editor" window will close.

11. Repeat this process with the remaining four nodes. As you proceed, you may want to compare your scene with the Chapman scene in the "Ch06" folder of the CD. The Chapman campus scene is fairly simple and straightforward, with each node containing only one or two hot spots. You can, however, define up to 256 hot spots in a more complex scene. You can proceed to "making the scene" once you have finished defining your hot spots.

12. Click on the "Settings" button in the "Scene Maker" window. In the "Playback" tab, you may set "Viewing Size" and "Imaging" parameters as you did when you created each of the panoramas. In this case, adjust the settings as follows (Figure 6.68):

a. "Viewing Size": Width 320, Height 240
b. "Static Quality": High
c. "Static Correction": Full
d. "Motion Quality": Normal
e. "Motion Correction": Full

Always use the same correction settings for both static and motion. In the "File" tab, make sure the "Flatten to Data Fork" is checked. If you wish to type in extra information, you could do so in the boxes provided. Click "OK" to save settings and close the box.

Figure 6.67 You can use the rectangular editing button to cut the flagpole out of this hot spot.

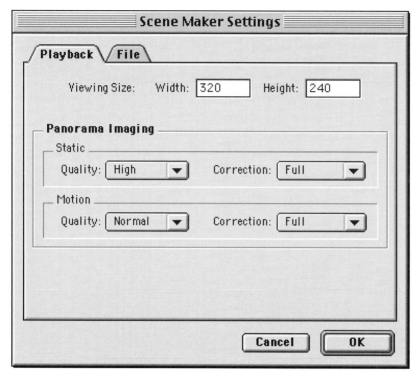

Figure 6.68 The "Scene Maker Settings" window.

13. If you want to change the starting node for the scene, click on the node you wish and select "Scene/Set Start Node" from the menu bar. Click the "Make Scene" button in the upper right-hand corner of the "Scene Maker" window. QTVRAS will proceed to compile all nodes and hot spots into a single QuickTime VR movie.

Be sure to go through the various hot spots in the movie to make sure that all is correct; if the hot spots do not function properly, go back to the "Scene Maker" window and make the appropriate changes and make the scene over again. Congratulations, you have made a multinode QTVR scene!

QTVR movies like this can be put on a hard disk, CD, or on the Web if you like—just be sure to export the scene as a QuickTime movie or go to the file and change the extension from ".scene" to ".mov."

Repositioning and Resizing QTVR Tracks

As a final note, it is possible to reposition and resize a QTVR video track, as discussed in Chapter 4, the same way it is done with linear movies. Before you can do this, however, you must temporarily change the QTVR controller to a standard movie controller, make your changes, and then change it back to the QTVR controller:

1. Open the QTVR movie and select "Movie/Get Movie Properties."
2. Select "Controller" from the right pull-down menu (Figure 6.69).
3. In the "Controller" properties, select "Movie Controller" rather than "QTVR Movie Controller" (Figure 6.70).
4. Close the "Movie Properties" box; notice the linear movie controller in place of the QTVR controller.
5. Select "Movie/Movie Properties" again and select an appropriate track—in this case, "VR Panorama Track"—from the left-hand pull-down menu (Figure 6.71).
6. Now go to the right pull-down menu and scroll down to "Size." Use the resize and position controls as described in Chapter 4.

Figure 6.69 In "Movie Properties," select "Controller" from the right pull-down menu.

Figure 6.70 In the "Controller" properties, select "Movie Controller" rather than "QTVR Movie Controller."

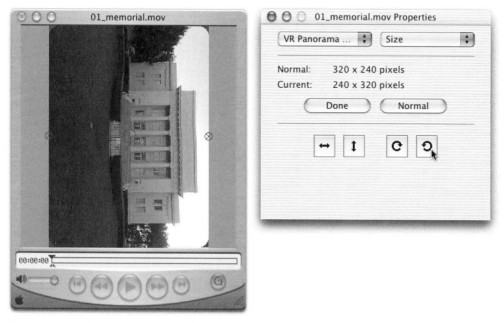

Figure 6.71 Now go to the right pull-down menu and scroll down to "Size." You will see a number of controls to resize and position the QTVR frame.

7. Do any resizing or repositioning you wish, and change the left pull-down back to "Movie." Set the right pull-down once again to "Controller" and change the setting back to the original "QTVR Movie Controller" (do not use the QTVR 1.0 settings!). Now your QTVR movie can exhibit some unorthodox behavior (Figure 6.72). Note that in this case the panning controls will still move right and left, even though the QTVR pans up and down.

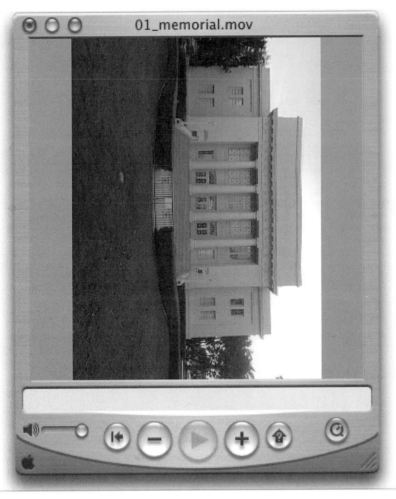

Figure 6.72 If you turn the QTVR frame on its side, note that planning controls will move right and left, even though the QTVR pans up and down.

7 Interactivity with QuickTime

"The interactive filmmaker's task becomes that of producing a set of film materials and plotting some pathways through it. The viewer then follows the pathways, deviating or continuing in a line as the mood takes him [or her]."

—**Grahame Weinbren**[7]

The act of viewing movies has traditionally been passive, and, in fact, many media players allow viewers only a passive experience. QuickTime, on the other hand, provides a number of capabilities that allow the user to interact with a movie. Some of the most notable interactive features and functions of QuickTime include:

- Slide shows
- Text tracks
- Flash tracks
- Media skins
- Wired sprites

A Basic Interactive Slide Show

One of the simplest projects to build with QuickTime is the slide show. This is a great way to present still images, a dynamic storyboard, or simply create a presentation. Before you dismiss the slide show as a boring series of dull images trotted out at family reunions, remember that one of the most influential and seminal science fiction movies, *La Jetee*, was, in fact, nothing more sophisticated than a slide show photographed and presented as a film.

First choose and compile your slides. You will want to save your images into any one of several compressed formats; JPEG, GIF, or PNG are good choices, but you can use just about any digital-image format that QuickTime understands. If you use Photoshop, be sure to compress your images into one of these formats, or QuickTime cannot use the images. Many presenters create slide shows using Microsoft PowerPoint these days, and you can import your slides using the method described next.

Digital cameras typically capture images in an aspect ratio of 4:3 (or 1:33 for film people), so when you resize your images, they should retain these proportions; 320 × 240 pixels is a good intermediate size, neither too big nor too small.

To export a slide show from PowerPoint

1. Open your slide show in PowerPoint and select "File/Save As." In the dialog box that appears, click on the "Options" button.
 a. Be sure that "Save PowerPoint Files As:" is set to "PowerPoint 98-X Presentation" for the widest compatibility.
 b. Under "Save slides as graphics files," make sure that "Save every slide (series of graphics files)" is selected.
 c. Select the advanced resolution you desire, generally 72 dots per inch (dpi) for Macintosh, 96 dpi for Windows.
 d. The default image size will be 720 × 540 pixels. You might want to change this depending on your mode of deployment.
 e. Depending on how you wish to deploy your slide show, you might also opt to compress the files by checking the appropriate box and selecting the setting from "least" to "best" quality.
 f. When you are finished selecting your options, click "OK."
2. Back in the previous box, choose your format. If your slide show has a lot of photographs and you are interested in quality images of the smallest possible size, you may want to choose JPEG; otherwise PNG is a less lossy way to go and yields better results with graphics.
3. Your slides will be saved in a separate folder with sequential numbering ready for import into QuickTime.

If you are not bringing your slides over from PowerPoint, be sure to name your image files with appropriate sequential numbers and place them all in the same folder or directory so that QuickTime will be able to arrange them in the proper order. Now it is time to create your QuickTime slide show.

Make a slide show with QuickTime Pro

1. Gather up your images for your slide show into one folder. If you wish, you may use the images in the "Ch07/Slide Show/images" folder of the CD.
2. Open QuickTime Pro, if it is not already.
3. Go to the menu bar and select "File/Open Image Sequence." If this option does not appear, you have not yet upgraded to QuickTime Pro.
4. Browse to your folder of images, find the first image file of your slide show, and click the "Open" button.
5. In the next dialog box that appears, choose the slide duration that suits you and your presentation best (Figure 7.1). In this case, select the "3 frames per second" option and click "OK."

In the next dialog box that appears, choose the slide duration that suits you.

6. A progress bar will appear as QuickTime automatically imports all the images in your folder into a QuickTime movie.

Figure 7.1 Making a slide show: Browse to your folder of images, find the first image file of your slide show, and click the "Open" button. In this case, select the "3 frames per second" option and click "OK."

7. Save your new slide show, making sure you check the "Make movie self-contained" option.

8. When you tap the right arrow key, you can move forward through your slide sequence, while doing the same with the left arrow key will take you back through the slides.

9. You can present this slide show without the player by going to "Movie/Present Movie," or "Movie/Full Screen" (Figure 7.2). In this mode, your show will play automatically in the center of the screen surrounded by a black border. You can still navigate through the slide sequence by using your arrow keys. You can stop the show entirely and return to the desktop by hitting the "Escape" key.

Figure 7.2 You can present a QuickTime movie without the player by selecting "Movie/Present Movie," or "Movie/Full Screen."

Adding a soundtrack to your slide show

Now that you have created your image sequence, you may want to add some kind of soundtrack, either music, narration, or both. Go to "Ch07" in the CD, and open the QuickTime movie titled "Cogan_ragtime.mp4" for your soundtrack.

1. With your slide show from the previous tutorial open, (if you saved and closed your slide show in the meantime, open it up again), go to "Movie/Get Movie Properties," and in the "Movie Properties" dialog box, pull down the right-hand menu and select "Time" (Figure 7.3). Check the duration of your movie; the previous slide show included 8 slides at 3 seconds each for a total time of about 24 seconds.

2. The "Cogan_ragtime" piece is approximately 24 seconds in length; in any case, the soundtrack you use should be the same length as your video movie. If you like, you may use another suitable audio track of music, voiceover, or mixed track in MP3, AIFF, WAV, AAC, MP4, or other compatible format and open it in QuickTime.

Figure 7.3 Adding a soundtrack: Go to "Movie/Get Movie Properties," and in the "Movie Properties" dialog box, pull down the right-hand menu and select "Time." Check the duration of your movie; a slide show already mentioned included 8 slides at 3 seconds each for a total time of 24 seconds.

3. In the QuickTime audio file, go to "Edit/Select All," and "Edit/Copy" (or simply hit the "Control" and "A" keys, and then "Control + C") to copy the sound file into your computer memory to add to the slide show.

4. Go to your slide show, and in this case select "Edit/Add Scaled." This will add the stretch or compress the track to fit the existing video movie, so it may change the pitch and key of the musical piece! If you do not want to change the soundtrack in this way, select "Edit/Add."

5. Choose "File/Save" from the menu and save the slide show with the soundtrack. To view your slide show with soundtrack, simply press the play button in the QuickTime Player.

Creating a basic text track movie

During the last few years, a revolution in software design has given us user-friendly and inexpensive applications such as Textation (www.feelorium.com, $23) that greatly simplify the making of text tracks. Nonetheless, it is a relatively simple task to use a basic text editing application to write and edit your text content and edit it using QuickTime Pro:

1. With TextEdit or SimpleText for the Mac, or Notepad or WordPad on Windows, simply write a list of text descriptions for the chapter places in your movie; as you compile your list, be sure to separate each entry by hitting the "return" or "enter" key after each. If you would like to compile some lines of text to use in the slide show we just completed, type the following:

    ```
    A colorful pub on Inishmore.
    A dog crosses a lonely road.
    This way to Ballyconnelly.
    A stone building along the way.
    A dramatic Aran sea vista.
    An Irish cyclist safari.
    Reflecting on a pool in Mayo.
    A donkey by the road in Connemara.
    ```

 If you are using TextEdit, be sure to choose "Format/Make Plain Text" or Quick-Time will not be able to open the resulting rich text format (.rtf) file. You can also use Microsoft Word to create the document, but be sure to name and save the file as a .txt document.

2. Now import that text file into QuickTime using the "File" menu command. In the "Save converted file as:" dialog box, click on the "Save" button to save the file. The file will automatically be saved as a QuickTime movie file.

If you are using Windows or Mac OS 9, you have access to the "Options" dialog box, where you may specify fonts, point size, and align in their respective pop-up menus and "Style" options to set text properties. To specify a text or background color, click the boxes marked "Text Color" and/or "Background Color," then select an appropriate hue from the "Color Picker" dialog box that appears (Figure 7.4). Make any changes you wish and enter a file name in the "Convert" dialog window, hit "OK," and QuickTime will create a text movie from your text file, formatting each line of text in separate, 2-second movie segments (Figure 7.5).

Note: If you are using Mac OS X, you may be surprised to find neither an "Options" box nor a "Convert" dialog box! See sidebar on "Mac Users Take Note: Changing Type Criteria in Existing Text Tracks" for information on changing type characteristics in QuickTime text tracks.

Figure 7.4 To specify a text or background color, click the boxes marked "Text Color" and/or "Background Color," then select an appropriate hue from the "Color Picker" dialog box that appears.

Figure 7.5 QuickTime will create a text movie from your text file, formatting each line of text in separate, 2-second movie segments.

Mac OS X Users Take Note: Changing Type Criteria in Existing Text Tracks

If you use Mac OS X, you may have found that methods described in this chapter to change type styles and point sizes do not apply (where is that "Convert" button, anyway?). You will need to change these criteria by changing the text once it is already in the text track. To replace existing text:

1. Select a section of your QuickTime movie containing the text you want to change.
2. Create or change the style or point-size type you wish to replace the movie's existing type. Here you need to use a text editor that will support drag and drop—TextEdit for OS X, or SimpleText for OS 9—Microsoft Word will not support drag-and-drop text!
3. Select "Movie/Get Movie Properties" to bring up the "Movie Properties" box.

4. From the left-hand pull-down menu, choose "Text Track." In the right-hand pull-down, choose "Text Replace."

5. If you are aiming to replace text content, select and drag the replacement text from the word processor application to the phrase "Drag Text Here" in the "Movie Info" window (Figure 7.6). If you wish to change the font, style, or point size of the type in the movie, drag and drop from a type selection of your desired font, size, or style onto the phrase in the box reading "Drop Style Here." In either case, a border appears framing the words when your pointer moves over the phrase. The selected text in your movie will then change to the text you just dropped in.

Figure 7.6 If you are aiming to replace text content, select and drag the replacement text from the word processor application to the phrase "Drag Text Here" in the "Movie Info" window.

3. To make further modifications, let's go to the menu bar, select "File/Export" and create a text descriptor file for your text track.

4. Select the "Text to Text" option in the "Export" pull-down menu at the bottom of the "Export" dialog.

5. In the "Use" pull-down, select the "Text with Descriptors" option that is now active.

6. If you click on the "Options" button, a box will appear showing more choices. Make sure the "Show Text, Descriptors, and Time" radio button is selected, along with the "Movie" radio button under the heading "show time relative to start of:". In the "Show fractions of seconds as 1/ . . .", choose $\frac{1}{30}$, as this is the default frame rate of video. This facilitates syncing your text to any video. Click "OK" to return to the previous box.

7. Click "OK," choose a name for your text descriptor file and save. QuickTime creates one video frame for each paragraph of text.

8. Double-click on your text file and you will see lots of new code beginning with the tag "{QT text}" followed by instructions for font, size, text color, and other information. Notice also the running times in brackets following each line of text. Each running time refers to the preceding line of text. You can edit this code easily; for instance, if you wanted to change the running time of each line, you could do so by changing the seconds in the time information in each set of brackets. If you add a running time of a specific length after all the text and times, you can specify a length of time wherein no text will appear at all.

More about text descriptors

You have seen a little about how text descriptors can help create dynamic text tracks. Let's go into a bit more depth:

QuickTime text descriptor code shares some similarities with the hypertext markup language (HTML) used in constructing Web pages, with curly brackets in place of angle brackets. A text descriptor is a command that defines the format of the text immediately following it. Saving text with text descriptors included lets you edit text from a text track along with its formatting in a word processing or text editing program. When you import text with text descriptor defined, formatting is preserved. This allows localization, or the preparation of movies for different languages, spelling differences, and other differences in style.

Descriptor syntax

Text descriptors are enclosed in curved braces (`{and}`) and set the format of the text that follows them. Similar to HTML tags, some are simple one-word commands having no parameters (`{bold}`) whereas others are multiword commands having one or more parameters. This type of descriptor is followed by a colon, its parameters separated by commas: (`{font:Verdana}`). You can change the format of text easily when you are working in your text editor by simply inserting a new text descriptor. You can, for example, change normal text `{plain}`, by substituting a descriptor for a different style `{italics}` and this will override the former descriptor designation.

Text track documents always begin with a tag that tells the QuickTime Player that what follows is QuickTime text `{QTtext}`.

The brackets contain information signifying text properties: Tags are placed for `{font}` and style—whether plain, italic, or bold—`{plain}`.

Be sure your last line of your file contains a time stamp and a carriage return for the end of the movie.

It is best to stick to fonts featured commonly in both Windows and Macintosh computers, such as Times New Roman, Ariel, Verdana, and the like.

Text color `{textColor}` is specified according to hexidecimal code.

By default, background color `{backColor}` is black unless you specify "Keyed Text," giving you type over a transparent background.

The time stamp tag `{timeStamps:absolute}` refers to the fact that time is specified from the movie's start. Another option is to specify relative time, meaning the duration since the last time specified.

The Most Commonly Used Text Descriptors

You can choose from the following text descriptors when editing your text track documents. QuickTime code is not case sensitive, but capitalization is used in the following examples to help you see the component words in the descriptor and you will want to be sure not to include spaces inside the text descriptors; the spaces that appear in the following examples are for illustrative purposes to describe what type of parameters are used here.

`{QTtext}`

This tag is required at the beginning of any text track document to tell Quick-Time that there are descriptors and time stamps. If this is omitted, the document will be interpreted as being simply normal text.

`{font: fontname}`

Designates what font to use for the text.

`{fontstyle}`

A one-word tag that specifies the style of the text that follows, of which there are eight:

`{plain}` = ordinary text
`{bold}` = bold text

Continued

{italic} = text in italics
{underline} = underlined text
{shadow}= text with a drop shadow
{outline} = outlined text
{condense} = text with narrow spacing between characters
{extend} = text with wide spacing between characters

{justify: alignment}

This tag specifies what margin the text will align flush to, whether justified to the left, the right, center, or default.

{justify:left} = text will align flush to the left margin
{justify:right} = text will align flush to the right margin
{justify:center} = text will be centered
{justify:default} = text will align to whatever script system is set

{size: pointsize}

Sets the point size of the text (1 point is equal to $\frac{1}{72}$nd of an inch), as in {size:12}.

{textColor: redvalue, greenvalue, bluevalue}

This tag defines the color of the text. These numerical red, green, and blue designations are RGB color values and must always proceed in this order: red, green, blue, separated by a comma. An example of red text would be {textColor: 65535, 0, 0}. Spaces before the color values are allowed but not required.

{backColor: redvalue, greenvalue, bluevalue}

Defines the background color upon which text appears.

{height: textrackHeightInPixels}

Sets the height of the text according to pixels, for example, {height:36}. A setting of "0" will automatically optimize the height of the text to best fit the content.

```
{width: texttrackWidthInPixels}
```

Functions much like the height descriptor in regard to width. A setting of "0" will set the width to either 240 or to the actual width of the movie it is imported into.

```
{language: languageNumber}
```

This parameter will define a specific language to be used. A designated number must be specified for the language rather than an actual name. The tag {language:11} sets language parameters for Japanese.

```
{timeStamps: relativeOrAbsolute)
```

Specifies if time stamps are based according to preceding time stamps {timeStamps:relative} or are defined relatively to the start of the movie {timeStamps:absolute}.

```
{timescale: numberPerSecond}
```

This tag designates what fractional increments are used when splitting seconds into smaller identical units of time. Video in the United States (NTSC) generally has a frame rate of 30 fps, video elsewhere at 25 fps, and film is traditionally projected at 24 fps. Video producers working in NTSC standard might well use a time scale of 30, and because this is also the default time scale of QuickTime Player, you would likely want to use this as well. Thus, the number of digits in the second fraction value of a time stamp is determined by the time scale.

You may find many more text descriptor tags and their definitions at Apple's Web site at www.apple.com/quicktime/tools_tips/tutorials/textdescriptors.html.

TIME STAMPS

When you export text with descriptors from a text track, you will also get a time stamp with each line of text separated by a carriage return. The time stamp denotes the starting and ending time of each line, or sample, either relative to the start of the movie (the tag would be {kMovieExportAbsoluteTime}) or to the end point of the previous sample (the tag would be: {kMovieExportRelativeTime}). When text is imported the time stamps keep the timing of the text samples relative to the video, audio, and other media of the movie.

Time stamps use the following format:

HH:MM:SS.xxx

HH refers to hours, MM stands for minutes, SS represents seconds, and xxx refers to the mantissa, or fractions of seconds. The mantissa may vary according to the time scale of the text track. The default time scale is 600; that is, seconds are broken down into $\frac{1}{600}$ths, but you may specify the time scale up to a maximum of 10,000. The mantissa is often denoted as 30, as video typically has a time base of 30 fps.

Subtitling your movie with QuickTime

It is easy to use text tracks to subtitle a movie such as if you want to add text along the bottom of your movie, add extra information such as a phone number or name, or make your content understandable in another language.

Follow the steps previously outlined in "Creating a Basic Text Track Movie." (You will want to put carriage returns to mark each frame of subtitle.)

Open your text document in QuickTime, choose "Import," and locate and select the text file you made; click the "Convert" button.

You can change the look of your text by clicking on the "Options" button and setting the font, text size, text color, text style, and background color you desire.

1. It is a good practice to check the "Auto-Size" option to ensure that the text track will not take up too much space on the movie screen; in this case, however, we will "Set Width to: 300 Pixels" and "Set Height to: 48 pixels" because our movie has a screen width of 320 pixels.

2. Save the converted text file as a QuickTime movie.

3. You should see a new movie appear containing your new text track, centered, with the type specifications you set earlier. Each line of text by default will appear in a frame with a duration of 2 seconds.

4. Next you need to sync up your subtitles so that they appear in proper relation to your content. To change the default time settings, export the text with the default time code so you can edit the text directly. Go to the "File" menu and choose "Export."

5. In the "Save" dialog box that appears, find the "Export" pull-down menu and choose "Text to Text." In the "Use" pull-down menu, make sure the setting is "Use Default Settings" (Figure 7.7).

6. Before saving, select "Options" to be sure the exported text file includes the time stamps you need to edit. In the dialog box that appears as "Text Export Settings," select "Show Text, Descriptors, and Time" and in the box next to "Show fractions of seconds as 1/," type in "30" for $\frac{1}{30}$ second (Figure 7.8). Click "OK."

7. Click "Save" to save your exported text file.

8. Now open your QuickTime movie and move it to one side of your computer screen. Open the newly exported text file in your favorite text editor and drag the text window to the opposite side of your screen (Figure 7.9). You need to keep both open to reset the time stamps. Your exported text should look similar to the following:

Figure 7.7 In the "Save" dialog box that appears, find the "Export" pull-down menu and choose "Text to Text." In the "Use" pull-down menu, make sure the setting is "Use Default Settings."

Figure 7.8 In the dialog box that appears as "Text Export Settings," select "Show Text, Descriptors, and Time" and in the box next to "Show fractions of seconds as 1/," type in "30" for $\frac{1}{30}$ second. Click "OK."

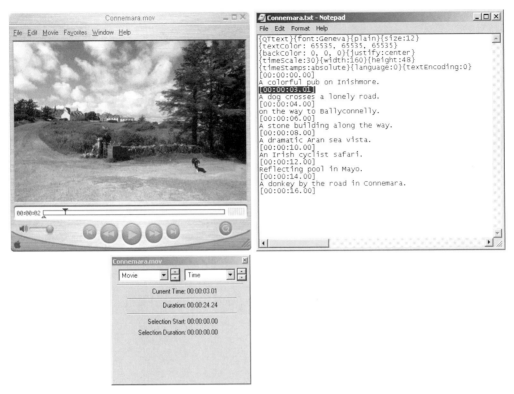

Figure 7.9 Open your QuickTime movie and move it to one side of your computer screen. Open the newly exported text file in your favorite text editor and drag the text window to the opposite side of your screen.

```
{QTtext}{font:Stone Sans ITC TT-Semi}{bold}{size:18}{textColor:
65535, 65535, 65535}{backColor: 0, 0,
0}{justify:center}{timeScale:30}{width:160}{height:69}{timeStamp
s:absolute}{language:0}{textEncoding:0}
[00:00:00.00]
A colorful pub on Inishmore.
[00:00:02.00]
A dog crosses a lonely road.
[00:00:04.00]
This way to Ballyconnelly.
[00:00:06.00]
A stone building along the way.
[00:00:08.00]
A dramatic Aran sea vista.
[00:00:10.00]
An Irish cyclist safari.
[00:00:12.00]
Reflecting on a pond in Mayo.
[00:00:14.00]
A donkey by the road in Connemara.
[00:00:16.00]
```

9. With the exported text and movie files open, go to the QuickTime menu bar, to "Movie/Get Movie Properties."

10. In the "Movie Properties" window, go to the right pull-down window and scroll to "Time."

11. A box with four lines of numbers will appear. The first line, "Current Time," provides the info you will need. Keep this box open and drag it to a place on your screen just under your movie.

12. Play or scrub through your movie to each place where you want a subtitle to appear. When you have the first place cued, take note of the time in the "Current Time" line.

13. Type the time that appears in the "Current Time" line into the text file you have open on the right side of your screen. The time for each line of text appears above the text. For example, if you want the line "A dog crosses a lonely road" to appear at 00.00.3.01, you must change the current time stamp (appearing just above "A dog crosses . . .") to reflect this (Figure 7.9).

14. Repeat these steps until you have finished entering all of the new time information into the time stamps. If you are following along with the slide show we made earlier, remember that each slide is held for a duration of 3 seconds; this should simplify setting the time stamps (which will logically occur at 3-second intervals).

Note for dialog movies: Be sure to enter in blank spaces in instances of no dialog. For example, enter in a time stamp where you wish the text to end and hit "Return." Thus, the next line of dialog will appear only in the next specified time.

Adding hypertext to your text tracks

Let's add a clickable link to your subtitles. QuickTime allows the ability to convert text tracks to hypertext reference (HREF) text to link to other Web pages and call them up as the movie plays. When you include such tracks in your movie, you can make Web pages load on demand or at predetermined times when the movie plays. To add hypertext links:

- Go to your text file (open in your text editor) and immediately before any text you wish to convert to HREF, type `{HREF:"http://theURLyouwishto linkto.com"}`. (Be sure to write the proper and exact URL of the site you want to link to in place of "theURLyouwishtolinkto.com").

- At the point where you want the link to end, type `{endHREF}`. Your descriptors might look something like this: `{HREF:http://www.connemara.org}` `Connemara Web Site{endHREF}`

- Be sure to type in your URL immediately after the colon; do not add a space or enclose your URL in quotes.

- You can also target an existing browser frame or window, a new browser window, QuickTime Player, or the QuickTime plug-in by adding a T⟨target⟩ parameter like this: Click `{HREF:http://www.apple.com/T<frame1>}here {endHREF}`. Thus if a target is specified, it is separated from the URL by a space and takes the form T⟨target⟩preceded by an uppercase "T" in angle brackets.
- Save your text file, and import into a new QuickTime Player; you now have a text track in movie format with a hypertext link.

At this point your text should look like this:

```
{QTtext}{font:Stone Sans ITC TT-Semi}{bold}{size:18}{anti-
alias:off}{textColor: 65535, 65535, 65535}{backColor: 0, 0,
0}{justify:center}{timeScale:30}{width:300}{height:48}{timeStamps:absol
ute}{language:0}{textEncoding:0}
[00:00:00.00]
A colorful pub on Inishmore.
[00:00:03.01]
A dog crosses a lonely road.
[00:00:06.00]
This way to Ballyconnelly.
[00:00:09.00]
A stone building along the way.
[00:00:12.00]
A dramatic Aran sea vista.
[00:00:15.00]
An Irish cyclist safari.
[00:00:18.00]
Reflecting on a pool in Mayo.
[00:00:21.00]
A donkey by the road in {HREF://www.connemara.org}Connemara.{endHREF}
[00:00:24.00]
```

BURNING IN YOUR TEXT OVER THE PICTURE

We can add the text track as is to our movie, but the text will appear in a black box. To make the black background of the text invisible and burn in your subtitles, you need to add the following text descriptor to the header of your text document before importing it into QuickTime: `{keyedText:on}`. Your header should now look like this:

```
{QTtext}{font:Stone Sans ITC TT-Semi}{bold}{size:18}{anti-alias:off}
{keyedText:on}{textColor: 65535, 65535, 65535}{backColor: 0, 0,
0}{justify:center}{timeScale:30}{width:300}{height:48}{timeStamps:absol
ute}{language:0}{textEncoding:0}
```

If you are using Windows or Mac OS 9, you can check the keyed graphics box in the "Options" dialog box when you initially import your text into QuickTime; unfortunately, this is not an option for those using Mac OS X.

Integrating your text into your movie

1. Open both your text track movie and the movie you wish to subtitle, if they are not open from the previous tutorial.

2. Working first with the text track movie, go to "Edit/Select All" to select the entire length of the movie, and "Copy."

3. Go to your video/audio movie, and from the "Edit" menu, select "All."

4. Hold down the "Alt/Option" and "Shift" keys, then click on the "Edit" menu and scroll down to "Add Scaled." The text should not be integrated into your movie.

5. Our main problem now is the position of the subtitles, which, in this case, are supertitles—meaning that they appear at the top of the QuickTime Player's screen.

6. To reposition the titles at the bottom of the player, go the "Movie" menu and select "Get Movie Properties."

7. On the pull-down menu on the left, scroll down to "Text Track 1" (or whatever number it is). From the right pull-down menu, choose "Size."

8. After selecting both the text track and size option, click on "Adjust."

9. Now it is time to move the subtitles. Click anywhere in the black selection area and drag the selection down as you hold down the mouse button. Be careful not to grab one of the red "handles" or else you stretch your text and distort it.

10. A clear box will appear as your mouse moves down the screen. Once you let up on the mouse button, the movie will reload with the subtitles in the position you placed them. You can move them farther if you like (Figure 7.10).

11. A clear box will appear as your mouse moves down the screen. Once you let up on the mouse button, the movie will reload with the subtitles in the position you placed them. You can move them farther if you like.

Figure 7.10 To reposition a title to the bottom of the frame, go to "Menu Bar/Movie/Get Movie" properties and select "Size" from the right pull-down menu.

12. Go to the "File" menu, choose "Save As," and be sure to save your movie as self-contained so it will play in any environment.

You are now finished creating subtitles for your movie.

Scrolling text

Scrolling text is a great way to take advantage of text tracks to roll credits or other text in QuickTime, especially because your original movie title crawl may very well be part of a QuickTime movie. And they are easy to make:

Write and export your text document. In the heading data, type in the tag `{scrollin:on}`. This will scroll the words of your text on screen, where they will roll until stopping at the last line of text. You can set the duration of the scroll by lengthening or shortening the seconds and fractions of seconds in the appropriate time stamps (remember, each line of text will appear for the length designated in the time stamp immediately following the line). You can delay the start of the scroll by inserting the following tag: `{scrolldelay: theTimeIntervalYouChooseInFractionsOfSeconds}`; for example, if you want the text to start rolling 2 seconds into the movie, you would write `{scrolldelay:60}`, inserting it in the heading code. You can make the text appear in the frame and then scroll off by replacing the "scrollin" tag with this one: `{scrollout: on}`. Now the text will scroll out until the last words of text are out of view. If both "scrollin" and "scrollout" are set, the text will scroll in, and then out.

You can get a ticker-tape effect as seen on news broadcasts with the `{horizontalScroll: on}`; this will scroll a single line of text horizontally. If the horizontalScroll flag is not set, then the scrolling will be vertical. And finally, if you fancy a reverse scroll effect like the goofy title sequence from the movie *Kiss Me Deadly*, use the `{reverseScroll: on}` and your text will scroll vertically down rather than up.

Applescripts (for Mac users)

There are many benefits that come with using Windows—more applications, more variety of hardware, and more fellow PC users. But Mac users are the beneficiaries of a useful set of tools available free for the downloading: Applescripts. Applescripts let you streamline and automate actions and steps without writing a single line of code. You can download Applescripts for QuickTime at www.apple.com/applescript/quicktime. Here's one of the many things you can do with them—create rolling text:

1. Download the Applescripts for QuickTime from the URL just mentioned if you do not already have them.
2. Open the QuickTime movie wherein you want to add a rolling title sequence.
3. Look for the folder on your desktop (or wherever your downloaded files are stored) labeled "QuickTime 5.0.2 Scripts," open it and go to the "Text Tracks" folder and double-click on the file labeled "Rolling Credits for Front Movie" (Figure 7.11).

Figure 7.11 Go to the "Text Tracks" folder and double-click on the file labeled "Rolling Credits for Front Movie."

4. The "Script Editor" window will appear showing the Applescript itself (Figure 7.12). The good news is that you do not have to understand a thing about how this works in order to use it.

5. Now click on the "Run" button. A small dialog box appears; click "Set Prefs" to choose the font style and point size and type in your title, personnel, and copyright info. When you have completed these steps, click on "Done."

6. Applescript will create a new movie file with the title crawl. If this meets your approval, select "All" and copy the text movie.

7. Go to your open movie, move the pointer to the start of the movie, and select "Paste."

8. In order to trim your credit to your desired length, choose "Option/Edit/Trim" and copy and paste the title sequence into your movie.

```
property default_font : "Geneva"
property default_size : "18"

property title_font : "Times"
property title_size : "24"

property credits_font : "Geneva"
property credits_size : "18"

property copyright_font : "Geneva"
property copyright_size : "14"

property master_copyright : "©2000
My Company
www.my_company.com"

property default_copyright : ""

tell application "QuickTime Player"
    activate
    if not (exists movie 1) then return
    stop every movie

    repeat
        display dialog "Rolling Credits for Front Movie 1.0" & ¬
            return & return & ¬
            "Title Font: " & title_font & return & ¬
            "Title Size: " & title_size & return & ¬
            return & ¬
            "Credits Font: " & credits_font & return & ¬
            "Credits Size: " & credits_size & return & ¬
            return & ¬
            "Copyright Font: " & copyright_font & return & ¬
            "Copyright Size: " & copyright_size buttons {"Cancel", "Set Prefs", "Continue"} default button 3
        if the button returned of the result is "Continue" then
            exit repeat
        else
            set the passed_message to ¬
                "Enter the name of the typeface to use for the title:"
            set the title_font to ¬
                my prompt_for_font(passed_message, title_font)
            set the passed_message to ¬
                " for the title size:"
            set the title_size to ¬
                my prompt_for_size(passed_message, title_size)

            set the passed_message to ¬
                "Enter the name of the typeface to use for the credits:"
            set the credits_font to ¬
                my prompt_for_font(passed_message, credits_font)
            set the passed_message to ¬
                " for the credits size:"
            set the credits_size to ¬
                my prompt_for_size(passed_message, credits_size)
```

Figure 7.12 The Applescript "Script Editor."

Chapter tracks in QuickTime movies

A chapter track is a text track that displays chapter titles next to the scroll bar in the Player (Figure 7.13). When chapter tracks are implemented, the QuickTime movie controller automatically makes room along its right side for a pop-up menu containing titles referring to the different parts of the movie. More importantly, chapter tracks allow random access to predetermined segments of a movie.

1. Start with a basic text track (see "Creating a Basic Text Track Movie"), with each line of text a chapter name for your movie.
2. After exporting the text descriptor file, open it up in your word processing application and change the time stamps to mark the starting place of each chapter. Save your work.
3. Now go to QuickTime and import the edited text file (with the newly changed time stamps) into a new Player.
4. Select "All" and copy the entire movie.

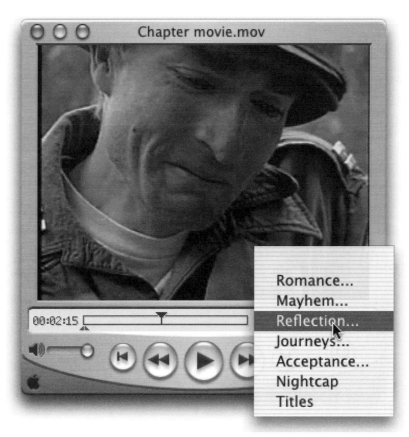

Figure 7.13 A chapter track is a text track that displays chapter titles next to the scroll bar in the Player.

5. Open the QuickTime movie where you want to add chapters and select the entire movie.

6. Hold down "Alt/Option" and "Shift" keys and choose "Edit/Add Scaled" from the menu bar.

7. Close the QuickTime movie with the text track only.

8. In the left pull-down menu, choose the text.

9. Click anywhere in the QuickTime movie you are adding chapters to, and go to "Movie/Get Movie Properties" in the menu bar.

10. In the left pull-down menu, select the text track you added, and go to the right pull-down and select "Set as Chapter Track." Now, click "Set Chapter Owner Track" to link your chapter track with another track in the movie.

11. In the "Select Owner Track" dialog box that appears, choose any track from your movie.

12. Click "OK" to list the track you just selected in the "Set as Chapter Track" panel. In the Player window, chapters should appear in the control bar to the right of the time slider.

13. Note: If you need to adjust for the controller to change the width of your movie, go to "Movie/Get Movie Properties," choose the "Chapter track" from the left pull-down menu, and then choose "Size" from the right pull-down menu. Click on a handle in the lower-right red area and slide it a bit to the right. You should now see the chapter titles appear in the controller bar window. Now position the text track back to its original size.

14. Because you are making a chapter track that will appear in the controller, you will want to disable the text track so that it does not appear in the movie area. Go to "Edit/Enable Tracks" in the menu bar.

15. A box appears showing all the movie's tracks. Next to each track is an "On/Off" switch. To disable a track, simply click that button to "off." This ensures that the chapter will only appear in the control bar where it belongs.

16. Click "OK" and save your movie. Users will be able to skip ahead to each chapter that you have set.

Making Custom Media Skins

The user-customized, movie-specific media skin is one of the many reasons why Quick-Time is so appealing to the filmmaker. Users of MP3 music and media players have enjoyed the ability to swap out the standard interface design or "skin" of their players with any one of a plethora of custom movie skins usually provided by the software supplier or third-party providers. The Windows Media Player boasted this capability to accommodate different interface designs long before the same was possible with QuickTime. The arrival of QuickTime 5 brought something even better: the option of creating custom media skins to your movies to include your own branding and logos. No other streaming or video play-back application lets you create your own media skins the way QuickTime does.

Putting a media skin on your movie lets you control the overall presentation when that movie is viewed by anyone, whether they access it over the Internet or open it as a file from a CD or other medium. Whereas other media players let users put a skin on their own player alone, QuickTime provides media creators the tool to control the appearance of the player themselves with a skin that is part and parcel of the movie. The custom player window can be any shape or size and created in any of the file formats supported by QuickTime. The only real limitation is the requirement that the user use QuickTime 5 or better.

There is more than one way to skin your movie. One method is to use QuickTime Pro, with a text editor and a graphics program such as Photoshop. If you use a Mac, you also have the option of using Applescripts to streamline the process. The welcome arrival of simple, inexpensive applications such as Tattoo and QTI now allow quick-and-easy movie skins for the technically disinclined. If you really want to ramp up, you may use a powerful application such as TotallyHip's LiveStage Pro (LSP) or Adobe GoLive to create skins with custom controllers, wired sprites, and other goodies.

Whichever method you choose, you do need to have certain necessary applications to make your media skin. If you are making your skin with QuickTime Pro, you will need a text editor such as TextEdit (Mac OS X), SimpleText (Mac OS 9 and before), or NotePad (Windows). If you used a sophisticated word processor such as Microsoft Word, you need to save your documents without formatting (save as raw text). The second application you will need is a graphics editing program such as Adobe Photoshop. And finally, you will need a program to assemble the elements as a QuickTime movie: QuickTime Pro, Adobe GoLive, LSP, eZedia QTI, or Feelorium's Tattoo.

Instant Media Skins with Tattoo

In the spring of 2002, the software company Feelorium released a small application specifically designed for creating QuickTime media skins. Creating a skin with this application, called Tattoo, has never been easier. A demonstration version of Tattoo may be downloaded over the World Wide Web at www.feelorium.com and can be registered for full functionality for only $23. The elements for the following tutorial may be found on the accompanying CD. Now, let's make a skin:

1. Open Tattoo (see previous paragraph for downloading URL), and you will see the main window along with an "Info" box that lets you make adjustments to the skin, movie, or button you are working with. Unlike other applications for creating interactive QuickTime movies, Tattoo has a refreshingly simple, straightforward interface (Figure 7.14).

2. Click on the button labeled "Set Skin." In the box that appears, navigate to the CD folder labeled "Ch07." Within this folder, open the folder labeled "Tattoo_Skins" and double-click on the file labeled "curtains.png." The graphic will appear in the "Tattoo" window. (You can also simply drag the file into the

Figure 7.14 The Tattoo interface is simple and easy to navigate.

window if you prefer instead of clicking the "Set Skin" button and navigating to the file.)

3. The graphic may appear to be too large for the window; if so, click and drag the lower right-hand corner to expand the window for easy visibility.

4. Click and hold on the black rectangle in the window labeled "Movie" and drag it to position it where you like it. You can also drag a corner of this to enlarge the rectangle. This is the frame where your movie will appear, so you may want to hold the "Shift" key if you resize it so that it will retain its proper aspect ratio. You can also input this information numerically in the "Left," "Top," "Width," and "Height" fill-in boxes in the "Movie Info" window that appears alongside the "Tattoo" window. Because the movie we are going to skin is in 1.85 aspect ratio, we will drag it to a wide-screen format (Figure 7.15).

5. In the "Movie Info" window that appears alongside the "Tattoo" window, you can set these parameters as well:
 - The "Normal Size" button restores the movie frame to its default size.
 - The "Display Frame" slider lets you select the exact frame where you like your movie to begin. Check the "Auto Play" box if you want the movie to start playing when the user opens it.
 - Check the "Loop" box if you want your movie to repeat over and over until the user stops it.
 - Check the "Topmost Layer" button if you want your movie to be visible!

Figure 7.15 Position the "Movie" frame where you want your movie to appear. Because the movie we are going to skin is in 1.85 aspect ratio, we will drag it to a wide-screen format.

6. Click on the button labeled "Set Movie" located at the top of the "Movie Info" box; alternately you can also click on the middle button located at the top of the "Tattoo" window. Navigate to the "Tattoo_Skins" folder in "Ch07" of the CD and load the movie file "Showdown.mov."

Now that you have placed your movie in the skin, you will want to add some wired buttons to make the skin truly interactive (many QuickTime interactive commands such as "play" and "stop" can be activated via keyboard commands, but users often expect interactive buttons and may be confused when they do not appear in your movie skin).

7. Click on the third button from the top-left corner of the "Tattoo" window labeled "Add Button" and a generic blue button (actually a blue circle) will appear in the middle of the frame. Drag this circle over to the area where you want the button to appear; in this case, drag it to the black band at the bottom of the skin.

8. In the "Button Info" box, click on the "Set Image" button to navigate to the folder labeled "Ch07." Within this folder, open the folder labeled "Tattoo_Skins" and double-click on the file labeled "Play.png."

9. The "Play" button graphic will appear. You can adjust the size and position of this button by dragging or inputting numerical information into the "Left," "Top," "Width," and "Height" windows of the "Info" box.

10. In the "Button Info" window, change the "Cursor" pull-down to "Right Arrow." Now change the "Action" pull-down to "Play."

11. Follow these steps and add a "stop" button (use the "Stop.png" file in the "Tattoo_Skins" folder).

You can add buttons for lots of functions, as you can see in the "Action" pull-down. One button you will want to add is a "Close Window" box so that the user can dispense with the movie when he or she is finished with it:

12. Repeat steps 6 and 7 and load the "Close.png" graphic. Move the graphic to the upper right-hand corner of the skin.

13. In the "Button Info" window, change the "Cursor" pull-down to "Pointing Hand." Now change the "Action" pull-down to "Close Window."

You can make more button graphics and add them to do things such as adjust audio volumes, go to end or beginning, go to a URL, and other functions. Along with setting the proper actions, you can also choose from a number of different cursors you can designate for each button.

14. When you are satisfied with your movie, click the "Export" button in the top right-hand corner to save your movie with your skin and wired buttons. Be sure to give your movie an appropriate name and choose a place where you wish to save it, and make sure that you check the button labeled "Make movie self-contained," and press "Save."

Making a Skin with QuickTime Pro

If you do not want to purchase Tattoo, QTI, or another application, you can still make a media skin using only QuickTime Pro. Start with the basic ingredients:

Movie. The movie you wish to "skin." This can be a video, slide show, QTVR movie, or even a simple audio track. We will call this "yourmovie.mov."

Graphic. Because QuickTime is not an application for creating content, you will need to find or create a graphic in a graphics editor such as Adobe Photoshop. I scanned an image from a clip-art book for my basic design, and then I modified it in Photoshop to my liking.

The Procedure

In your image editor, create and output three image files: the "Skin," "Window-Mask," and "DragMask." You should save these files as PICT (Mac) or TIFF (Windows). Next, arrange these components as layers, from top to bottom: (a) "DragMask," (b) "WinMask," and (c) "Video Window." You need to make a window in your skin graphic for the video to show through. This window can be the same size as the original video, or it may be smaller, in which case some of the video picture will be masked out. Keep in mind that you do not have to stick with the traditional rectangular frame; you can use circles, ellipses, trapezoids, or other irregular shapes if you wish.

The skin is the graphic image your media skin will display, with transparent areas in either black or white, and the area for your video in either back or white. In this case, a rectangular frame is set into the graphic. Take note that the dimensions of the skin are somewhat bigger than the video in order to have decorative graphic elements showing (Figure 7.16). Save this as "Skin.pct" or "Skin.tif."

The "WindowMask" is a kind of black stencil in the shape of the movie skin (Figure 7.17). The black shape is surrounded by white. Save this as "WindowMask.pct" or "WindowMask.tif."

The "DragMask" must be a solid black stencil with an appropriate-size white frame for your video picture, as well as similar holes for any buttons or interface you wish to use (Figure 7.18). You must leave holes for any controls or they will be masked and rendered nonfunctional! As with the "WindowMask," all the space surrounding the mask should be white. Save this as "DragMask.pct" or "DragMask.tif."

Figure 7.16 The media skin.

Continued

Figure 7.17 The "WindowMask" is a black stencil in the shape of the movie skin.

Figure 7.18 The "DragMask" should be an opaque black stencil with an appropriate-size white hole for your video frame.

Now we are ready for your QuickTime video movie, which we will call "yourmovie.mov." The following helps you create an image of your new media skin.

To combine the movie and the media skin:

1. Open both the media skin ("Skin.pct") and the video movie ("your-movie.mov") in QuickTime Pro.
2. Copy the media skin, and go over to "yourmovie.mov" and add the skin by selecting "Edit/Add Scaled." It is important to add this as scaled to apply it to all the frames of the movie; otherwise the skin will be added to one frame only.
3. Now go to "Movie/Get Movie Properties" ("Control/Command + J") to make your adjustments.

4. In the "Properties" window, select "Video Track 1" for your movie (your skin should be on "Video Track 2").

5. In the "Properties" window, select the "Layer" option. Adjust the "Layer" numbers to place the video either behind or in front of the skin. Remember: higher numbers are farther back while lower numbers are farther forward. If you decide to have the video play through transparent areas of the media skin, simply set the video track to the background (higher number), then modify the "Graphics Mode" to set the "Skin" track to "Transparent"; then set the transparent color (generally black or white). Now your video track will show through.

6. Save the movie as self-contained, and for now, let's call it "Skin_movie.mov."

Making the Masks

The skin, window mask, and drag mask are all included in the CD for this tutorial in the "Ch07," but if you wish to design your own media skin graphic in Photoshop, follow these steps to create your own window mask and drag masks:

Window Mask. Create a mask image identical in size and shape to your movie frame. This 1-bit (black-and-white) image defines the window for your movie. The image must be black where you want your window and white everywhere else. Save this as a BMP, GIF, PICT, or another format that QuickTime can open. We will call this file "WindowMask.pct."

Drag Mask. Make a second mask image in the size and shape of the frame—the parts where you want to be able to click your pointer drag the movie around the desktop. This is usually the same as the first mask, except with white areas through which text, video, and controls will appear. BE SURE YOU LEAVE CLEAR WHITE SPACES OR HOLES IN ANY AREA WHERE BUTTONS OR INTERACTIVE CONTROLS WILL APPEAR, OTHERWISE THEY WILL NOT FUNCTION PROPERLY. Save this also in a QuickTime-compatible format, in this case as "DragMask.pct."

Making the Text File

Open your text editor and write the following, making sure you preserve the proper syntax of the code:

```
<?xml version="1.0"?>
<?quicktime type="application-qtskin"?>
```

Continued

```
<skin>
<movie src="Enclosed.mov"/>
<contentregion src=WindowMask.pct"/>
<dragregion src="DragMask.pct"/>
</skin>
```

Now save this as a plain text file, including the ".mov" file extension in the same folder along with your other files. We will call this "XML.mov." This will appear as a movie icon rather than a text-file icon.

You will want to save a movie as a complete file. To do this, go to the menu bar and click "Save As" (rather than simply "Save"). You can rename this file, but be sure to check the option "Make movie self-contained." This will save all the components of the film so that it will play in any context, rather than just within the directory where the movie currently resides. You can now put your movie on a CD or link it to a Web page.

Wired Sprites

What are wired sprites? These are interactive elements that store samples displayed on the screen. Sprites can play sounds when the user clicks a mouse, they can jump to a different point in a movie, and they can control the playback or stop of a movie.

Think of the sprite as the actor on a stage, the stage being the boundaries of your movie frame. Like their living counterparts, sprites can perform in many different ways: they can make graphics dance around within the frame, they can change their appearance, or they can interact with the user. What's more, a sprite's properties can change within the context of the movie.

Sprite animation is an entirely different animal from standard time-based animation. Each sprite gets assigned an image that appears when it displays on the screen. Animation of this sprite occurs in real time; that is, all the data the movie contains is the image or images assigned to the sprite, along with instructions on when, where, and how that sprite will move or be directed on the user's screen. Because this type of animation is data-driven and not dependent on large files, it significantly decreases the file sizes of movies. This makes sprite animation ideal for Web distribution.

Sprites often find use in navigation interfaces in the form of buttons and other interactive features. Although QuickTime Pro does not facilitate the creation of sprite tracks, applications such as LSP and Adobe GoLive let you easily add wired sprites in the form of buttons to your media skins. Do not be daunted by the complexity of this application; the learning curve is akin to the initial incline of the Viper roller coaster at Six Flags Magic Mountain, but once you have scaled this slope, the fun really begins. Now let's create a custom-skinned interactive multinode QTVR movie with wired sprites using LSP 4.

Tutorial: Make a QuickTime VR Skinned Movie with Wired Buttons, Hot Spots, and Text

The QTVR scene we made in the Chapter 6 tutorial is a self-contained movie that you may play from a hard drive, CD, or Web page. Now let's take it a step farther and create a custom-skinned interactive QuickTime QTVR movie.

You will use LifeStage Pro for this tutorial, incorporating many of the QuickTime features you have been reading about up to this point. If you have not yet downloaded the LSP (at time of writing in Version 4) demo software, go to www.totallyhip.com and install the application.

When you have downloaded LiveStage, open the "Ch07/LiveStage_tutorials" folder on the CD and double-click on the QuickTime movie named "chapmantour.mov" to see the final version of the project you will create here. This project consists of a movie skin with a clickable map, QTVR movies, wired buttons, and text tracks. The assets you will find on the CD consist of graphics for buttons allowing zoom in, zoom out, pan and tilt, and hide/show hot spots. You will also work with some predefined actions to apply to sprites—also known as behaviors—that you will also find on the CD. LSP is a powerful packaging tool for interactive QuickTime, but you must create your content, including any QTVR, with another program. LSP 4.0 sports an important new feature known as FastTracks, allowing shortcuts to frequently used movie elements that eliminate the need for scripting. This innovation represents a quantum leap toward making LSP a much more user-friendly authoring tool than before, and the learning curve is not nearly as steep as before Version 4.0. Let's begin:

1. Go to the CD and drag the "LiveStage_tutorials" folder to your desktop or hard drive. Launch the LSP demo, and open a new project. You should see the "Timeline/Stage" window appear (Figure 7.19).

The "Movie Inspector"

2. Hit "Command/Control + I" (or select "Window/Show Inspector" from the menu bar) to bring up the "Movie Inspector" box (Figure 7.20). If the "Inspector" or "Library" does not appear, hit "Command/Control + I" or "Command/Control + Y" to reveal them.
 a. In the "Movie Inspector," type "myQTVRtour.mov" in the "File Name Field" text box.
 b. You can set the QuickTime version compatibility in the "Version" pull-down; although setting a lower number lets you reach users with older QuickTime versions, you must set this to QuickTime 5 or newer to allow the use of media skins—thus, set it to QuickTime 6.
 c. Make sure the "Controller" pull-down is set to "None" because we will make our own interactive controls.

Figure 7.19 The LiveStage Pro "Timeline/Stage" window.

 d. You will notice that the "Height" and "Width" of this movie are set to a default of 320 × 240; change these dimensions to 640 × 480 pixels.

 e. Click on the "Advanced Tab" of the inspector; you will notice that "Auto Start" has been checked; this will let the movie begin playing immediately when it opens (a feature more useful in linear movies than QTVR). If you want to discourage users from saving versions of the movie when they access it from the Internet, check the "Copy Protect" box. Leave all other settings as they are.

3. Save your project as "myQTVRtour.lsd" ("lsd" refers to "livestage document"), making sure you save it in the "LiveStage_tutorials" folder you copied to your computer. This will ensure that you can access the assets necessary to complete the project.

The "Library" window

4. Hit "Command/Control + Y" to bring up the "Library" window, which consists of three components, indicated by three tabs: "Media," "Local," and "Scripts"

Figure 7.20 The "Movie Inspector" box ("Basic" tab).

(Figure 7.21). The "Local" library contains all the assets you will need to complete this project—check to see that you have the following folders within the "Local" library:

- "Behaviors"—containing scripted actions you will apply to your sprites
- "Graphics"—containing necessary graphic assets such as skins to complete the project
- "The right buttons"—containing graphics for interactive controls

The "Local" library must reside within the same folder as your LSP project to access the necessary assets, or you will get error warnings as the application attempts to find the assets. The "Media" (also known as the "Global") library houses all the media that all projects

Figure 7.21 The "Library" window consists of three components, indicated by three tabs: "Media," "Local," and "Scripts."

created with LSP can use. The "Scripts" library can be accessed by every project you create in LSP. Within the "Scripts" library are folders for "Qscripts" and "Behaviors." Qscripts are special QuickTime scripts used exclusively in LSP. Behaviors are special custom-made Qscripts that you can drag and drop into your LSP project. If you are using a Macintosh you may be interested to find a folder for Applescripts within the "Behaviors" folder.

The "Timeline/Stage" window

The "Timeline" can hold numerous tracks that you specially create for various types of media in your movie—you can create tracks for movies, VR, picture, sprites, and audio, as well as FastTracks for skins and movie controls by clicking on buttons along the top of the "Stage" (Figure 7.22) or by selecting a track type from "Movie/Create Track" in the menu bar.

Let's make our first track—the movie skin:

5. Click on the "blob" (or is that a pelt?) icon button to create a "Skin FastTrack" (Figure 7.23). You should see a large black frame appear in the "Stage" window, along with a "Skin FT" window containing the same picture. We will not use the default skin, so uncheck the "Use Background" box; the picture in the window will change to a gray box.

6. From the "Local" tab in the "Library" window, in the graphics folder, drag the file "chap_skin_shape.gif" to the "Skin FT" window without releasing it. When the screen splits into three horizontal areas, drop the file into the top third of the

Figure 7.22 You can create tracks for "Movies," "VR," "Picture," "Sprites," "Audio," and "FastTracks" for skins and movie controls by clicking on buttons along the top of the "Stage."

Figure 7.23 Click on the "blob" icon button to create a "Skin FastTrack."

window labeled "WindowShape"—this is your window mask for the skin. You can check that the file was deposited by clicking on the "Skin" button under the window.

7. Now drag the file titled "drag.gif" to the "Skin FT" window and drop it into the middle shaded area labeled "WindowDragArea"—this is your drag mask. You can see the drag mask in the window when you click on the "Drag" button beneath the window. You can use the slider on the left side of the window to zoom in or out to see the entire image (Figure 7.24).

You have the option of including controls for closing the QuickTime window and expanding it to full screen, two very useful features for media skins. Because we will wire our own "close window" sprite, remove both of these by selecting each in the "Buttons" group to the right of "Settings" and unchecking the "Enabled" box for each (Figure 7.25). You can also delete the images by clicking on the "Clear" button.

Figure 7.24 You can see the drag mask in the window when you click on the "Drag" button beneath the window.

Figure 7.25 Remove the default "Close" window and "Full Screen" buttons by selecting each in the "Buttons" group to the right of "Settings" and unchecking the "Enabled" box.

Adding a second track for the skin graphic

8. Go to the "Local" tab in the "Library" window and drag the file titled "chap-mantourskin.jpg" into the "Stage" window to create a new picture track. (You can also select "Movie/Create Track/Picture" from the menu bar or click on the "Picture" button to the left of the "Color" button along the top of the "Stage" window to create a new picture track.) Notice that the graphic that appears may be distorted and might need to be resized to 640 × 480 (Figure 7.26). We will fix this soon.

9. In the "Picture Inspector" box (hit "Command/Control + I" to open if it is closed), make sure the following controls are set as follows:
 a. "Name": type in "Skin Graphic"
 b. "Left: 0, Top: 0, Width: 640, Height: 480." Note: if LSP will not let you set these coordinates and shows the following error message: "The width of the track cannot be made greater than the width of the movie," then click in the "Stage" window to change the "Inspector" back to "Movie Inspector" and check the width and height coordinates you set there—they may have slipped to smaller dimensions. If so, retype the width and height as 640 and

Figure 7.26 Notice that the graphic that appears may be distorted and might need to be resized.

Figure 7.27 Click in the "Skin Graphic" header to bring up the "Skin Graphic Inspector" window.

480 and click in the "Skin Graphic" track header (Figure 7.27) to return to the "Picture Inspector," where you should be able to re-input the proper 640 × 480 dimensions.

 c. "Layer": −1

 d. "Offset": leave untouched

 e. "Draw mode": Dither

 f. "Track": check "Enabled"

 g. Leave "Advanced" settings as they are

10. Now double-click in the "Picture" ("Skin Graphic") track header to bring up the "Track Properties" box. Select the "Spatial Tab" to double-check that the following coordinates match those that you set in the "Picture Inspector": "Left: 0, Top: 0, Width: 640, Height: 480" (Figure 7.28).

11. Note that the two tracks stacked one over the other on the "Timeline" both extend to 00:01.000. Because the QTVR scene we will add next has a length of 10 seconds, we will need to extend these tracks. The easiest way to accomplish this is to click your pointer on the end of the colored track band—called the "sample"—and drag it to the 00.10.000 point of the "Timeline" (Figure 7.29). You can zoom the timeline back to see the 10-second mark with the "Zoom Slider" control at the bottom of the "Timeline" frame (Figure 7.30). Notice that the "Skin FT" track springs to follow and conform to the length of the extended picture track.

Figure 7.28 Select the "Spatial Tab" to double-check that the following coordinates match those that you set in the "Picture Inspector": "Left: 0, Top: 0, Width: 640, Height: 480."

Figure 7.29 You can extend the length of a track sample (the colored band of the track) by clicking and dragging on the right end of the sample (see circled area).

Figure 7.30 You can zoom back to see the 10-second mark with the "Zoom Slider" control at the bottom of the "Timeline" frame.

Adding the VR track

12. Grab the file titled "campus_scene.mov" from the "Graphics" folder in the "Local" tab of the "Library" window and drag it to the "Stage" window, ignoring the band that appears across the window warning "Invalid Media" (Figure 7.31). Dropping the QTVR scene into the "Stage" automatically creates a VR track, but you will need to drag the VR scene to the correct position (Figure 7.32).

13. Double-click on the VR track header to bring up the "VR Properties" box and in the "Track" tab, type "Pano" in the "Name" field (Figure 7.33).

Figure 7.31 Grab the file "campus_scene.mov" from the Graphics folder in the "Local" tab of the "Library" window and drag it to the "Stage" window, ignoring the "Invalid Media" warning band.

Figure 7.32 Dropping the QTVR scene into the "Stage" automatically creates a VR track, but you will need to drag the VR scene to the correct position.

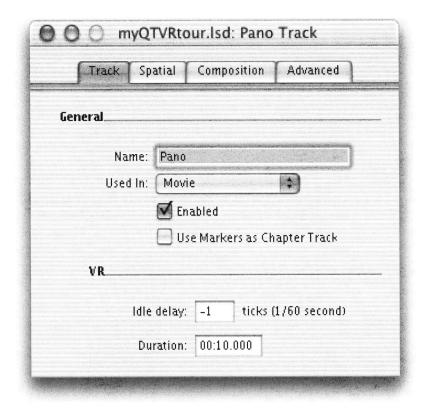

Figure 7.33 In the "VR Properties" box, type "Pano" in the "Name" field.

14. The VR frame is a bit smaller than we would like, so let's resize it to fit the movie
 skin by going to the "Inspector" (now the "VR Inspector" when you are working
 in a VR track) window and set "Left" to "15," "Top" to "130," and the "Width"
 and "Height" to "450" and "300" pixels, respectively. You can also use the arrow
 keys on your keyboard to nudge the "VR" window into place.

Now you have three tracks in place: "Skin FT," "Skin Graphic," and "VR." Take a look at
your work so far by hitting "Command/Control + R"; LSP will compile the QuickTime
movie so you can judge your progress. If your work is free of bugs, you will hear the melo-
dious sound of a plucked harp (but you will hear a descending violin twang if something
is wrong). At this point the movie skin will be intact—but without buttons—and the
QTVR scene should appear (Figure 7.34) and be fully functional (via keyboard
commands).

Note: If you do not see the QTVR window frame in the movie skin, go back and check
the layer order of your "Pano" and "Skin Graphic" tracks; the "Pano" should be at "layer
−1," whereas the "Skin Graphic" should be at "0." If these check out OK and the pano
still does not appear when the movie runs, try reversing the numeration ("Pano" at "0,"

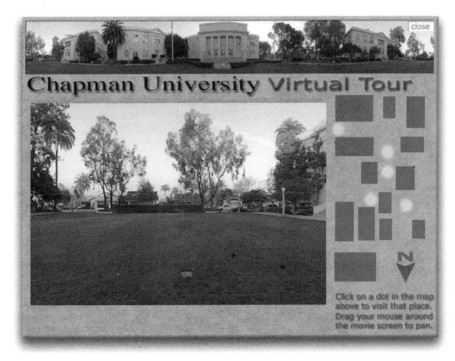

Figure 7.34 At this point the movie skin will be intact—but without buttons—and the QTVR scene should appear.

"Skin Graphic" at "−1") and then dragging the "Pano" track above the "Skin Graphic" to reset the stacking order. This usually corrects the problem.

Adding the wired controls

Wiring sprites with Qscripts used to be akin to pulling teeth when using LSP Versions 3.0 and older, but LSP 4 brings new streamlined and relatively painless options for creating interactive controls with its "FastTrack" options. Let's use the "VR Controls FastTrack" feature for our next track:

15. Select "Movie/Create Track/VR Controls FT" or click on the "VR Controls FT" button (Figure 7.35) to create a QTVR controller track.
16. You should see the pre-made QTVR controller bar appear in the "Stage." Click and drag this controller to just under the lower right-hand corner of the VR image (Figure 7.36) to put it in its proper position.
17. Click the "clapper board" button at the top right-hand corner of the "Stage/Time-line" window (or hit "Command/Control + R") to preview the movie. Notice that the controller bar is fully functional in all VR nodes, and we did not have to suffer through a single script or behavior! We still need controls for showing

Figure 7.35 Click on the "VR Controls FT" button to create a new "VR FastTrack."

Figure 7.36 You should see the pre-made QTVR controller bar appear in the "Stage." Click and drag this controller to just under the lower right-hand corner of the VR image to put it in its proper position.

and hiding hot spots and a "close window" sprite to make the movie disappear, however, and we will get to these soon.

18. Hit "Alt + F4" in Windows, or "Command + W" in Macintosh, to lose the movie. Although the generic controller looks fine with our movie skin, you may prefer to go with custom controls. Notice the "VR Controls FT" window that appears when the "VR Controls" track is active. You can replace all of the controls with images of your own (or someone else's) design by clicking on the "Clear" button and dragging in suitable new graphics from the "Library" window (Figure 7.37).

19. Let's go with some custom buttons:

 a. In the "Global" tab of the "Library" window, go to "VR Control Buttons/XP/Pan Left" and drag the "Down.pct" file into the small window at the bottom of the "VR Controls FT" box (Figure 7.38). Notice that the window divides into three horizontal sections much like the "Skin FT" window did for us earlier. Drop the file into the middle section labeled "Down Image." Now drag and drop the "Over.pct" and "Up.pct" from the "Pan Left" folder.

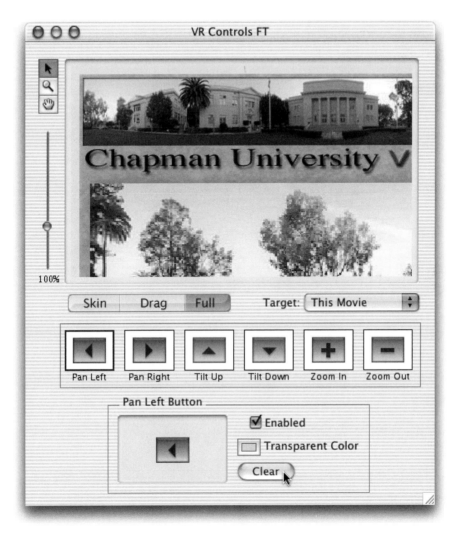

Figure 7.37 Notice the "VR Controls FT" window that appears when the "VR Controls" track is active. You can replace all of the existing button images by clicking on the "Clear" button and dragging in suitable new graphics from the "Library" window.

b. Hit "Command/Control + R" to run the movie. Notice the new custom button replacing the old (Figure 7.39). The black background has become transparent so that the button appears to float on the movie skin.

c. Now that you see how easy it is to use custom buttons, go head and replace all the generic controls with the custom buttons using the method in step 18(a).

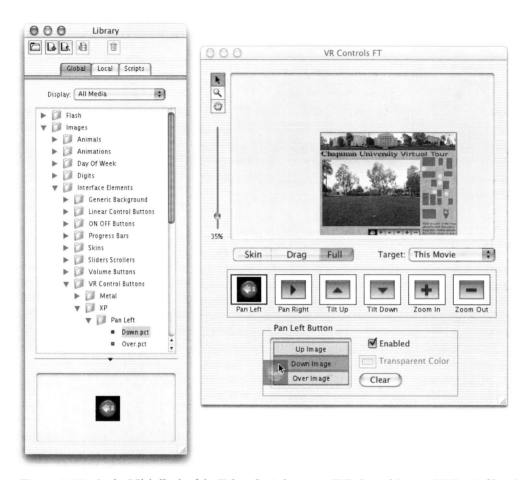

Figure 7.38 In the "Global" tab of the "Library" window, go to "VR Control Buttons/XP/Pan Left" and drag the "Down.pct" file into the small window at the bottom of the "VR Control FT" box.

Figure 7.39 Hit "Command/Control + R" to run the movie. Notice the new custom "VR Controls FT" button replacing the old.

Adding a sprite track

Before we go much farther, let's add node buttons on the map and a sprite for closing the window of this QuickTime movie. We can do all these things and more with a sprite track:

20. Click on the second button from the upper left-hand side of the "Stage" window (or select "Movie/Create Track/Sprite") to create a sprite track.

21. In the "Timeline," click and drag the right end of the "Sprite Track" sample and extend it until it is flush with the other tracks below it.

22. Double-click on the "Sprite Track" header to bring up the "Sprite Properties" box, go to the "Spatial" tab, and set these coordinates:
 a. "Left": 0
 b. "Top": 0
 c. "Width": 640
 d. "Height": 480
 e. "Drawing Layer": −3 or less
 Click on the "Composition" tab and set the "Mode" to "Transparent" (Figure 7.40). Close the box. Your "Stage/Timeline" should now look something like Figure 7.41.

23. In the "Image" tab of the "Sprite" window, type "Map_buttons" in the text box in the upper left-hand corner of the box. From the "Local" tab in the "Library" window, go to "the right buttons" folder and drag the file "minus.gif" to the left column window of the "Sprites" window. The image of the graphic will appear in the right side of the window (Figure 7.42). We do not actually want this image to appear, so go to the "Sprites" tab and make sure the "Properties" tab is activated. In this tab, make sure the "Visible" checkbox under the "Visibility" heading is unchecked—this will make our sprite invisible (sprites must always be attached to a graphic, even when they are not supposed to be seen!). Now under the "Matrix" heading, enter "592" in the "Left" text box and "8" in the "Top" text box; this will put the sprite in the "close" box of the movie skin (Figure 7.43).

24. Now click on the "New Sprite" button at the left-bottom corner of the window. We need to give the sprite a script, so click on the "Scripts" tab. In the text window in the lower right-hand portion of the window, type the following exactly as follows: CloseThisWindow.
 Make sure you capitalize the first letter of each of the three words but do not allow any spaces between them (Figure 7.44). When you finish typing the phrase, the letters should turn blue—this tells you that LSP recognizes the script. Very good, you have written your first LSP script!

25. Hit the "clapper board" button at the upper right-hand corner of the "Stage" window to run the movie. You should be able to close the window of the movie by clicking in the "close" box in the upper right-hand corner now.

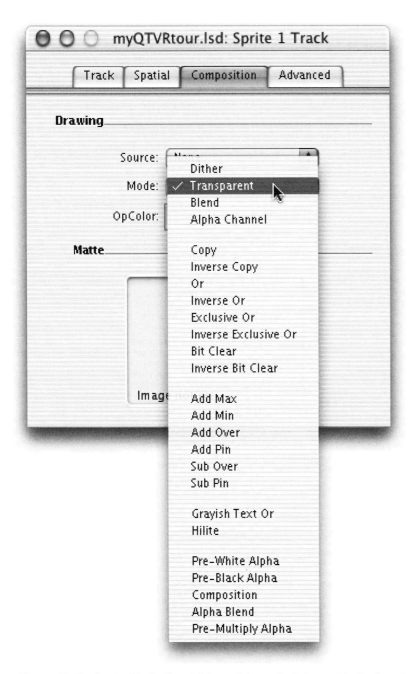

Figure 7.40 In the "Sprite Sample" box, click on the "Composition" tab and change the "Mode" to "Transparent."

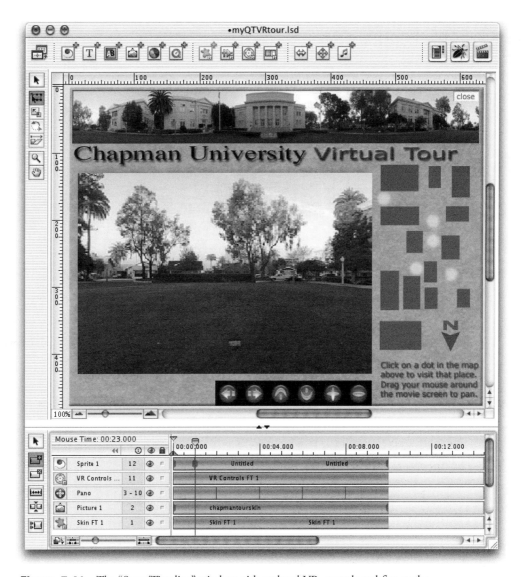

Figure 7.41 The "Stage/Timeline" window with replaced VR controls and five tracks.

We still need to add the clickable node buttons, and we can add them to our present sprite track:

26. Click on the "Images" tab of the "Sprite" window to activate it.
27. From the "Local" tab in the "Library" window, go to the "graphics" folder and drag the following files to the left-hand window where the "minus" graphic resides: "red.png," "green.png," "orange.png," "green.png," and "blue.png" (Figure 7.45).

Figure 7.42 From the "Local" tab in the "Library" window, go to "the right buttons" folder and drag the file "minus.gif" to the left column window of the "Sprites" window. The image of the graphic will appear in the right side of the window.

Figure 7.43 Make sure the "Visible" checkbox under the "Visibility" heading is unchecked—this will make the sprite image invisible. Under the "Matrix" heading, enter "592" in the "Left" text box and "8" in the "Top" text box; this will put the sprite in the "close" box of the movie skin.

Figure 7.44 In the text window in the lower right-hand portion of the window, type the following exactly as follows: CloseThisWindow. Make sure you capitalize the first letter of each of the three words but do not allow any spaces between them.

Figure 7.45 From the "Local" tab in the "Library" window, go to the "graphics" folder and drag the following files to the left-hand window where the "minus" graphic resides: "red.png," "green.png," "orange.png," "green.png," and "blue.png."

28. Click on the "Sprites" tab, and click on the "New Sprite" tab. In the "Sprite Name" box, type in the word "Node1" (Figure 7.46). Now, in the ID text box, type the number "134." This identifies this sprite with the proper number of the VR node to jump to when the node button on the map is clicked (you can see the number assigned to each node for reference on the VR sample in the timeline). Under the "Image Index Heading" on the right side of the window, select "red" from the "Image" pull-out menu. This links the sprite with the red dot

Figure 7.46 Click on the "New Sprite" tab. In the "Sprite Name" box, type in the word "Node1."

Figure 7.47 To wire this button, select "Node1" in the "Sprites" window and go to the "Local" tab in the "Library" window, then click on the "behaviors" tab and drag out the file titled "GoToNode.lsb" to the "Behaviors" window on the right side of the "Sprites" box.

image. Now set the "Left" coordinate (under the "Matrix" heading) to "576" and the "Top" coordinate to "271" to position your button correctly.

29. To wire this button, select "Node1" in the "Sprites" window, go to the "Local" tab in the "Library" window, then click on the "behaviors" tab and drag out the file titled "GoToNode.lsb" to the "Behaviors" window on the right side of the "Sprites" box (Figure 7.47). If you click on the little "I" icon to the left of the "GoToNode" in the "Behaviors" window, a blurb with information about the

behavior will appear in the window (Figure 7.48). This particular behavior will tell the button to take the user to node 1 when the red button is clicked.

30. Run the movie to see how the node button works (you will have to change nodes via hot spots, then click on the red button to see if it transports you back to node 1).

31. If the button behaves as intended, then go ahead and create sprites for the remaining four nodes as you did for node 1 in steps 27–29. Be sure to type in the specific ID number for each node (node 2 = 135, node 3 = 136, node 4 = 137, node 5 = 138). Also, take care to assign a different-colored button to each node in the "Image Index Image" pull-out menu. The "Top" and "Left" values should be typed in as follows:
 a. Node2 (blue button): Left = 522, Top = 261
 b. Node3 (green button): Left = 548, Top = 220
 c. Node4 (orange button): Left = 548, Top = 190
 d. Node5 (purple button): Left = 470, Top = 157

We have one more sprite to add before we move on to our last track, the reveal/hide hot spots control.

32. Drag the "hotspots.png" file from the "graphics" folder of the "Local" tab in the "Library" window and drop it into the "Image" window (just under the other graphics for "minus," "blue," "green," and so on).

33. Go to the "Sprites" tab and click on the "New Sprite" button—name the sprite "ShowHotspots."

34. Change the "Image Index Image" pull-out to "HOTSPOTS," and type "10" in the "Left" text box and "430" in the "Top" text box.

35. Click on the "Behaviors" tab. Select the "ShowHotspots" sprite and drag this behavior from the "behaviors" folder of the "Local" tab in the "Library" window to the "Behaviors" window: "HideShowHotSpot.lsb."

Figure 7.48 If you click on the little "I" icon to the left of the "GoToNode" in the "Behaviors" window, a blurb with information about the behavior will appear in the window.

36. Click on the small icon below the "Information" icon to the left of the "HideShowHotSpot" blurb. Enter the number "7" in each text box for "Image Index When On" and "Image Index When Off" (Figure 7.49). This creates links to the "HOTSPOTS" graphic in both the on and off position.

37. Run the movie. The buttons and controls should all be wired and working properly.

Adding the text track

The last thing to do here is to add some text about each of the five QTVR panoramas in this movie. LiveStage uses QuickTime's text track capabilities, so much of the following should be a refresher to our discussion of text tracks earlier in this chapter:

38. Click on the "T" button at the top-left corner of the "Stage" window to create a new text track. A square text box appears in the upper left-hand corner of the "Stage." Click and drag the square by selecting the lower-right corner of the square to form a rectangular text box, as illustrated in Figure 7.50. Alternately, you can set these coordinates in the "Spatial" tab of the "Text Track Properties" box (double-click on the "Text Track" header to bring it up) as "Left: 40, Top:

Figure 7.49 Click on the small icon below the "Information" icon to the left of the "HideShowHotSpot" blurb. Enter the number "7" in each text box for "Image Index When On" and "Image Index When Off."

Figure 7.50 A square text box appears in the upper left-hand corner of the "Stage." Click and drag the square by selecting the lower-right corner of the square to form a text box at the bottom part of the frame.

370, Width: 400, and Height: 50." In the "Composition" tab of the "Text Track Properties," change the "Mode" to "Transparent" to make the text box invisible.

39. The default text sample on the "Timeline" extends to 1 second; let's drag the right end of the sample to 2 seconds to match the length of the VR node. If you slide the playback head to 2 seconds, you will see node 2; this is where our first sample should end.

40. We will need four more samples for each of our nodes. Click on the "Sample Creation Tool" button directly to the left of the highest track—in this case it is the "Text Track"—header (Figure 7.51). Now line up the "Playback" head at the end of the first "Text" sample, at 2 seconds, and click in the "Text Track"—just to the right of the "Playback" indicator line (Figure 7.52). You will see a new sample appear right after the first sample (if you want to remove any samples, click on the "Sample Delete Tool" button just below the "Sample Creation" button); click on the "Arrow" button above the "Sample Creation" button (Figure 7.53) and drag this sample to 2 seconds, lining the end up with the end of node 2. Do this until you create five samples, each 2 seconds in length (Figure 7.54). The main thing here is to start a new text sample as one node ends and another begins.

Hint: Alternately, you can start with one "Text" sample, stretch it on the "Timeline" to 10 seconds in length to match the other samples, and use the "Sample Split Tool" (click on the second button from the bottom, as in Figure 7.55) to split the sample into five sections at 2-second intervals.

41. Let's create text for node 1. Double-click on the first "Text" sample to bring up the "Text Sample" box and make sure the "Text Tab" is activated. In the text box,

Figure 7.51 The "Sample Creation Tool" button.

Figure 7.52 Now line up the "Playback" head at the end of the first "Text" sample, at 2 seconds, and click in the "Text Track"—just to the right of the "Playback" indicator line. You will see a new sample appear right after the first sample.

Figure 7.53 The "Arrow" ("Selection") button resides above the "Sample Creation" button.

Figure 7.54 You should create five text samples at 2-second intervals to match the nodes in the VR track.

Figure 7.55 The "Sample Split Tool" button.

type the following: "Memorial Hall, built in 1921, houses the University president's office, as well as a 1000 seat auditorium." Select the entire line of text you just typed.

42. Go to the menu bar and select "Font"; from here choose the font Verdana (always use a font common to PC and Macintosh), a point size of 14, and bold style.

43. Now choose "Font/Color" from the menu bar to bring up a color picker: choose a bright yellow (Figure 7.56).

Figure 7.56 The "Type Track Sample" box for node 1.

Figure 7.57 The "Properties" tab of the "Text Sample" box. Make sure the "Keyed Text" checkbox is checked along with "Visible" and "Auto Scale" checkboxes. Set the "Justification" pull-down to "Center."

44. Click on the "Properties" tab of the "Text Sample" box. Make sure the "Keyed Text" checkbox is checked along with "Visible" and "Auto Scale" checkboxes. Set the "Justification" pull-down to "Center" (Figure 7.57).

45. Now add text to the remaining four text samples using procedures outlined in steps 39–42; you can copy and paste the following lines for each node:

Figure 7.58 The completed project as it appears in the "Stage/Timeline" window.

Figure 7.59 The completed interactive QTVR movie.

 a. (Node 2) Liberty Plaza features a 12-foot slice of the Berlin Wall set in a reflecting pool.

 b. (Node 3) Peaceful Schweitzer Mall stretches across the center of campus.

 c. (Node 4) Wilkinson Hall, on the National Register of Historic Places, has stood since 1904.

 d. (Node 5) The Panther, opposite Argyros Hall, remains the symbol of Chapman University pride.

Now your text tracks should be complete. With any luck, your "Stage/Timeline" window should resemble Figure 7.58. Run the movie to see your work—it should look like Figure 7.59. If everything checks out fine, export your finished movie to the format of your choice (Web, CD, and so on) and give yourself a pat on the back—you deserve it!

The interactive QTVR tour we constructed here is just one example of interactive QuickTime projects possible with LSP. Now, on to QuickTime deployment and exhibition.

8 QuickTime Options for Distribution and Exhibition

"There's always been a real bottleneck in the industry in terms of getting films out . . . Once you can get away from the economic constraints of striking prints and shipping them, you can really get into a whole new area of distribution for films."

—Lance Weiler[8]

Once your motion picture is in the form of a QuickTime movie, you will need to optimize it, via compression. We will delve into the intricacies of compression in Chapter 9, but before you can move into this phase of deployment, you must decide which avenues you wish to use for distributing your film, be it the World Wide Web, CD-ROM, or DVD. Motion picture/video files are probably the biggest files that computers deal with regularly, and the primary vehicles for disseminating digital video information are the computer hard disk, the CD-ROM, and the Internet (Table 8.1).

Exhibition via Hard Disk

In many ways, the easiest and most reliable way to show digital content is directly from the hard drive of a computer. This can be as simple as taking your laptop with you to meetings with producers, agents, and would-be patrons, plopping it on their desk or coffee table, and pressing play. A more formal way to screen specialized video content to the general public is via the kiosk—simply a rugged stand-alone computer and viewing screen in a box or stand that can play videos or offer limited interactivity (Figure 8.1). Touch screens enable a user to enter and display information, dispensing with the traditional mouse or keyboard. Kiosks are generally designed to stand in public places such as museums, lobbies, trade shows, and other areas where audiovisual information can be disseminated on a limited basis. Although the viewing experience is generally less than stellar, the kiosk offers the content producer much more control over software and hardware than is possible via the Internet or CD. In case a kiosk does not house the very latest in computer hardware, at least you can maximize your content for the particular machine(s) where it will be playing. The conditions that will influence the degree of compression you choose is largely influenced by the access speed of the computer's hard drive, the power of the CPU, and to some degree the size of the display. That said, exhibiting video from a hard drive can be many

Table 8.1. Comparison of QuickTime delivery media

Medium	Comparative Speed	File-Size Limitations	Pros and Cons
Hard disk playback	High bandwidth— transmission speeds exceeding 200 K/second	Files can be huge, in the tens or hundreds of megabytes	Pro: Allows almost unlimited file size and high-quality play. Con: Limited portability. Impractical for mass dissemination.
CD-ROM playback	Relatively high bandwidth— transmission speed less than 200 K/second and varies according to age and reading speed of computer/disk driver of computer where CD is played	Each CD can hold maximum of 700 MB of data, fairly large in QuickTime terms	Pro: Excellent, inexpensive distribution mode. Good reliable playback on newer computers. Con: User needs CD-ROM drive as part of computer in order to play. Discs may not play optimally on older computers or drives. CD data capacity may be too limited for some content.
Internet playback	Extremely limited bandwidth varies according to connection hardware of user. Data transmission speeds less than 2 MB/second under best of conditions and often does not exceed 5 K/second	Bandwidth and storage consideration dictate small file sizes, from 100 KB to 25 MB (typical *Star Wars* trailer) maximum	Pro: Theoretically allows widest possible audience. Con: Files must be small and highly compressed, compromising quality. Limited Internet bandwidth is still prohibitive factor. Content producer has little control over viewing conditions.

times faster than it is on the Web or from a CD and might be a deployment option to consider if your content is strictly informative in nature and needs to be made available to the general public as part of an exhibition, show, business, or other application.

Because kiosks usually offer user-activated media as part of the basic user experience, your content will benefit from an interactive interface that can be created with the use of sophisticated software such as LiveStage Pro and other applications. When you set up a kiosk, you will need to know how the media will be stored, the speed of the CPU, bus transport, and video cards, and be sure that all drivers and other important elements are working in unison. The control you have with a kiosk is one of the most attractive aspects of using one.

A kiosk can be as simple as a laptop computer that you take with you to various venues, but if you are setting up a booth in a show or putting the kiosk up on a semi-permanent

Figure 8.1 A typical kiosk.

basis, then you will want a large display and computer safely locked away in one of the boxes offered by firms specializing in commercial kiosk design. Your kiosk will have even greater versatility if it can be connected to a LAN or the Internet.

Exhibition via CD-ROM

CD-ROM is the medium where QuickTime originally flourished and indeed ruled, long before movies on the Web were a reality, and it remains an important mode for

distribution of video and multimedia content. CD drivers are not particularly fast at reading data, but they have improved substantially in reading speed from their predecessors of just a few years ago, offering 32× and higher reading speeds and writing speeds exceeding 52× for recordable CD-R and re-recordable CD-RW disc recorders ("burners" in popular vernacular). See Table 8.2 for a look at how CD drives compare; keep in mind that most computers came equipped with 8× drives by 1996, 12× drives by 1998, 24× drives by 2000, and now commonly exceed 40× in computers available today. Whatever idealized data rate a CD drive is touted to achieve, you should reduce the figure by at least a third to reflect real-world data rates.

A CD's capacity depends on what kinds of files are written to it. An audio CD playable on a conventional stereo CD player will hold about 80 minutes of music or other audio material. The same CD will hold roughly 10 hours of audio files compressed in the popular MP3 format (although it will take a computer or a special CD player to play it back). Alternately, the CD can hold about 3 hours of highly compressed video, 54 minutes of video CD (MPEG-1) quality video, or just over 20 minutes of DVD-quality video (MPEG-2).

CD-ROM has been the media of choice for authoring multimedia content produced with such software as Macromedia Director and is still enormously popular for games, encyclopedias, and educational content. CDs are an attractive distribution and archiving medium, being cheaper by far than just about any other storage media available today. As an added bonus, CDs are said to have a much greater shelf life than magnetic media such as tape, Jaz discs, or floppies and thus come as close to being archival as any other digital storage mode available.

CD-ROM compression settings

As a CD content producer, you should assume that a segment of your target audience may view your content on older 2× CD drives. Double-speed CD-ROMs operate at an actual sustainable data rate of 180 KB/second, so if you keep your data rate at or under this figure, your content should be viewable to all users. Using QuickTime Pro, you should get good results with either of these compression options:

Table 8.2. Comparison of CD drive speeds

Reading Speed	Ideal Data Rate in KB/second or MB/second	Real-World Data Rate in KB/second or MB/second
2×	300 KB/second	200 KB/second
8×	1200 KB/second	800 KB/second
12×	1.75 MB/second	1.2 MB/second
24×	3.5 MB/second	2.2 MB/second
40×	5.8 MB/second	3.5 MB/second

- Cinepak. Choose a frame size no bigger than 300 × 225 (240 × 180 recommended), a frame rate of either 10 fps or 5 fps, and a quality setting about 50%. Quality is OK, but the main reason to use this codec is because it is less demanding on the user's CPU, important for those with computers more than a couple of years old. In most cases, this should be used only with a reference movie (see next item) expressly for slow machines.

- Sorenson 2 or 3. Frame size of 320 × 240 or smaller, frame rate of 10 fps or 15 fps, data rate limited to 200 K/second, maximum. Experiment and test various settings; you can reasonably compress video that looks fine even down to 40 K/second. Sorenson quality beats Cinepak but requires a newer computer with more power behind it. If you think a considerable segment of your audience will be using older computers, avoid Sorenson and use Cinepak instead.

Be sure to check your movie's data rate with QuickTime Pro's "Get Movie Properties" feature to verify that your maximum data rate is below about 200 K/second (Figure 8.2). If the rate is set higher, your movie will stutter on playback.

The following audio settings work well when creating a QuickTime movie:

Figure 8.2 You can check the size and data rate of your movie in QuickTime Pro's "Get Movie Properties" feature.

- 22 kHz
- 16-bit mono
- IMA 4 : 1 compression

The QuickTime Installer

When you put your QuickTime content on CD, make sure you include the QuickTime installer just in case your user does not have the most current version. You can download the QuickTime installer at the Apple site www.apple.com/quicktime/download/standalone and the license for the installer at developer.apple.com/mkt/swl/agreements.html#QuickTime.

The biggest benefit of deploying your movies on CD-ROM is the sheer number of computers that can accommodate this format, giving you potentially the biggest audience for your work. On many continents—Asia, Africa, South America, and even Europe—broadband Web access still lags far behind CD-ROM in the number of people who can access it. Just the same, for all its benefits, CD-ROM was developed before the high-quality motion picture protocols MPEG-2, DV, and other formats and therefore is not really suitable for top-quality feature film and video exhibition in disc form. For this, we must look to DVD.

DVD

The digital versatile disk (sometimes known as digital video disk) or DVD, as it is commonly called, was unveiled in Japan in the fall of 1996 and became the fastest growing new consumer-oriented audio/video technology on record, dealing a death knell to Laserdisc technology and taking its place as the ultimate digital distribution medium. Home DVD recording technology lagged (as with user CD recording) for about 5 years, when Apple and Compaq unveiled computers featuring Pioneer's revolutionary SuperDrive DVD recorder. Now the DVD is poised to replace the VHS cassette as the primary nontheatrical mode of distribution. The DVD uses MPEG-2 compression technology rather than QuickTime protocols, and although Apple does offer a $19.95 add-on for the QuickTime Pro Player, it is not able to directly encode in the MPEG-2 format. Although DVD technology falls outside the purview of this book, filmmakers and videographers are encouraged to explore the growing options for producing and distributing multimedia content in this format.

Exhibition via the World Wide Web or Other Network

The most direct and least expensive way to distribute your work via QuickTime is to post it on the World Wide Web. Web sites featuring film and video, as well as animated Flash movies, have become commonplace on this graphical part of the Internet. Indeed, short films have become hot properties among such sites as AtomFilms.com. Thankfully, putting motion pictures and sound on the Web is much easier than film production. Nonetheless, putting a film or video online in a form and length that Web surfers are going to want to view is challenging enough on its own terms.

Streaming and nonstreaming media

The term streaming video has stirred up a lot of excitement these days as more and more filmmakers turn to the Web to exhibit their work. The term describes several modes of disseminating video and audio from a server to a client over a network, though most people construe streaming media as video or audio files that may be viewed or heard immediately over the Web and do not require downloading in their entirety first. QuickTime streaming comes in two flavors: Fast Start (progressive download) streaming and Real Time streaming, including RTP and Real-Time Streaming Protocol (RTSP) streaming.

Early versions of QuickTime, as well as many other media protocols, required that movie files accessed over the Internet be downloaded completely before they could be available for viewing. The advent of QuickTime 3 brought a unique mode of Web delivery known as Fast Start, or progressive download. When you encode a QuickTime movie in this fashion, users can download the entire file at the highest data rate their connections can support. The plug-in determines when a sufficient portion of the movie has downloaded and then begins playing the movie while the download is in progress and continues to the end. A Fast Start QuickTime movie can start playing long before the entire file has been completely downloaded, and if the net connection rate is higher than the movie's data rate, the movie plays smoothly with no waiting.

QuickTime's RTP was introduced in 1999 with QuickTime 4—comparatively late in the streaming media game. Rather than relying on downloading files like http and file transfer protocol (ftp), RTP dispenses a continuous one-way stream at a constant data rate, playing the program in real time. A movie will play in its entirety for its exact running time, providing the Internet connection has sufficient bandwidth to handle a continuous data stream. The movie is not downloaded to the user's computer but is discarded after the show finishes playing.

There is one more mode for streaming QuickTime: RTSP. RTSP differs from RTP as it allows two-way communication and thus is much more interactive. RTSP is always used together with RTP, as RTSP controls the session while RTP actually sends the data. A viewer can go back and view previous material in the movie or go ahead to a chapter.

How do you know which streaming solution is the right one for you? Tables 8.3 and 8.4 outline the advantages and disadvantages to each protocol:

Table 8.3. Fast Start advantages versus Real Time advantages

Fast Start Delivery	Real Time Delivery
No special server software required	Offers the only way to transmit live feeds
The movie transmits regardless of the connection speed	Allows broadcasts and multicasts (single stream to multiple viewers)
If user has a fast connection, the movie plays while downloading, appears to be streaming to user	Permits random access within pre-recorded movies
Compatible with all types of QuickTime media, including QuickTime VR and sprites	Movies are not downloaded and thus take up no space on user's hard drive
Lost packets are retransmitted until they are received	Streaming media uses no more bandwidth than it needs
Firewalls do not cause problems	No copy is left on the user's computer
No special server software required	Can stream individual tracks into a movie from any streaming server anywhere

Table 8.4. Fast Start advantages versus Real Time disadvantages

Fast Start Delivery	Real Time Delivery
Cannot broadcast or multicast	Requires streaming server and/or broadcaster
Cannot transmit live events	Movie prone to image breakup if the data rate exceeds connection speed
Users cannot skip ahead any further than amount the movie has downloaded	Lost packets expire and cannot be recovered (movies streamed over the Internet always lose data)
The user receives a copy of the movie	Streaming cannot be used with certain media types, including QTVR and Flash
	Firewalls and network address translation (NAT) gateways can block the stream

Getting it in QuickTime

You can convert videos to QuickTime simply by opening the file in QuickTime Player and saving it as a self-contained file with the ".mov" file extension. This action does not change the file size or the compression ratio. If you wish to change the size of the file, then you must recompress it (see Chapter 5).

QuickTime Player cannot open all formats, however. Certain proprietary formats such as RealMedia must be opened with an industrial-strength compression application such as Discreet Cleaner, and from there exported as QuickTime movies. And QuickTime can only open Windows AVI files compressed with codecs that QuickTime can understand (leaving out some Indeo codecs).

Preparing movies for RTSP streaming

To simplify the handling of your movie, you should save it as a self-contained file, otherwise the movie will need constant access to components that must be stored in any folder where the movie will reside. Saving a movie as "self-contained" consolidates the movie's dependencies and makes it a stand-alone file. To do this, open the file in QuickTime Player and select "Save As." In the dialog box that appears, rename the file, making sure to end it with the ".mov" extension, and click in the circle labeled "Make movie self-contained" (Figure 8.3).

An important step in preparing media for RTSP streaming is the process of hinting your movies. Hinting is another word for adding information to the movie that the streaming server uses to package media data to be sent out over the Internet. It is a simple process to hint your movies:

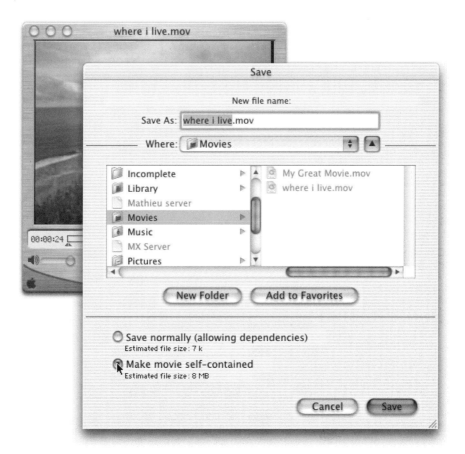

Figure 8.3 Saving a movie as "self-contained" consolidates the movie's dependencies and makes it a stand-alone file. To do this, open the file in QuickTime Player and select "Save As." In the dialog box that appears, rename the file, making sure to end it with the ".mov" extension, and click in the circle labeled "Make movie self-contained."

1. In QuickTime Player, go to the "File" menu and choose "Export."
2. Is your movie already compressed and the data rate set? If so, choose "Movie to Hinted Movie" from the "Export" pop-up window (Figure 8.4). Now choose "Default Settings" from the "Use" pop-up menu. This default setting usually is a good choice for many movies. Click "OK," and you are finished.
3. If you need to compress your video or set other parameters, select "Movie to QuickTime Movie." Open the "Use" menu and choose from one of the many preset options for streaming files (do not use the options at the bottom of the menu labeled "CD . . ."), if you find that one applies, and skip ahead to step 9. If you are uncertain about which to use, choose the closest option to your need and continue to step 4.
4. Press the button labeled "Options"; the "Movie Settings" box appears.
5. In the "Video" and "Sound" fields, click the "Settings" buttons to specify compression settings (see Chapter 5 for more detailed instructions on compressing movies).

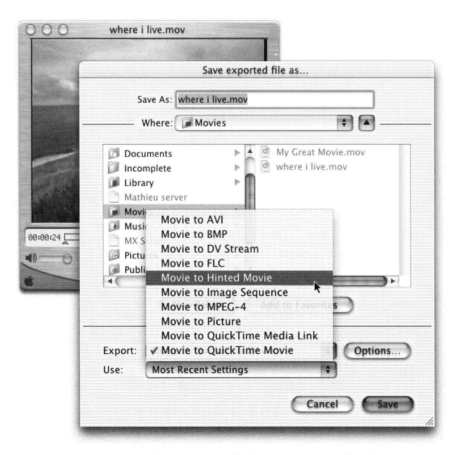

Figure 8.4 Is your movie already compressed and the data rate set? If so, choose "Movie to Hinted Movie" from the "Export" pop-up window.

6. At the bottom of the "Movie Settings" box, check "Prepare for Internet Streaming."

7. Set the pull-down menu for "Hinted Streaming" and click the "Settings..." button to open the "Hint Exporter Settings" dialog box. Check "Optimize Hints for Server" to enable the media data to be embedded in your hint tracks (Figure 8.5). This allows the server to read hint and media track packets all at once. This increases the number of viewers the server can support.

8. In the "Hint Exporter Settings" dialog box, click on "Track Hinter Settings" to change the compressors and data rates for each streamable track. If you know the

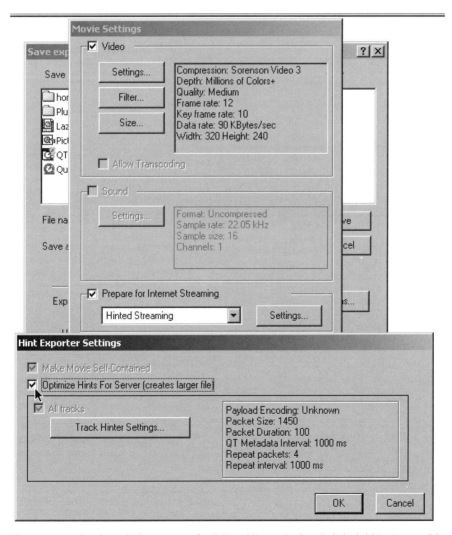

Figure 8.5 Set the pull-down menu for "Hinted Streaming" and click the "Settings..." button to open the "Hint Exporter Settings" dialog box. Check "Optimize Hints for Server" to enable the media data to be embedded in your hint tracks.

maximum packet size your network allows, you can set that as the streaming packet size. You can also increase the number and frequency of data repetitions for text and music, improving those tracks. Beware, however, that following this procedure will drive up the data rate of your movie.

Once you have hinted your movie, name the file in a manner that the Web server can understand. Eliminate spaces between words, be sure to be case-consistent in your titles, and always add the ".mov" file extension to your movie's file names.

One important point to remember when preparing your movie for Fast Start streaming is that you should try to conform the data rate of the movie to the bandwidth of your intended user. Your movie should already be compressed for the optimum delivery (see Chapter 5). In QuickTime 3 and later versions, movies are usually saved as Fast Start movies, with the self-contained feature checked. It is simple to convert older QuickTime movies to Fast Start movies by opening them in QuickTime Player and saving them under new names. You can deliver your Fast Start movies by embedding them in a Web page (see next section).

QuickTime and HTML

QuickTime movies can be downloaded over the Web and played individually, or they can be embedded in a page. It is useful to have a working knowledge of HTML, the code used to write most Web pages with hyperlinks, but it is easy to pick it up as you go along if you are not used to working with code.

If you are unfamiliar with HTML code, you can get a basic idea of how it is constructed by looking at a Web page's source code. You can look at the code of any Web page in a Web browser by going to the menu bar under "View/Source." In addition, most what-you-see-is-what-you-get (WYSIWYG) Web page editors such as Adobe GoLive and Macromedia Dreamweaver will let you display a document in source code as well as in layout mode.

The most basic way of presenting a QuickTime movie via the Web is to link it to a page using the <A HREF> tag. Thus, if your Web page contains a tag like this:

```
<A HREF="flick.mov">My Latest Flick,
```

a user may click his or her pointer on the hypertext link "My Latest Flick" and bring up a window containing the appropriate QuickTime file. The window itself is a stark affair, containing only the movie on a neutral background (gray in Netscape, white in Internet Explorer).

If you use frames in your Web pages, you can get a bit more elaborate if you place your linking page and your QuickTime movie within the same frame set. When the user clicks a link in one frame, the movie will load in another. Even so, linking movies is a very limited and ultimately frustrating endeavor. This leads us to the most satisfying method of Web presentation, embedding on a page.

The <EMBED> tag lets the Web designer call up media types that are not necessarily supported by a browser. Netscape 2 and later versions, as well as all versions of Internet Explorer from Version 4 to 5.5, support the tag itself.

What Is Windows Media Player Hijacking?

Here is a not-uncommon scenario that may irritate QuickTime content providers:

A PC user tries to access your QuickTime movie site but the movies will not load, even though the movies play fine for other PC users as well as all Mac users. What happens is that the Web browser tries to play the QuickTime movie, reading the QuickTime .mov extension and launching the appropriate plug-in to handle it. The problem arises when Windows Media Player, or WMP—standard in all PCs—attempts to play QuickTime movies. This is particularly a problem with VR and other enriched QuickTime files that WMP is unable to play. Although the WMP plug-in will not work, it still behaves as if it is the designated QuickTime player and fails to warn the user of the problem. Thus, even if a user needs to download QuickTime to play the file, no warning appears to him or her of this. The user is faced with a white rectangle instead of a movie and often leaves with the feeling that something in the Web page is broken.

The workaround for preventing this problem is to embed the QuickTime movie using a source, a dummy file, and a QuickTime source. Because WMP tends to recognize the .mov extension as a file it can open (but often cannot), the thing to do is write your Web page to include another extension type before your movie file that only QuickTime can recognize, such as .qti, .qtif, or .pntg. If there is a QuickTime source file present, the QuickTime plug-in will launch first, and it will ignore the first source file in the HTML code but will play the second file instead. WMP does not understand the aforementioned extensions and thus will not jump into trying to open the file. If users do not have the QuickTime plug-in installed, they will get a proper notice to get QuickTime and then they can download it. Also, if you specify a file using the "qtsrc" parameter, the QuickTime plug-in will ignore the .qtif or .pntg file and play only the QuickTime Source (QTSRC) file. Incidently, QuickTime 4 and later versions recognize .qti and .qtif files, whereas QuickTime 3 and later will open .pntg files.

Thus, when you want to make sure that a user's browser always opens the QuickTime plug-in to play your QuickTime movies, do as follows:

Create a QuickTime image file using either the .qti or .qtif extension, or a MacPaint file using .pntg.

Continued

1. Here is an example of how to change your HTML, say from `<EMBED SRC="MyQTmovie.mov" HEIGHT="316" WIDTH="400">`

to

2. `<EMBED QTSRC="MyQTmovie.mov" HEIGHT="316" WIDTH="400" SRC= "GetQT.pntg" TYPE="image/x-macpaint" PLUGINSPAGE=http:// www.apple.com/quicktime/download/>`

Be sure to include the TYPE parameter in your HTML to ensure proper handling when a user plays this content from a CD or other disk. The only users who will ever see the MacPaint file are those with QuickTime 3 (and that is pretty old at this point). If you want to ensure that they see something, create a 575×720 ppi black-and-white file (no grays) in Photoshop or other image editor. It is a good idea to make this file a custom-made "Get QuickTime" sign with the download link to alert users who do not have QuickTime installed.

Another way to head off hijacking expressly in Internet Explorer for Windows is to use the <OBJECT> tag and CLASSID parameter (see sidebar "The Quick-Time ActiveX Parameter"). If you include both of these parameters, you should have no complaints about hijacking.

The QuickTime ActiveX Parameter

In 2001, Microsoft stopped supporting EMBED tags in Windows versions of Internet Explorer, starting from Version 5.5 on. Since that time, Internet Explorer has turned a blind eye to the code written with this tag. Consequently, Windows users using older versions of Explorer who visit your site may be unable to view QuickTime content in the browser. In order to have your QuickTime content accessible to all browsers, you must add some extra HTML code and nest your embed commands with OBJECT code. QuickTime displays movies from your Web page via a plug-in that works with the user's browser. Prior to this, an EMBED tag alone would be all you would need to include to display QuickTime content within the browser, as in the example below:

```
<EMBED src="flick.mov" width="400" height="316" autoplay="true"
CONTROLLER="false"
PLUGINSPAGE="http://www.apple.com/quicktime/download/">
```

In order for this to function properly, the user must have the QuickTime plug-in installed on his or her computer. If the appropriate QuickTime plug-in is not

installed, the movie will not appear when your HTML page with QuickTime content is loaded into the user's browser. Instead, the user will see a "broken plug-in icon" in place of the movie and attempts to direct the user to a download site to get the required software. Thus, the user is directed away from your site and may go surf the Web elsewhere.

To ensure your QuickTime movies display properly on all platforms with all browsers, include an OBJECT element with the enclosed EMBED element, as in the following example:

```
<OBJECT CLASSID="clsid:02BF25D5-8C17-4B23-BC80-D3488ABDDC6B"
WIDTH="400" HEIGHT="316"
CODEBASE="http://www.apple.com/qtactivex/qtplugin.cab">
<PARAM name="SRC" VALUE="flick.mov">
<PARAM name="AUTOPLAY" VALUE="true">
<PARAM name="CONTROLLER" VALUE="false">
<EMBED src="flick.mov" width="400" height="316" AUTOPLAY="true"
CONTROLLER="false"
PLUGINSPAGE="http://www.apple.com/quicktime/download/">
```

Be aware that the CLASSID value must always be "clsid:02BF25D5-8C17-4B23-BC80-D3488ABDDC6B" and the CODEBASE value must always read "http://www.apple.com/qtactivex/qtplugin.cab"

In addition, the PLUGINSPAGE tag must always equal: http://www.apple.com/quicktime/download/

The other attributes should be customized to your Web page. You need to substitute "flick.mov" (in both SRC attribute elements) with the URL of the actual movie to be played. You should also change the HEIGHT and WIDTH parameters to match the height and width of the movie (in pixels).

If you already have EMBED elements for the QuickTime plug-in on the relevant pages, you need to enclose each of them in an OBJECT element with CLASSID and CODEBASE parameter values, as shown in the previous example, and with SRC and other parameter values to match those in your existing EMBED element. The OBJECT element can use any EMBED attributes QuickTime understands. Visit www.apple.com/quicktime/authoring/embed.html for more information.

The `<EMBED>` tag is like the `` tag for referencing graphic files, and both share the SRC, WIDTH, and HEIGHT parameters. The SRC parameter tells the browser what file to display, whereas width and height specify the aspect ratio of the movie:

```
<embed src="mymovie.mov" width="320" height="256">
```

The SRC attribute is the media file to display either by an absolute or relative URL. The HEIGHT attribute specifies the vertical size in pixels of the SRC attribute. The WIDTH attribute specifies its horizontal size.

The controller bar in embedded movies

As we have seen, QuickTime movies may be stopped, played, or "scrubbed" through by means of a controller bar that normally appears below the movie frame. The bar appears by default unless a parameter is added to remove it: CONTROLLER=FALSE. When the CONTROLLER=TRUE is used, the controller will appear. You must allow 16 pixels in addition to the actual height in pixels of the vertical dimension of the movie if you wish the controller to show. For example, set HEIGHT="256" for a movie 240 pixels high: `<EMBED SRC="mymovie.mov" WIDTH="320" HEIGHT="256">`. In the case of a sound-only movie, specify a height of 16 for the controller and any width that looks proportionate to your page. You can reduce the controller to a simple PLAY/PAUSE button by setting the width as well as the height to 16. Do not set HEIGHT or WIDTH to less than 2, even if the movie is hidden.

The Most Common EMBED Attributes

EMBED attributes are parameters written in HTML code that let you customize the presentation of your QuickTime movies. The following are some of the most widely used EMBED attributes:

PLUGINSPAGE

The PLUGINSPAGE parameter lets you designate a URL where the user can download the necessary plug-in if it turns out that he or she cannot play the movie. If your browser cannot load the plug-in when loading the page, it will notify the user and present a URL where the proper plug-in may be downloaded. The usual URL for this plug-in is www.apple.com/quicktime/download:

```
<embed src="sample.mov" width="200" height="240"
pluginspage="http://www.apple.com/quicktime/download/">
```

Please note: Although it is a very good idea to include this parameter in all of your QuickTime EMBED tags, it is not a foolproof method of ensuring that your end

user will be able to view your movies. Quite often, other plug-ins (notably WMP's) will elbow the QuickTime plug-in aside and attempt to play the movie. This is known as "hijacking." If this occurs with QTVR panoramas or objects in particular, the movies simply will not play. The user is left staring at a black box or a slider bar, without even a "get QuickTime" notice to invite him or her to the proper URL for downloading. Thus, it is good insurance to add a "Get QuickTime" badge in a visible place on your page, just in case the PLUGINSPAGE attribute is defeated. You can easily find and download this "Get QuickTime" badge from the Apple Web badges page: www.apple.com/about/webbadges.

AUTOPLAY

If you want your movie to begin automatically, as soon as the page is loaded, then use the AUTOPLAY attribute, set to TRUE. To be more accurate, this will ensure the movie starts playing as soon as the QuickTime plug-in determines that it will be able to play the entire movie without waiting for any more data.

KIOSKMODE

When you include this parameter, KIOSKMODE=TRUE, the plug-in disables the "Save As" pop-up menu from the movie controller and prohibits the user from dragging and dropping to save the movie. This attribute affords some protection against copying but can be defeated by those with a little know-how. A more foolproof method of keeping your work your own is to use the PlugInHelper (see later in this chapter).

```
<embed src="sample.mov" width="200" height="240"
kioskmode="true">
```

LOOP

This attribute can be either TRUE, FALSE, or PALINDROME, the default being FALSE. When set to TRUE, the movie will play over and over, as a loop. The PALINDROME setting allows the movie to play beginning to end and end to beginning alternately. Obviously, this is not an option for QTVR movies.

HIDDEN

This attribute may be simply added to the tag:

Continued

```
<EMBED SRC="flick.mov" width="320" height="256" hidden>
```

or may be designated as HIDDEN=TRUE (FALSE is the default).

The HIDDEN parameter simply makes the movie invisible and thus is appropriate for sound-only files that must be hidden from view. It is a good idea to make the height and width parameters very small, such as 2 pixels each dimension, so as to discourage artifacts with certain browsers. This has no relevance in QTVR movies.

VOLUME

The VOLUME parameter allows you to set the level of the sound for your movie. By default, QuickTime plays at 100% volume, but you can specify any percentage if you do not want to blow your user away when your sound plays. You can set this to play background sounds at barely audible levels. Levels set to exceed 100% may distort and clip the sound, so it is advisable to avoid setting levels this high. If you use the looping feature, you may well wish to set the audio much softer than normal.

QTNEXT

In the past, movies projected in movie houses were shown in a succession of shorter reels, which were alternately screened using two projectors. This allowed the potentially cumbersome feature film to be handled in more manageable portions. QuickTime will allow you to do the same thing, by using the QTNEXT parameter. When one small movie finishes playing, another will begin. This is an excellent way to show a much longer film, as only each currently playing movie will take up valuable memory. It is possible to designate up to 256 separate movies:

```
<EMBED SRC="flick0.mov" WIDTH="200" HEIGHT="240">
QTNEXT1="<http://www.website.com/flick1.mov>
T<myself>"
QTNEXT2="<http://www.website.com/flick2.mov>
T<myself>"
```

You can also tell the string of movies to start again from number one if you specify the GOTO parameter.

AUTOHREF

When set to TRUE, this parameter will start loading any URL specified in the HREF parameter, without the need for the user to click a mouse. One good use for AUTOHREF is to embed a QuickTime movie in your main page that automatically sends people with QuickTime to the desired content page—just add HREF and AUTOHREF parameters to the movie's <EMBED> tag. Then add an HTML refresh tag to your Web page to automatically redirect people without QuickTime—either to a download page or an alternate content page.

BGCOLOR

This parameter lets you choose a color for the rectangle where the QuickTime movie appears. This is important if the movie is smaller than the rectangle, or if the movie is slow to load. You can specify any Web-safe color using hexadecimal codes (rrggbb). QuickTime also accepts color names in place of certain RGB hues.

PLAYEVERYFRAME

The default for this option is FALSE. When set to true, your movie will play without skipping over any visual information. This is a compromise between having a smoothly playing movie and having the proper time. When this parameter is in effect, time is sacrificed and the movie plays more slowly, thus the audio track is silent.

CACHE

This attribute can be set to "true" if you want the movie to remain in the browser's cache even after users left the page for another. This is a good option if you expect users to return to this page and you do not want them to wait for a new download. If you do not specify this parameter, the QuickTime Plug-In defaults determine this setting.

STARTTIME and ENDTIME

These attributes let QuickTime begin playing a movie past its actual start point and stop playing the movie before its true end point. For instance, the following

Continued

example will start 7 seconds in and conclude 12 seconds before the actual end of the movie:

```
STARTTIME=7.0, ENDTIME=12
```

The entire movie must still download regardless of what is set here. Users can see the frames before and after these settings by using the "Step" buttons and the indicator in the time slider, but they will only be able to play the part of the movie within the prescribed range.

SCALE

This tag can control the size of the QuickTime frame using TOFIT, ASPECT, or a number. The default SCALE value is 1. When the TOFIT setting is used, the movie will scale to fit the embedded frame while maintaining the original aspect ratio. When the protocol is ASPECT, the movie will scale to fit the embedded box and remain faithful to the original aspect ratio. This parameter scales the movie by the number given (for example, 1.25). An example would be:

```
<embed src="movie.mov" width ="240" height ="320" scale="tofit">
```

TARGETCACHE

The TARGETCACHE attribute works very much the same as the CACHE parameter but sets a cache value for a movie referenced by an HREF attribute in the EMBED tag.

Reference movies

One of the frustrating realities of the Internet today lies in the number of options for users, which translates into a lack of standards with which you as a Web author must contend. Web designers have grappled with multiple platforms and disparate browsers for years in their quest for consistency in the appearance of their output. The biggest challenge you will likely face in putting your movies online—apart from dealing with the several media-playing formats to optimize your movies for—will be juggling between maximum quality and maximum speed of delivery. Part of your audience will be accessing Web information at very slow rates, with older computers and dial-up modems with bit/second rates of 56.6 down to 14.4. Others will enjoy relatively brisk throughput rates thanks to DSL, cable modem, T1, and T2 connections. The small-pipe users will need highly compressed movies.

A smaller segment of users lust after large-size, high-resolution media and will not be satisfied with tiny video windows. How do you deliver the optimum product to both?

QuickTime has answered this need with the reference movie. The reference movie is a file with pointers to two or more alternate movies of different data rates and file sizes. You can create a version of your movie optimized for 56K dial-up access, a version for cable modem connections, and a version for T1 access, place them all in a Web directory, and let the reference movie choose the most appropriate version for each viewer based on the connection criteria of each. The easiest way to do this is to use QuickTime Pro and a freeware application distributed by Apple called MakeRefMovie. MakeRefMovie is available in Mac OS, Mac OS X, and Windows versions at developer.apple.com/quicktime/quicktimeintro/tools.

MAKING ALTERNATE DATA RATE MOVIES

Making several files of differing sizes—known as alternate movies—that will play optimally for different users and their connections is a fairly simple process. These movies can be prepared for either RTSP or progressive download streaming. You will probably want to have one movie optimized for 28.8 K bits/second modems, another for 56.6 K bits/second modems, and one for high bandwidth connections such as DSL, cable modem, or T1/T3. It would also be prudent to make a version that does not depend on the QuickTime engine. You may even want to optimize alternate movies based on the different CPUs your viewers may be using (because the Sorenson codec, for instance, does not play well on slow computers, you may want to compress a file using Cinepak or other compressor). You may even have movies optimized for different languages such as Spanish, German, or others.

You will want to start with a movie of the highest possible quality. This movie should have the largest frame size, highest frame rate, and the least compression possible on both video and audio tracks. This will be your master movie. Create the alternate movies from the master using the most appropriate image sizes and codecs. You can do this easily with QuickTime Pro using the "Export" option in the "File" menu. You can also do this with Discreet Cleaner, which will let you generate all your alternative movies in one batch according to the settings you select (see tutorial on Cleaner in Chapter 5).

You can make some of your alternates into streaming movies if you create Fast Start files that point to the streaming files and designate the Fast Start movie as the alternate for the stream.

MAKING A REFERENCE MOVIE

1. Place all the various alternate movies you have created for a given file into the same folder that matches the directory where you will upload them onto your Web server.
2. Upload any alternate movies designed for RTSP delivery to your QuickTime streaming server.
3. Open MakeRefMovie and a "Save" dialog box appears (Figure 8.6). Type in a title—followed by the .mov extension—for your reference movie. Save this reference movie in the same folder where your alternate movies reside.

Figure 8.6 Open MakeRefMovie and a "Save" dialog box appears.

4. Click "Save" and an empty window will come up.
5. If you have any of your alternate movies on your local hard drive, go to the "Movie" menu and choose "Add Movie File."
6. Locate an alternate movie and click "Open" (Figure 8.7).
7. If you have any alternates that are already uploaded onto your Web server, then go to the "Movie" menu and choose "Add URL" to specify the location of one of these movie files on the Internet. Click "OK."
8. Repeat steps 6 and 7 until you see all your reference movies listed in the window.
9. In the "Speed" pop-up menu for each alternate movie, choose the appropriate connection rate.
10. If you wish to designate some alternate movies for the relative clock speeds of various computers, choose the CPU "Speed" pop-up menu and make settings accordingly.
11. If you wish to have different movies for different languages, select the "Language" pop-up menu to choose the language for each of your alternates.
12. If you want any of your alternate movies to be able to play with earlier versions of QuickTime, you may choose a value in the pop-up menu under "Speed." When you designate an alternative movie to be compatible with QuickTime 3 or earlier, you will want to check "Last Choice" from the "Priority" pop-up and check the box labeled "Flatten Into Output," as these older versions of Quick-Time do not know how to read reference movies on Web pages.
13. Choose "Save" from the "File" menu.

Figure 8.7 Locate an alternate movie and click "Open."

14. Embed the reference movie on your Web page (see previous section under "QuickTime and HTML").

15. Be sure that all your alternative movies are uploaded into the folder with the proper reference movies, in the same order and hierarchy that you created them on your computer.

You may have an advanced application such as Cleaner 5 automate many of the steps outlined. This is a very powerful and flexible tool for compressing and optimizing movie files. Be sure not to change the names or relative locations of your alternative movies after placing the reference movies, otherwise the reference movie will not be able to link to them.

Poster movies

QuickTime lets you reload a new movie in the same space as the original embedded movie, which can be done without reloading the Web page itself. A single-frame QuickTime movie such as this is known as a poster movie. When the user clicks on this still image, the QuickTime plug-in loads the specified movie in the same frame as the poster movie. This allows the user to view a still image of each QuickTime movie you have embedded without having to wait for all of them to download or begin streaming, and the user can also choose which

to view in its entirety. You can have your Web page display any image you wish in place of the embedded QuickTime movie.

Making a poster movie

There are several ways to make poster movies: you can create an image in a program such as Adobe Photoshop or take an actual frame from the movie you want to embed into your Web page. In any case, it is important that the file be saved in a format that QuickTime Pro can import.

Note: When constructing single-frame poster frame movies, it is recommended that the movie frame be recompressed using a high-compression algorithm such as Photo-JPEG.

1. Open QuickTime Pro and import the file you wish to use as your poster movie frame. You may also use a frame of video from your movie—in this case, disable any audio tracks by choosing "Delete Tracks . . ." from the "Edit" menu.

2. Choose "Export" from the "File" menu. You will need to be sure that your file name ends with the extension .mov. Be sure that the option "Movie to QuickTime Movie" is selected. This will automatically designate your movie as "self-contained," allowing the file to be viewed by other users.

3. Now you can upload the poster movie to your server. Remember, the poster movie must reside in the same directory or folder as your QuickTime .mov file; otherwise, the user will click on the poster movie and bring up the file in a new browser window.

4. Create your Web page and embed the poster movie into the page, positioning the <EMBED> tag to your HTML document where you want the file to appear. The final step is to upload the page.

Using the QuickTime Plug-In Helper

Apple's Plug-In Helper allows you to store information in the actual movie—information that would normally have to be encoded into your Web page itself. For example, you could include playback control settings or URLs to link to when the user clicks on the movie or any given tracks. You can also prevent the movie from being saved by a user by setting this parameter within the movie information. You need to do this specifically if the movie to be played is not the one embedded into the Web page—in the case of a "poster movie"—or if you simply want to conceal the parameters from the viewer or make the movie and its parameters self-contained. It is important to note that any attributes written into the EMBED tag of the page where the movie resides will override the parameters set with the Plug-In Helper.

PUTTING EMBED ATTRIBUTES INTO A MOVIE USING PLUG-IN HELPER

1. Open the application PlugInHelper (you may download this utility free from developer.apple.com/quicktime/quicktimeintro/tools).

Figure 8.8 The Plug-in Helper window.

2. From the "File" menu, choose the "Open" command, then find and open the QuickTime movie you wish to modify. You can also drag and drop the file into the window area below the "Open" and "Export" buttons to open it if you wish.

3. The Plug-In Helper window appears (Figure 8.8).

4. Click the "Add" button in the upper right-hand area of the window labeled "Plug-in Settings" ("plug"). In the "Edit User Data" dialog box that appears, enter valid EMBED tags (see previous sidebar "The Most Common EMBED Attributes"). You can use any tag supported by the plug-in except CACHE, WIDTH, HEIGHT, and HIDDEN. A tag often placed here is the "AUTOPLAY=true." Make sure all tags contain no spaces on either side of the equal sign. You can also put an HREF tag to load another HTML file into the current document, such as text information about the movie in the frame when the movie appears. You can only use one HREF tag here. Click "OK" when you have added the attribute.

5. Repeat step 4 until you have added each attribute you want to include. You can use the "Edit" and "Delete" buttons to alter these attributes as you wish.

6. If you do not want a copy of your movie to remain on the user's computer or storage disk, you can click in the checkbox labeled "Disallow saving from plug-in." This affords the greatest protection if you want to keep control over the ownership of your movie.

7. Click the "Export" button.

8. The "Save" dialog box appears; enter a file name ending in .mov and choose location, then click "Save."

Targeting and Loading URLs with HREF Tracks

The HREF track is a powerful tool that allows you to encode URLs in a QuickTime movie that allow a user to click and open at predetermined points during the movie. The HREF is like an invisible text track that contains one or more URLs embedded into a QuickTime movie that link to other Web pages and online files and calls them up at predetermined points as the movie plays. Combining this command with frames allows the user to create presentations with synchronized components such as video and audio synchronized to a slide show. To make an HREF track that loads a URL when a user clicks on the movie, do as follows:

1. Open the movie you wish to use and make a selection (see Chapter 4 on editing with QuickTime if you forget how to do this) where you want a URL to open.

2. Using your text editor, type in angle brackets the URL of the site you wish to load, like this:

```
<http://www.ferncase.com>
```

This will open the URL in the current window.

An even more powerful use of HREF tracks is to target another Web page, in which case you would type:

```
<http://www.ferncase.com> T<_blank>
```

The "T<_blank>" tag will make the URL load in an empty browser page. If you want your URL to appear in a frame on the same Web page along with Quick-Time movie, type "T" followed by the name of the frame you desire (<bottom>, <top>, <left>, <right>).

3. Now copy the text, go back to your movie in QuickTime Pro, and select "Edit/Add Scaled." You can scrub through your movie and you will see the text track appear in just that portion of the movie.

4. To convert this to an HREF track, to go "Movie Properties," select the current text track in the left pull-down. Then go to the right pull-down, select "General," and click on the button at the bottom of the box labeled "Change Name." In the "Change Track Name" box, change the name using this exact spelling and case, "HREFTrack," and click "OK."

5. If you want to make the text track invisible, select "Edit/Enable Tracks" and disable the text track.

6. Save your movie as self-contained and give it a new name.

7. Open your Web browser on a blank page and drag your movie into the browser window to simulate a Web page. Play the movie. Notice that when you click in the movie frame, the movie stops and will resume playing when you click again. When you click during the selected portion of the movie where the HREF track resides, it will load the prescribed URL and Web page. Of course, you will probably want to keep the movie in view while it plays, so most likely you will want to build the movie into a frame set so that the URL will load into a frame alongside the movie.

You can also create HREF tracks that target URLs automatically in certain places as the movie plays. Follow steps 1 and 2 but type an "A" before the line of text. The "A," which stands for "anchor," tells the movie which Web page to call up. Repeat the rest of the process (after you delete your previous HREF track, if you perform this on the same movie you used in the last tutorial) and save the movie with a new name. You can add as many HREF tracks as you like by repeating this process with each of your URLs.

You can also target a URL to load in place of the movie itself by using the T<myself> parameter in your HREF track. In this case, the URL must lead to a file type that Quick-Time can understand. This is a great way to link several QuickTime movies to play one after another in one extended multi-"reel" movie. You can also use the parameter T<quick-timeplayer> to launch a movie in the QuickTime Player.

9 QuickTime Tools and Applications

There are dozens of applications built on or supporting QuickTime in major ways. Some of QuickTime's special features are only accessible through programs such as LiveStage Pro and others. The following is a brief roundup of some of the more useful software and shareware available for the QuickTime filmmaker.

Nonlinear Editing

Not so long ago, filmmakers had a simple choice when it came to motion picture editing: whether to use an upright Moviola editing machine or a flatbed editing console. The video revolution, demanded electronic editing, which amounted to one form or another of re-recording and necessitated linear editing and subsequent generation loss. Computers, originally intended for number crunching and other mundane tasks, were put to the task, and the rest is history.

Final Cut Pro 4

Final Cut Pro was the first nonlinear editing application to be built around the QuickTime architecture and thus dovetails extremely well with QuickTime. The latest version of the software incorporates Apple's ColorSync technology to keep accurate color information from the camera to postproduction. Another notable feature is its ability to render effects—including color correction and numerous transitions—in real time without the need for additional cards or hardware. This allows the use of laptop computers for editing in the field. Other features include the OfflineRT format, harnessing QuickTime's M-JPEG codec to let the user store up to 40 minutes of footage on a gigabyte of hard-drive memory. Final Cut Pro can work with virtually any QuickTime-understandable file format and provides some powerful presets for media export. Final Cut Pro is available from Apple Computer (apple.com) and Apple resellers for the Macintosh platform only, $1000.

Cinema Tools

For professionals working with film and editing with Final Cut Pro, Apple's Cinema Tools simplifies handling the coding headaches that come with editing film digitally. In fact, Cinema Tools feels like a natural extension of Final Cut Pro, if with a somewhat barebones

interface. It can run on Apple's PowerBooks as well as G3 and G4 desktop computers, enabling working in the field.

Cinema Tools imports and exports edge code numbers for both 35 mm 4-perf and 16 mm 20-pitch perforated stock, the two most prevalent film formats in use today. It allows you to find a specific frame in Final Cut Pro by edge code, footage, and frame location on the original film negative and lets you identify a film frame on a video clip by inputting its corresponding timecode number.

Cinema Tools also supports 24 fps progressive-scan HD video (HD 24 P), a standard that threatens to supplant film in the not-too-distant future. You can edit HD footage at 29.97 fps, and Cinema Tools will convert your edit decision list to 23.98 fps to work with HD online. You can also handle down-converted HD footage like film footage with the reverse telecine process, editing at 23.98 fps.

In general, Cinema Tools does a fine job keeping track of your keycodes and timecodes while you edit in Final Cut Pro and generates edit decision lists needed for negative cutters and film labs. It requires a 300-Mhz Macintosh PowerPC G3 or G4 processor or better with built-in Firewire, at least 256 MB of RAM, Final Cut Pro 3.0.2 or newer, Mac OS X v10.1.3 or more recent, QuickTime 5.0.4 or later, and a minimum of 10 MB of available disc space. From Apple Computer, $999.

Avid Xpress DV

This application does not rely on QuickTime but it is included because of its importance as a likely contender to Final Cut Pro. In the realm of nonlinear editing throughout the 1990s, Avid's Media Composer was king. This revolutionary hardware- and software-driven application single-handedly brought the digital age to Hollywood's film editors and post houses. The Media Composer and its sibling Film Composer were fantastically expensive, however, and often beyond the reach of the independent filmmaker and student. With Final Cut Pro's dramatic inroads into the professional editing community, Avid has unleashed a new contender in DV editing and there is sure to be a battle for users in the digital post arena.

Avid has carried its famous interface and workflow technology over to Xpress DV, and seasoned editors can bring their technique and working modes over, whereas neophytes will learn skills that they can bring to the more advanced Avid systems.

Xpress DV follows in Final Cut Pro's footsteps by offering customizable real-time effects. Because Xpress DV relies exclusively on software, it requires a powerful processor—at least a 500-Mhz Mac G4 running OS 10.1 or higher or a Pentium PC or better. All real-time effects are preview only and thus cannot be viewed on an external monitor until ultimately rendered for final output. Xpress DV accommodates eight video tracks and unlimited nesting, DV scene extraction, Edit Decision List (EDL) import and export, and the ability to use import/export bins from other Avid editing programs. At the time of writing, Xpress DV does not offer a "workprint" mode of low-resolution offline editing a la Final Cut Pro's OfflineRT. As its name denotes, Avid Xpress DV cannot handle uncompressed or HD video. You can, though, bring an offline project from Xpress DV to Film

or Media Composer for final assembly. Available for both Mac and PC in the same package from www.avid.com, $995.

Adobe Premiere

This editing solution has been around a long time and preceded DV, thus it was designed from the start to accommodate the importation of video from just about any source (given the user had installed the right hardware). One of the chief selling points of Premiere has been its integration with other Adobe image editing applications such as Photoshop, Illustrator, and After Effects. If a user understands the Info, History, and Navigator palettes in those applications, he or she could use them in Premiere as well. Premiere operates on both PC and Macintosh platforms. Available from www.adobe.com and other vendors, $550.

iMovie

Apple's contribution to home movie editing, iMovie, has proven to be nothing short of a miracle for many trying to make sense of miles of DV footage. Its aims are relatively modest, as iMovie can only deal with DV-formatted streams. With QuickTime as its core technology, it can be thought of as a very basic version of Final Cut Pro. That said, iMovie can be a very useful application for exporting media from other applications into QuickTime movies. iMovie offers a quick and painless way to import DV and can function quite well as a sketchbook editing program when you do not feel like delving into the depths of Final Cut Pro or Premiere for just a simple assembly edit. iMovie works and ships only with Macintosh, but the price is unbeatable: free.

Streaming

QuickTime Broadcaster

With the unveiling of QuickTime 6 came the release of a new addition to the QuickTime array of multimedia tools: QuickTime Broadcaster. As the name suggests, Broadcaster simplifies live broadcasting over the Internet and, like QuickTime 6, captures and encodes QuickTime content, including MPEG-4, for live Web streaming. Broadcaster works in unison with QuickTime Pro, QuickTime Streaming Server, and QuickTime Player to give users an inexpensive method of producing and streaming live events.

Among QuickTime Broadcaster's features are:

- Live encoding with real-time preview
- Capability of recording and hinting in real time to a computer hard disk for video-on-demand
- Support for all QuickTime-understandable formats
- AppleScript support

- Capability to create custom settings
- Ability to support reliable communication through Transmission Control Protocol (TCP) between Broadcaster and Streaming Server
- Can configure the Broadcaster-Streaming Server connections

QuickTime Broadcaster offers a real-time scrubbing feature, which lets the user zip through on-demand streams using the time slider. In earlier QuickTime versions, it was not possible to see video speed up as you jogged forward, and the video typically has to re-sync itself to the audio stream as well.

QuickTime Broadcaster is free for download at the Apple Web site and requires QuickTime 6, Mac OS X (10.1 and later), Mac OS X Server, QuickTime Streaming Server, and compatible servers.

Sorenson Broadcaster

Before the release of QuickTime Broadcaster, it was necessary to look beyond the QuickTime Streaming Server if one wanted to encode video and audio for streaming, and Sorenson Broadcaster filled this need nicely. Sorenson Broadcaster allows live compression of audio and video signals into QuickTime streams.

Broadcaster offers presets to make the job of compression relatively simple, and a "customize" button gives you even more control over settings. Broadcaster offers a multicast mode if your audience connects over a LAN, allowing all users on the network to tune in to a single stream—all without the need of an additional application like QuickTime Streaming Server. If you are streaming over the Internet, you will have to create a reference movie that points to the live stream. Available from Sorenson Video (www.sorenson.com), $185.

Live Channel

If you have ever dreamed of having your own live broadcasting studio and you happen to use the Macintosh format, you will be interested in Live Channel. Live Channel is often called "a TV studio on your Mac," allowing you to easily broadcast video and audio live over the Web as you shoot it. The interface consists of 12 windows, including:

- A "Media" browser, where imported media files are stored
- Two "Video Clip" windows
- Two "Video Input" windows
- "Audio Input" window
- "Audio Clip" window
- "Overlay" window
- "Title" window
- "Main Broadcast" window
- "Transitions" window
- An "Information" window
- "Video Effects" applications

There are 11 transitions you can choose from, if you feel inclined to use such hokum (remember: use a wipe, go to jail). All you have to do to begin broadcasting is to import all the multimedia files you will need. You can bring in a wide array of format types, including .mov, mp3, .wav, and others. One annoying trait of Live Channel is its tendency to increase the size of your imported media by up to three times, which might put some big demands on your hard drive space. In all, however, Live Channel is a handy application for Internet broadcasting on a small scale. The free version of the software supports multicasts to up to five people, whereas the pro version sets no limits on the size of the multicast (available on local networks only). Users will need to determine their fixed Internet Protocol (IP) address rather than use dynamic IP addressing. Live Channel also supports the use of a QuickTime streaming server. And finally, IP addresses can be dynamically allocated. Live Channel Pro 2.0 is available from Channelstorm (www.channelstorm.com), $1000.

Special-Effects Software

Adobe After Effects

This application has been around for a while but curiously lacks some of the more familiar interface elements that define Adobe programs such as Photoshop. Traditionally a 2D effects program, After Effects acquired a "Z" axis with Version 5 but has undergone few dramatic changes since. Users of Apple's Final Cut Pro will find that After Effects dovetails nicely with Final Cut Pro, as you can use After Effects third-party filters to produce effects in Final Cut Pro. Available for Mac and PC from www.adobe.com and other venders; price varies.

Commotion Pro 4.1

Compositing, retouching tool

Pinnacle Systems Commotion Pro is a comprehensive video effects and retouching application expressly designed for professional moving image effects and multilayer compositing. With Version 4.0, Commotion has made major inroads into the turf traditionally dominated by Adobe After Effects. Commotion particularly excels as a rotoscoping (tracing elements in a frame for applying mattes) tool and retouch tool. Available from various software vendors, $1000.

Interactive QuickTime Tools

LiveStage Pro 4.0

QuickTime is a robust multimedia architecture, but oddly much of its power must be harnessed in applications that go beyond the abilities of QuickTime Pro. To get at

QuickTime's coolest interactive and other capabilities, you need to turn to something on the order of TotallyHip's LiveStage Pro, the most powerful tool available for authoring QuickTime-based programming. Although not a content-creation application like Photoshop or QTVR Authoring Studio, it continues to offer media producers the most extensive access to QuickTime's many interactive features.

The most important update is the much more intuitive interface improvements, something sorely missed in earlier versions of LSP. New features include an integrated "Timeline" and "Stage" window to provide the user a simultaneous visual and linear perspective, rather than having to toggle between two separate windows. Other improvements include more contextual right-mouse-button menus, more pop-up windows, and more shortcuts for ease of use.

The most dramatic change is the introduction of FastTracks. FastTracks offer shortcuts for accomplishing previously tedious step-by-step tasks. LiveStage Pro supports the inclusion of Flash files up to Flash 5 and permits the use of the MPEG-4 content.

With Version 4, LiveStage Pro continues to set the standard for innovative QuickTime content packaging, offering increased QTVR functionality in the 4.1 upgrade. See the tutorial in Chapter 7 for a walk-through of this remarkable application. Available for Macintosh and Windows from TotallyHip (www.totallyhip.com), $899.95.

QTI

Ezedia's QTI debuted in 2003 as a kind of younger cousin to LiveStage Pro. QTI lets you create media-rich Internet content and interactive QuickTime while avoiding much of the steep learning curve that made LiveStage Pro famous. No scripting knowledge is necessary to turn out media skins, wired sprites, and other interactive features. Available from eZedia (www.ezedia.com/products/eZediaQTI) for Macintosh and Windows, $100.

Macromedia Director

Macromedia Director and QuickTime have been buddies ever since the earliest days of CD-ROM authoring, and in fact that is where Director still shines, despite its entree into Web authoring with the Shockwave format. Version 8.5 simplified much of the cumbersome interface of yesteryear, but Director remains a hugely detailed and sometimes daunting application. Much of Director's fire has been stolen in recent years by its upstart sister Flash, as Director files can be quite large and require players custom-made for the platform where they are intended to be used. Available from Macromedia (www.macromedia.com) for Windows and Macintosh for a whopping $1200.

Macromedia Flash MX

This is the "killer app" that launched a thousand (or more) Web animations. No doubt about it, Flash helped revolutionize Internet-based interactive multimedia with a learning curve much gentler than its older sibling Director, with files a fraction of the size of Director's Shockwave movies. Flash and QuickTime go beautifully together: You can embed any

Flash animation in a QuickTime movie, just as you can now incorporate any QuickTime movie in a Flash animation. QuickTime 6 supports Flash 5, so if you want to incorporate Flash into your movie, just be sure it is saved as Flash 5 or 4. Available from Macromedia (www.macromedia.com) for Windows and Macintosh, $300.

Tattoo

QuickTime media skin creation software

Tattoo takes a lot of the tedium out of making media skins for QuickTime movies. It streamlines the process by allowing a user to simply drop a QuickTime movie and an appropriate skin graphic into the application work area. Tattoo also facilitates the creation of wired buttons that play, stop, step forward and backward, turn up or down sound, and provide Web links. The resultant skinned movies are QuickTime 5-ready documents that play in Windows or Macintosh platforms. If skinning movies with buttons is all the interactivity you require, Tattoo will let you do it without the expense or intense learning process you will find in LiveStage Pro. Available from www.feelorium.com, $23.

iShell

Multimedia authoring tool

iShell compares very favorably to Macromedia Director as an interactive authoring application, but representatives of the "Tribe" contend that the learning curve is considerably gentler. Its object-oriented architecture works well for drag-and-drop work methods. Users can drag commands from a panel and enter parameters from a pop-up menu. The name derives from the "shells" that nest commands. iShell finds its greatest use as a tool for creating custom media players and educational CDs. Available from Tribeworks (www.tribeworks.com/products/ishell), $495.

Compression and Encoding

Discreet Cleaner

Many still consider this application, despite occasional complaints about its interface and speed, to be the end-all and be-all of media compression. For a full walk-through and product description, see Chapter 5. Available in Version 6 for Macintosh and Version XL for Windows from Discreet (www.discreet.com), $600.

Sorenson Video 3 Pro codec

Sorenson Video 3 represents perhaps QuickTime's greatest codec, showing up even the much-ballyhooed MPEG-4. A must-have application for all doing batch QuickTime processing in conjunction with Cleaner. For a more comprehensive discussion on this

indispensable encoder, see Chapter 5. Available for Windows and Macintosh from Sorenson Media (www.sorenson.com), $300.

Sorenson Squeeze 3 compression suite

Sorenson offers Squeeze as an intermediate compression solution, bridging the basic QuickTime Pro and Discreet Cleaner. As befits a basic application, Squeeze's interface is basic but easy to navigate. Priced at $450, it is worth considering if Cleaner's $600 price tag is out of range. Available for Windows and Macintosh from Sorenson Media (www.sorenson.com).

HipFlics

HipFlics is TotallyHip's entry into digital video enhancement, compression, and processing applications. It can be used as a stand-alone product or with other digital and Web video authoring tools. It supports MPEG-4, AAC audio, and other codecs for QuickTime. HipFlics is an affordable solution to batch processing, cropping, watermarking, and filtering effects and also offers a "before/after" preview feature to show you how the file will appear before you process it. The most recent version of HipFlics boasts a unique timeline feature, faster compression, and full compliance with QuickTime 6. The price is $50; available for download from www.totallyhip.com.

QTVR

QTVRAS

The first application to streamline the creation of QTVR panoramas, objects, and scenes, QTVRAS still shines in the area of QTVR authoring. The interface is especially well-designed and easy to use. Sadly, Apple has not seen fit to keep this application updated, and it has not undergone a major revision or even a minor update since its release in 1998. Thus, if Cubic VR is something you want to pursue, this application will be of no help. That said, QTVRAS is still the program of choice for many QTVR content creators, and its unchanging stability can be seen as a virtue, even. Available from Apple Computer (www.apple.com/quicktime/qtvr/authoringstudio) and selected retailers, $275.

VR Worx™

For authors who wish to create QTVR content with a PC and therefore cannot make use of the venerable Mac-only QuickTime VR Authoring Studio, the VR Worx from VR Toolbox comes as a godsend. VR Worx bundles together three heretofore separate applications to include panorama, object movie, and scene-creation capabilities, bringing it to the level of QTVRAS, with the promise of regular updates to the software, no less.

VR Toolbox improved this application significantly with Version 2.1. The panorama stitcher no longer keeps source images within the project files, slimming file sizes down dramatically. Stitching goes faster and you can add transitions between two different panoramas. It is also possible to combine object movies with panoramas. There are some hitches in this most recent version of VR Worx, however. Unlike REALVIZ Stitcher, the panorama stitcher will not allow the creation of Cubic VR panoramas. Available from VR Toolbox (www.vrtoolbox.com) for Windows and Macintosh, $300.

REALVIZ Stitcher

Image stitching software

When Apple dropped the ball with its own QTVR authoring software, others picked it up and ran. Stitcher, one of the most interesting alternatives for creating virtual panoramas and object movies, has become the tool of choice for many who want to create Cubic VR movies and other sophisticated VR projects. Stitcher allows not only rectangular panoramas but also the creation of odd-shaped panoramas as well as cubics. Stitcher features an easy-to-navigate interface and handy tools such as focal-length controls and a command that smoothes out and blends divergent exposures and color balances in component photographs. Available from www.realviz.com, $500.

ConVRter

DeliVRator

VR Tools unveiled these QTVR tools some years ago, and it appears they have not upgraded them in awhile. They are optimized for QuickTime 3 and functional only in classic versions of Macintosh (no Windows support) and thus may be of limited interest. ConVRter manipulates pan, tilt, and field-of-view settings and lets you add controller bar text, edit URL hotspots, and create QuickTime VR streaming previews using QuickTime 3.0 Video Effects. It can also extract a full panoramic picture from any panorama node or extract a stand-alone single-node panorama movie from a multinode QuickTime VR movie.

DeliVRator optimizes QuickTime movie files and lets you know how fast your QuickTime files download by means of a virtual test connection. According to distributor VR Tools, DeliVRator:

- Tests the progressive download of QuickTime movies using a virtual connection
- Optimizes QuickTime movie files to maximize user experience of streamed movies
- Serves as an editor of low-level movie control structures, QuickTime AtomContainers, as well as exportable QuickTime movie image data

DeliVRator uses a simple drag-and-drop reordering of media samples to further optimize QuickTime VR and other QuickTime files. Available for Mac OS 9 and previous, only from VR Tools, vrtools.com/products/conVRter.html, free.

Other QuickTime Software

Snapz Pro 2.0 and 1.0

Still and motion computer screen capture

Macs and PCs both provide the ability to perform rudimentary screen captures, but users who need to capture screen information can benefit immeasurably with Snapz Pro. Snapz lets you save screen shots in numerous formats, notably including motion screen captures in QuickTime. The program lets you scale, crop, add watermarks, autoselect windows—the list goes on. The tutorials in the CD in the back of this book—like the ones done on scores of other how-to CDs—were created with Snapz. Available from Ambrosia Software, ambrosiasw.com. Mac OS 9 version, $40; Mac OS X version, $49; sans QuickTime Movie capture, $29.

QTBatchExporter

QuickTime movie batch processing

QTBatchExporter enables batch-compressing sets of video files rather than compressing them one at a time with QuickTime Pro. In Macintosh OS 9, the application gives the user the choice of processing exclusively with the CPU for maximum speed or running in the background to allow other computer activities such as reading email (such multitasking is a standard part of Mac OS X and Windows alike). QTBatchExporter also allows drag-and-drop functionality and accurate estimation of processing times. Unlimited processing with Activation key available from http.//order.kagi.com/cgi-bin/store.cgi?storeID=UUJ&&, $24.

Appendix A
Installing QuickTime and Upgrading to QuickTime Pro

You may already have QuickTime installed (if you are using OS X on the Mac, you already have this as part of the operating system). To see if you have QuickTime, follow these steps:

1. Open your "Control Panels" folder; Mac OS 9 users will see a "QuickTime Settings" icon (Figure A.1), whereas Windows users will notice the "QuickTime" icon (Figure A.2) if your computer is QuickTime ready. If you do not see the icon, then you do not have QuickTime and you will have to install it.
2. Double-click the "QuickTime Settings" of the "QuickTime" icon to open the control panel.
3. Make sure the fly-out menu setting at the top of the panel is set at "About Quick-Time," if it is not set already. Some wording in the control panel will tell you which version of QuickTime you have (Figure A.3).
4. If the version is anything less than QuickTime 6, you will want to get and install QuickTime 6. Icons bearing the captions "QuickTime 32" or "QuickTime 16" will indicate very old versions of QuickTime on Windows computers.

Standard or Pro Edition?

The standard version of QuickTime has many virtues: It is free and features exceptional playback of music, video, and text. If you want to take full advantage of what QuickTime has to offer, however, you will want upgrade to the Pro edition. If you do not know which version you have, follow these simple steps:

For Macintosh OS 9 and Windows users:

1. Open the "QuickTime Settings" panel.
2. From the fly-out menu, select "Registration" (Figure A.4).
3. Identify which version of QuickTime is on your computer. If the line "QuickTime Key" is followed by "5.0 Pro Player Edition," then you have the Pro version installed already. If the line reads "Standard Edition," then you should upgrade.

Figure A.1 The "QuickTime Settings" icon (Mac OS 9).

Figure A.2 The "QuickTime" icon (Windows).

Figure A.3 QuickTime version inquiry.

For Macintosh OS X users:

1. Open the "QuickTime Panel" in "System Preferences."
2. Click the "Registration" button to open the "Registration" dialog box (Figure A.5).
3. If the line "QuickTime" is followed by "6.0 Pro Player Edition," you have the Pro version. If you see the words "3.0 or 4.0 Pro Player Edition," you have an older version and will need to get a new registration key code to install the 6 Pro edition of QuickTime.

You need a reliable Internet connection to ensure an uninterrupted transfer in order to complete the installation. Open your browser (Internet Explorer, Netscape Navigator, Mozilla, Chimera, or other) and go to the QuickTime Download site at

Figure A.4 The "QuickTime Registration" box.

www.apple.com/quicktime/download (Figure A.6) and follow directions there. If you wish to install QuickTime without connecting to the Internet for the entire process, you may download a stand-alone installer at www.apple.com/quicktime/download/standalone. That way you can install it on computers that are not connected to the Internet.

Installing QuickTime on the Windows platform

Before you attempt to install QuickTime on your PC, please be sure your system satisfies the following minimum requirements:

- Windows 95, 98, NT, ME, or 2000 operating system
- At least 32 MB RAM
- Sound card and speaker
- DirectX multimedia suite, Version 3 or later

Figure A.5 The "QuickTime Registration" dialog box in Mac OS X.

QuickTime 6 may be installed over the World Wide Web using a small setup file that manages all the files you need for QuickTime. This simplifies installation by placing only the files you will need to run QuickTime on your operating system. The installer automatically detects updates to QuickTime software components as they emerge and downloads only those files deemed necessary for your system.

After clicking "Download QuickTime" on the QuickTime Web site, the QuickTime installer will automatically download and begin the Web installation process (Figure A.7).

Your computer will present a series of screens beginning with the welcome message (Figure A.8), followed by the license agreement (after reading, click "Agree").

The "Choose Installation Type" screen should appear next, giving you the following options:

- Minimum—Installs the QuickTime Player, Web Browser Plug-in, and essential QuickTime system software, including MP3, VR, and Flash. The approximate download size is just over 4 MB.
- Recommended—In addition to the minimum package (see previous bullet), this installs the PictureViewer, authoring support, DV support, and media exporters, for a total size of 7.2 MB.

Download the free player.

Select your operating system:

○ X Mac OS X
v10.1.3-10.1.5*

○ 📷 Mac OS 8.6/9

◉ 🪟 Win 98/NT/Me/2000/XP

*QuickTime 6 Included in OS X
v10.2
Check System Requirements

Select a language:

[English ⬍]

Subscribe to newsletters.

Newsletter subscriptions:

☐ **QuickTime News.** E-mail
announcements about QuickTime
events, updates, special offers,
and products.

☐ **Apple eNews.** E-mail newsletter
about Apple products, special
offers, and company news.

E-mail Address

[]

Read Note to QuickTime Pro, DVD
Studio Pro, and Final Cut Pro users.

(Download QuickTime)

If you experience internet difficulties installing QuickTime, download the
Standalone installer or visit QuickTime Support for installation help.

Figure A.6 The Apple "QuickTime Download" site.

Figure A.7 The QuickTime installer will automatically download and begin the Web installation process.

Figure A.8 Your computer will present a series of screens beginning with the welcome message.

- Custom—This option lets you customize QuickTime by installing just the components you choose. Options include QuickTime for Java, QuickDraw 3D, and QuickTime diagnostics.

To take full advantage of the options QuickTime has to offer, click on the "Custom" button and continue ahead by pressing the "Next" button. In the next screen, select all the components offered by checking all the boxes listed.

After selecting the setup type and installation options, click "Next" to go on to the "Select Program Folder" window (Figure A.9). The "Setup" program automatically creates a folder called "QuickTime" to install program icons. You can type a new folder name or select an existing folder from the list. Once you have made your selections, click "Next."

You should see the QuickTime Pro "Registration" window (Figure A.10).

If you have a registration number for QuickTime Pro, enter the name and number and click "Continue." If you have an old registration "key" number for QuickTime 5, you will need to get a new one for QuickTime 6, as the older keys will no longer work. You can skip filling in this information for now if you do not have a current registration number (Figure A.11).

The next screen gives you the option of designating a proxy, which may be the case if you are using an Internet Service Protocol (ISP) through your corporation. In this case, consult your system administrator about filling in the correct information. In most cases, however, you may leave this box unchecked. Click "Continue."

The next screen will ask you to choose your Web connection speed. Depending on what type of Internet access you have, select from the appropriate categories:

Figure A.9 The "Setup" program automatically creates a folder called "QuickTime" to install program icons.

Figure A.10 The QuickTime Pro "Registration" window.

Figure A.11 If you have an older version of QuickTime Pro installed, a window will appear asking if you want to continue the QuickTime 6 installation and lose the Player Pro functionality (you will have to pay for an upgrade if you want to have the latest version of QuickTime Pro). Click "Yes."

Figure A.12 This screen gives you the option of designating a proxy, which may be the case if you are using an ISP through your corporation.

- 28.8/33.6 K bits/second modem
- 56 K bits/second modem/ISDN
- 112 K bits/second dual ISDN/DSL
- 256 K bits/second DSL/cable
- 384 K bits/second DSL/cable
- 512 K bits/second DSL/cable
- 768 K bits/second DSL/cable
- 1 M bits/second cable
- 1.5 M bits/second T1/intranet/LAN
- Internet/LAN

The "QuickTime Installer" window appears next; click "Continue." You will see the installer downloading the software files and checking its progress (Figure A.13). Download time will vary according to the type and speed of your Internet connection. It can take as little as minutes or exceed an hour if your connection is very slow. If you lose your connection or cancel the download, the files will be saved nonetheless so that when you are ready to resume installation, the files will build from the point where they left off rather than start from scratch.

The QuickTime Setup Assistant appears next, sequentially displaying the following windows for you to double-check and, if necessary, change connection speed, browser plugin, and file-type associations. You should then see a screen indicating a successful installation (Figure A.14). At this point, if you would like to review the QuickTime "READ ME" file or see a sample movie using QuickTime Player, click the appropriate boxes. When you have completed your selections, click "Close."

Figure A.13 You can check the installer's progress as it downloads files.

Figure A.14 You will see this screen when the installation completes successfully.

Figure A.15 Mac users will see a file dubbed simply "QuickTime Installer."

Installing QuickTime on Mac OS 9 and previous operating systems

After following the detailed downloading process previously mentioned, Mac users will see a file dubbed simply "QuickTime Installer" (Figure A.15). Double-click this icon to begin the Web installation process.

Your computer will present a series of screens beginning with the welcome message (Figure A.16), followed by the license agreement (after reading, click "Agree").

The "Choose Installation Type" screen should appear next. To take full advantage of the options QuickTime has to offer, click on the "Custom" button and continue ahead by pressing the "Continue" button (Mac). In the next screen, select all the components offered by checking all the boxes listed. Click "Continue."

Figure A.16 Your computer will present a series of screens beginning with the welcome message.

If you have an old registration "key" number for QuickTime 5, you will need to get a new one for QuickTime 6, as the older keys will no longer work. You can skip filling in this information for now if you do not have a current registration number.

The next screen gives you the option of designating a proxy, which may be the case if you are using an ISP through your corporation. In this case, consult your system administrator about filling in the correct information. In most cases, however, you may leave this box unchecked. Click "Continue."

The next screen will ask you to choose your Web connection speed. Depending on what type of Internet access you have, select from the appropriate categories:

- 28.8/33.6 K bits/second modem
- 56 K bits/second modem/ISDN
- 112 K bits/second dual ISDN/DSL
- 256 K bits/second DSL/cable
- 384 K bits/second DSL/cable
- 512 K bits/second DSL/cable
- 768 K bits/second DSL/cable
- 1 M bits/second cable
- 1.5 M bits/second T1/intranet/LAN
- Internet/LAN

The "QuickTime Installer" window appears next; click "Continue." You will see the installer downloading the software files and checking its progress. Download time will vary

Figure A.17 A screen will appear telling you when the installation has completed successfully. Click "Restart."

according to the type and speed of your Internet connection. It can take as little as minutes or exceed an hour if your connection is very slow. If you lose your connection or cancel the download, the files will be saved nonetheless so that when you are ready to resume installation, the files will build from the point where they left off rather than start from scratch. A screen will appear telling you when the installation has completed successfully (Figure A.17) and requesting you restart your computer. Click "Restart."

Upgrade to QuickTime 6 Pro

Now that you have installed QuickTime Standard, you should upgrade to QuickTime 6 Pro ($29.95). This upgrade will allow you to:

1. Compress video and audio files using state-of-the-art MPEG-4 and AAC compression protocols.
2. Create and edit your own streaming movies from existing QuickTime content.
3. Convert pictures and still images between standard publishing formats.
4. Add special effects to your movies.
5. Provide full-screen movie playback.
6. Make presentations and slide shows that can be played back with any application that supports QuickTime 6.
7. Compress video using state-of-the-art Sorenson Video 2 and 3 compressors.
8. Export video, audio, and pictures to more than a dozen standard file formats.
9. Enable, disable, or extract specific tracks of a movie.
10. Compress audio using QDesign Music 2 up to 100:1 for Internet streaming.
11. Save movies from Web sites.

To purchase the registration code, you must do one of the following: Open your Web browser and go to the "Get QuickTime Pro" Web page at www.apple.com/quicktime/buy.

When you open QuickTime and see the advertisement or "nag" window that appears first, click the "Get QuickTime 6 Pro Now" (Windows and Mac OS 9) or "Go Pro Now" (Mac OS 10). The "nag" window, annoying as it is, will cease to appear once you upgrade to QuickTime Pro.

What Is the "Nag" Window Anyway?

The QuickTime prompt or "nag" window (Figure A.18) that appears with a thoughtful suggestion to purchase the Pro edition works like this: If you use the QuickTime Player, you will see the window appear once every week when you open a QuickTime movie. For the browser plug-in, you will see one once the first time you play a QuickTime movie (thankfully changed by Apple to come up with less frequency with the release of QuickTime 5). Some nags reset their computer date to some distant year in the future, such as 2010, play a QuickTime movie to trigger the pop-up window, dismiss it, and then restore the computer's actual day's date. The window never reappears. The "nag" window has been a bane to many QuickTime content producers and viewers, and although there has been much ado about banishing it for good, it looks as though it is here to stay, at least for a while.

Figure A.18 The infamous QuickTime "nag" window prompt.

Open the "QuickTime Settings" control panel (Windows or Mac OS 9) or "QuickTime Panel" (Mac OS X) and select "Registration" from the fly-out menu (Figure A.19) or click the "Registration" button (Mac OS X). When the "Registration" dialog box appears, click the "Register Online" button. Follow the directions you find on the "Get QuickTime Pro" page for purchasing the Pro version, and you will receive email containing your registration code. Once you have received this code, copy it and go to the "QuickTime Settings"

Figure A.19 Select "Registration" from the fly-out menu.

Figure A.20 When you purchase your own QuickTime code, copy it and go to the "QuickTime Settings" panel if you do not already have it open, choose "Registration," and click the "Edit Registration" button.

panel if you do not already have it open, choose "Registration," and click the "Edit Registration" button (Figure A.20). Paste or write in your registration code information (your name must match what you used to purchase your registration number), and you are off and running with QuickTime Pro.

Updates and Corrections

Users of QuickTime may receive regular updates of their software simply by choosing one of the following steps:

When QuickTime Player is open, go to the "Help" menu and choose "Update Existing Software." In Mac OS X, you can also go to "System Preferences" (found in the "Dock" or third item down in the Apple menu), click on the QuickTime logo, and then click "Update."

Go to the "QuickTime Settings" control panel, choose "Update my existing QuickTime software only," and click "Update."

QuickTime will periodically check for updates itself when you are using the World Wide Web, notify you when such updates become available, and offer to download and install them on your computer.

Appendix B
Glossary

3:2 Pull-down. A method of converting 24 fps film to 30 fps NTSC (American standard) video in order to successfully enable viewing motion pictures in an electronic media format. This process adds approximately six duplicate fps to the film transferred. These pull-down frames—created by blending frames from the original source in a specific pattern—are considered undesirable for compressed movies.

4:1:1 Color. Refers to moderately compressed video color subsampling, in which the luminance channel is not subsampled but the resolution of the chrominance channel is reduced by 25%. Most DV formats, including miniDV, use 4:1:1 color.

4:2:0 Color. A form of moderately compressed video color subsampling similar to 4:1:1. Standard color for MPEG.

4:2:2 Color. Slightly compressed video color subsampling that does not rely on subsampling the luminance channel, though the chrominance channel resolution is reduced by 50%. Commonly used in professional video formats, such as BetaCamSP.

4:3 Aspect Ratio. The most common display aspect ratio for computer monitors and standard NTSC and PAL television, where the horizontal dimension exceeds the vertical dimension of the screen by 33%. Also known as 1:33 in motion picture production and exhibition.

4:4:4 Color. Uncompressed video color that has no subsampling.

8-Bit. Color depth in a video display allowing just 256 colors to show simultaneously. The GIF image format, used for displaying graphic images over the World Wide Web, uses a typical 8-bit compression protocol.

16:9 Aspect Ratio. The standard display aspect ratio of HDTV. With a horizontal dimension some 78% longer than the vertical dimension, 16:9 provides for a widescreen picture that more closely approximates a theatrical movie experience. When displayed on a normal television (which is 4:3), 16:9 material must be "letterboxed," with black bars at the top and bottom of the screen.

16-Bit. Video display color depth that allows thousands of colors to appear simultaneously. Known also as "Thousands of Colors" on the Mac OS and "high color" on Windows.

24-Bit. Color depth that allows millions of colors to be displayed simultaneously; 24-bit images can be truly photographic in quality. Also called "true color" on Windows and "Millions of Colors" on Mac OS.

ADSL. Asymmetric digital subscriber line. A type of DSL using existing twisted-pair copper wires in a standard telephone line. ADSL facilitates relatively fast downstream rates, though somewhat slower upstream rates. Rate of transmission typically ranges from 1.544 M bits/second to 8 M bits/second.

AIFF. Audio interchange file format. A file format typically used for high-quality audio information, including sampled audio and musical instrument digital information (MIDI) data. AIFF constitutes the high-quality music information file format of choice for the Macintosh platform.

ALaw. A mode of compression used for voice recordings.

Algorithm. A complex mathematical formula that exchanges codes for repetitive data in an effort to reduce the size of certain digital files. Many algorithms are designed to eliminate information that is deemed beyond the limits of human perception, as with MP3 files, for example.

Analog. Describes a method of replicating visual, audio, or other information by electronically creating and adding signals of varying frequency or amplitude to carrier waves of given frequencies of alternating electromagnetic current. Traditional telephone and broadcast transmissions as well as audio and videotape recordings have been produced using analog processes. Analog is commonly used as a term to differentiate processes that use continuous waves from those that use binary code or digital forms.

Anchor. A hypertext link denoted by an underscore to indicate that the text so underlined will take the user to a new Web page when the link is clicked.

API. Application Program Interface. An interface between the operating system of a computer and the applications running on the computer that specifies how the two communicate with one another.

Applet. A small Java application embedded in a Web page that can be downloaded and executed by a browser.

ASF. Advanced Streaming Format. The proprietary streaming media format developed and promoted by Microsoft encoded for use with Windows Media Player.

ASP. A scripting environment for Microsoft Internet Information Server that allows the combination of HTML, scripts, and reusable ActiveX server components to create dynamic Web pages.

Aspect Ratio. The relationship of the height of a movie frame to its width. Traditionally, the aspect ratio of television and video (and 35 mm film, prior to 1954) as well as consumer DV has remained a boxy 1:1.33 or 4 × 3 ratio. By contrast, most American theatrical feature films are released in an aspect ratio of 1:185 or 1:235 (anamorphic), whereas European features screen in a ratio of 1:1.66. HDTV schemes have been standardized to an aspect ratio of 1:77, or 16 × 9.

Asymmetric Codec. A compressor/decompressor that compresses slowly and decompresses quickly.

ATM. Asynchronous Transfer Mode. A packet-switching protocol for fast long-distance communications, allowing data transmission at rates surpassing 600 M bits/second. ATM was designed to support multiple services, including voice, graphics, data, and full-motion video, and allows telephone and cable TV companies to dynamically assign bandwidth to individual customers.

AU. A digital audio format used primarily in UNIX systems.

AVI. Audio-video interleave. A video format developed as part of Microsoft's Video for Windows, wherein picture and sound elements are stored in alternate interleaved chunks in the file instead of in the form of tracks, as in QuickTime. The .avi protocol has been largely supplanted by Windows Media Player's .asf format.

Background Color. The color of a background behind a sprite or other image.

Bandwidth. The capacity of an information-carrying conduit, expressed as data speed in bits/second, thousands of bits/second (K bits/second), and increasingly in thousands of thousands of bits/second (M bits/second). Bandwidth is often colloquially referred to as "pipe size," using the analogy of a tube carrying data in a liquid form such as water.

Bit. A single portion of data carrying a value of 0 or 1.

Bit Depth. The number of bits that make up the color of each pixel in a graphic image. A higher number of bits allow more nuance fidelity and richness in the color of a graphic.

Bit Rate. The speed at which binary content is streamed on a network, measured in kilobits per second (K bits/second). It takes 8 bits to make up 1 byte, which is the size of one letter, number, or symbol. Bitmap. A mode of storing graphical information by assigning a numeric value to each pixel in an image.

Bits/Second. A standard measurement of bandwidth and data transmission capacity.

BMP. A bitmapped graphics format used for still images on the Windows operating platform.

Bps. Bytes per second.

Broadband. A high-speed network connection, such as T1, cable modem, or DSL.

Buffering. In streaming media, a method of storing enough data of a streaming file to ensure that the media file can play continuously. Buffering acts as a kind of data reservoir to ensure that there is enough ready data to play the file continuously even when the stream is interrupted. Often when data streams encounter network congestion, the media file may stop playing momentarily so that the buffer can be refilled.

Byte. Eight bits.

C. A programming language used for creating complex applications. QuickTime's API was designed in C.

Cache. A directory or folder in a computer's memory where data may be stored temporarily and readily accessible. Web-page information is generally stored for a short time on the user's hard drive for ready access on return visits. Caching can also refer to distributing Internet content to multiple servers to be periodically replenished.

Capture. The process of acquiring video footage into a digital device, such as a computer or DV camera, by changing or transferring digital or analog audio or video files to binary files, which can then be edited and encoded.

CD-R. A recordable CD.

Cel-based. Pertaining to animation created from a series of still images (rather than vectors). Cel-based animation originally referred to a sophisticated method of creating cartoons by painting the drawings on separate acetate or "celluloid" sheets to be photographed over an intricate background.

CGI. Common Gateway Interface. A method used by World Wide Web documents to communicate with applications running on a Web server using scripting languages such as PERL.

Chapter List. A list of predetermined points in a QuickTime movie. A user can go directly to each point by selecting a specific chapter item in the list.

Choke Speed. A network implementation that deliberately limits bandwidth to prevent a single user from taking over and possibly crashing a network connection.

Clipping. A method of cropping a graphic so that parts of the image that extend beyond the clipping area are not displayed.

Codec. Abbreviation for Compression/Decompression. Refers to an algorithm or formula used to encode and compress media, which is later decoded and decompressed using the same protocol as the user views or listens to the file. Compression algorithms eliminate redundancies in data that are considered to be imperceptible and hence dispensable.

Color Depth. The range of colors available for a movie or image. Color depth is measured in bits, with higher values such as 24-bit providing higher quality images, albeit at a larger file size.

Compositing. The amalgamation of several visual tracks or layers to create a new or enhanced visual experience.

Compression. A method of reducing file size by discarding certain "superfluous" information in a file to facilitate and streamline transmission and reduce storage requirements of the file. Files are typically compressed before transmission and then decompressed to be played or read later.

Controller. The QuickTime control bar appearing under the movie frame allowing interactive control of the movie playback.

CPU-intensive. Refers to computer operations that require relatively large amounts of central processor power. CPU-intensive processes generally add an extra burden to the computer processor and may even lead to crashes on slower machines.

D1. A high-quality digital video standard.

DAT. Digital audio tape.

Data. Information in the form of words, numbers, or images in the form of bits. Data can be read by a computer, stored as memory, or transmitted over the Internet.

Data Rate. The amount of information per second a movie produces while playing, expressed in kilobytes per second (K bits/second). The higher the data rate, the higher the resolution and overall quality of the file.

Descriptor. A tag that defines the appearance and specific characteristics (such as font, style, and so on) of text in a text track.

Digitize. To convert analog data into a binary form. See Capture.

Dithering. A mode of transforming subtle gradations of value and hue in a random pattern of tiny dots so that graphical images can be viewed more accurately on a computer or monitor of lower bit-depth.

DNS. Domain name system. A server that converts URL descriptions into IP addresses.

Download. The act of copying a file onto one's computer hard drive from a source on the Internet, as opposed to installing a file from a CD-ROM or other disc source.

DSL. Digital subscriber line. A high-speed Internet access line that uses existing telephone lines. DSL typically provides connections directly from a telephone switching station to a home or business, avoiding much slower conventional dial-up modem connections.

DVD. Digital video disc. A disc, similar in appearance to a CD, that allows for over 6 MB of information. Movies are often recorded and stored on DVDs in the MPEG-2 format.

DVI. Digital video interlace. A video compression standard.

Effect. A type of visual media that creates an image from a combination of video data sources or generates original video data. Often used for visual transitions, including wipes and dissolves.

Effect Track. A track in a QuickTime movie that applies effects such as wipes or dissolves to a movie.

EMBED Tag. An HTML command within angle brackets that specifies how a graphic, movie, or external file will appear in a Web page. EMBED tags are part of the Netscape

JavaScript commands that are no longer recognized by Microsoft's Internet Explorer and have been superceded to a large degree by OBJECT tags.

Encoding. The process of rewriting or converting audio, video, or other media such as images into a presentable compressed video format, often including capture, reformatting, and compression.

Event Handler. A QuickTime script within a sprite intended to run in response to a user action. For example, a mouse-click event handler will operate when a user clicks his or her mouse on the sprite. Event handlers can also be triggered by the scripts themselves.

Extension. An add-on utility that enhances or extends the capabilities and functions of a given application.

Fast Start. Also known as progressive download, this feature allows a user to begin viewing and/or hearing a downloading QuickTime movie before the movie has completed loading on the user's hard drive. This feature is only available with movies using http streaming.

Favorites Drawer. In the QuickTime Player, a pull-down menu feature that enables a user to store aliases of selected movies to be loaded and played by double-clicking the icon in the drawer.

Firewall. A security device or application designed to limit or prohibit unauthorized access to a private network. Firewalls can create headaches for media producers when they impede or block the delivery of streaming media.

Firewire. Apple Computer's name for the IEEE 1394 protocol.

Flash. A proprietary format for creating vector-based animation, designed and marketed by Macromedia, Inc.

Flash Track. A track in a QuickTime movie containing Macromedia Flash media samples.

Flattening. The act of making a QuickTime movie self-contained, removing all references to external media used in the construction of the movie. Flattening is the last stage of QuickTime movie development before distribution to the Web or other exhibition platform.

FLIC, or FLC. An animation format originally developed by Autodesk, Inc.

Format. The specific arrangement of information an application or device requires in order to play or operate the file. Examples of formats for video storage and presentation are VHS, MiniDV, DVD, and so on.

Frame. A single image in a movie or video sequence.

Frame Animation. In QuickTime VR, a process whereby all frames play off the current view.

Frame Differencing. A method of time compression wherein only pixels in the dynamic portions of a motion picture or video frame series are described anew from frame to frame, whereas the static portions of frames following remain unchanged. For example, if a person appears speaking before a blank background, frame differencing allows considerable compression by describing all the pixels in the first (key) frame and thereafter only those pixels that make up a moving area in the frames; thus the background does not need to be described in subsequent frames of the same scene.

Frame Rate. The sample or playback rate of a motion picture or video file, determined by the number of discrete still images that will play or be recorded per second to preserve the illusion of moving pictures. The traditional frame rate for motion picture production and exhibition was established by Thomas Edison as 16 fps and standardized at 24 fps when sound films became the norm. NTSC television recording and playback uses a nominal 30 fps (actually 29.97 since the adoption of color), whereas the PAL standard uses 25 fps. Frame rates for playback over the Internet are flexible and vary according to file size and the amount of bandwidth available for streaming. Streaming video is generally encoded at a lower frame rate than the original recording rate (often 12 or 15 fps) to decrease the file size and facilitate streaming over the Internet.

FTP. File Transfer Protocol. A method for uploading or downloading files from a Web server.

Gamma. The difference between the brightness range of an image displayed by one computer/display and the same range displayed by another. Macintosh computers boast built-in gamma correction, whereas most PC computers are uncorrected. Thus, images that appear normal on a Mac will look dark on a PC monitor.

GIF. Graphics Interchange Format. A type of file format designed by Compuserve to encode, present, and store graphics files at a high rate of compression. GIF is considered a lossless format, meaning that no information is discarded in the encoding of data. GIF files can incorporate limited animation and transparency of selected colors. GIF files are limited to 256 colors and are the preferred format for presenting pixel-based type, line art, and simple color graphics over the World Wide Web.

Graphics. Any digital information presented as still or nonmoving. Generally 2D artwork, including pixel-based type, line art, illustrations, and photographs. Typically produced or formatted using a graphics application such as Illustrator or Photoshop.

Graphics Mode. A modification of an image that determines how it blends with its background.

GSM. A lossy compression format for speech.

H.261, H.263. Standard codecs for video streaming.

Hint Track. A QuickTime track for streaming movies that specifies how the content will be divided into packets for transmission.

Host. A computer on the server side of a network connection that a user accesses to receive and send information.

Hotspot. An interactive clickable area embedded into a QTVR panorama or object node that a user can click a mouse on in order to visit a new node, a Web page, or other place of interest.

HSV. Acronym for hue, saturation, and value. A method of defining colors.

HTML. Hypertext Markup Language. A simple tag-based computer language incorporating hypertext, used to create World Wide Web pages.

Http. Hypertext transfer protocol. A protocol for sending Web page information and hypertext data over the Internet.

IEEE 1394. Also known as "Firewire" and "I-Link." A cross-platform high-performance serial bus providing a single plug-and-play connection supporting up to 63 devices, theoretically supporting data transfer speeds up to 400 M bits/second. IEEE 1394 is expected to replace older parallel and serial interfaces, including the Small Computer System Interface (SCSI).

IEEE 1394-b. The next implementation of IEEE 1394, allowing data transfer at rates up to 800 M bits/second.

Image. A picture or 2D representation, usually a photograph, illustration, or other graphic. Digital images may be either bitmap or vector-based.

Immersive Imaging. Another term for virtual reality.

Interpolate. The process of calculating an intermediate value between two values.

Interstitial. An advertisement placed during, before, or after a media presentation over the World Wide Web.

Intranet. A local network used by a business or school for data sharing, presentations, or other applications.

IP. Internet Protocol. The protocol defining the method of formatting, addressing, and sending data over the Internet. The IP contains routing information associated with datagram delivery.

ISDN. Integrated Services Digital Network. A medium-speed electronic data transmission technology, often provided over modified telephone lines. Single ISDN runs at 64 K bits/second, whereas double ISDN runs at 128 K bits/second.

ISO. International Standards Organization. A consortium that sets worldwide standards for multimedia and photographic data formatting and transmission, such as exposure indices for film.

ISP. Internet service provider. A business that provides Internet service between computers and a main server.

Java. An object-oriented programming language evolved from C++, implemented for use on Web pages and designed to run on several platforms.

JavaScript. A scripting language unrelated to Java (Netscape bought the rights to the name in 1995) for adding interactive elements triggered by commands embedded in Web pages.

JFIF. A still-image graphics format related to JPEG.

JPEG. Joint Photographic Experts Group. A widely used format for encoding and presenting photographs and other artwork digitally. JPEG uses a compression scheme that discards information to reduce the size of files and is thus considered a "lossy" format unsuitable for archive purposes. JPEGs are used primarily for graphics disseminated over the World Wide Web.

K Bits/Second. Kilobits per second. The standard used to gauge the rate that data flows over a communication line. See Bandwidth.

Karaoke. A QuickTime movie where a music track is accompanied by synchronized text tracks, allowing lyrics to run concurrently with a song.

Keyframe. A frame that is described in its entirety by a temporal compression codec. The keyframe is usually determined by its dissimilarity to preceding or succeeding frames. The keyframe does not rely on other frames or samples in a sequence for any of its information but occurs intermittently according to the set keyframe rate or other factors. The greater number of keyframes designated in a movie, the bigger that file will be.

Keyframe Rate. The frequency that keyframes are set in a temporally compressed frame sequence.

LAN. Local-area network. A network that connects terminals within a single facility, often not connected to the Internet.

Layer. The order in which tracks are stacked in a QuickTime movie, determining which tracks are visible. Images with lower layer numbers are displayed on top, whereas images with higher layer numbers may be obscured by images of lower layer numbers.

Linux. An open-source operating system based on the UNIX platform, created by Linus Torvald.

Local Playback. A file residing on the same device as the QuickTime Player (or other media player).

Lossless. Regarding a type of compression that conserves the data of a file without discarding any information. Also called nondestructive compression.

Lossy. A term describing a compression scheme that discards data deemed redundant or unnecessary so that a file can be compressed to a small size. JPEG is a good example of a lossy compression format.

Lowband. See Narrowband.

LZW. A proprietary lossless compression scheme used in compressing GIF files.

M3U. A metafile pointing to an MP3 stream.

M Bits/Second. Megabits per second. A measure of bandwidth used to measure comparatively high data transmission rates. An Ethernet connection can operate at 10 M bits/second, whereas a dial-up telephone Internet connection runs at a maximum of 56.6 K bits/second.

Mask. A monochromatic image used to block areas from appearing in an original image. In QuickTime movies, masks must conform to the original image size and use only black and white.

Matte. Defines which pixels will be displayed in a QuickTime movie track. QuickTime movie mattes can be 8 bits deep and specify various degrees of transparency.

Metadata. Refers to machine-understandable information for the Web. Metadata is data about data, including structured data about digital and non-digital resources that can be used to support a wide range of operations. In general, the term refers to any data used to aid the identification, description, and location of networked electronic resources.

Metafile. A file containing a URL that points a media player to a streaming media source. Metafiles may be served only using http and may be static or generated dynamically. Metafiles commonly use the extensions .mov (QuickTime), .ram (RealMedia), .asf, and .wmx (both Windows Media).

MIDI. Musical instrument digital interface. A format for sending music instructions to a synthesizer.

Mime. Multipurpose Internet mail extensions. MIME enables Web browsers and installed plug-ins to open and play non-HTML files, specifically those including video and audio.

Modifier Track. A track in a QuickTime movie that modifies data of other tracks. An example of one type of modifier track is a tween track.

Movie. An amalgam of QuickTime tracks, each track containing media used to display pictures or play video or audio. A movie can consist of video, still images, text, VR, or even audio only, or any combination of these.

Movie Controller. An interactive component usually located at the bottom of a QuickTime movie player or plug-in screen. The controller consists of buttons and sliders that allow the user to control the playback of the movie.

Movie Poster. A still image that serves as the opening or preview picture of a QuickTime movie in a Web page or player window. The poster can derive from a frame of the movie itself or can be a separate image.

MP3 (MPEG-1, Layer 3). The MPEG audio Layer 3 standard used for compressing audio signals defined by the Moving Picture Experts Group. MP3 uses perceptual audio coding

and psychoacoustic compression to remove portions of sound data deemed audibly imperceptible by human listeners. MP3 also adds a modified discrete cosine transform (MDCT) protocol that implements a filter bank, increasing the frequency resolution 18 times higher than that of MPEG audio Layer 2. MP3 has emerged as the most popular format for compressing, transferring, and storing songs on the Internet, due in part to the inability of the music industry to control and impose user fees on its implementation.

MPEG. One of several protocols designed to compress digital video and audio information as laid down by the Moving Pictures Experts Group, which belongs to the ISO. See MPEG-1, MPEG-2, MPEG-4, MP3.

MPEG-1. A lossy compression method using an interframe compression scheme predicated on the assumption that most action in a video occurs before a static background. Under this system, each entire frame is not necessarily compressed, rather only the differences between frames. The interframe method encodes frames according to three types: I-frames, P-frames, and B-frames.

MPEG-2. A broadcast-quality codec/format for video and multimedia. MPEG-2 is widely used for compression and storage for DVDs.

MPEG-4. A multimedia codec designed for video transmission over the Internet. A major advantage of MPEG-4 is its inherent scalability, wherein programs are encoded once and automatically played back and transmitted at various rates depending on the available bandwidth of given network connections.

Multicast. A form of streaming where one program is transmitted to many users simultaneously. Users can join or leave a multicast at any time but cannot interact during this kind of media.

Music Track. A track in a QuickTime movie containing sound samples, specifically music.

NAT. A method of connecting numerous computers to the Internet or another IP network using one IP address.

Nodal Point. The point in a lens where an image inverts as it travels through to the camera target or film plane. It is crucial to establish a lens's nodal point and rotate the camera on this point to prevent parallax error when photographing QTVR panoramas.

Node. In QuickTime VR, the point from which a QTVR panorama is photographed and subsequently viewed. Numerous nodes make up a VR scene.

NTSC. National Television System Committee. The standard for television capture, recording, and transmission used predominantly in the United States, Canada, Mexico, and Japan. The current NTSC system was adapted from a monochrome system inaugurated in the 1940s and adapted for color in 1953.

Object Image Array. In QTVR, a 2D sequence of frames in the video track of an object movie containing images of an object photographed or otherwise rendered from a variety of angles.

Object Node. In QTVR, a description of the angle and other characteristics for viewing an object.

Packet. A unit of data routed between a server and a user on the Internet or another network. These chunks of data are created when Transmission Control Protocol (TCP) divides a file to facilitate efficient passage through routers. Each packet is separately numbered and identified with the Internet address of the destination. The individual packets for a given file may travel different routes through the Internet. Upon arrival, the user's TCP reconstitutes them into the original file.

PAL. Phase Alternation Line. A color-encoding video standard used primarily in Europe, wherein a subcarrier phase taken from the color-burst information is inverted in phases from one scanning line to the next. The PAL system avoids hue errors that often result in NTSC systems when video information is transmitted.

Palindrome Looping. A mode of continuous play where a QuickTime movie plays forward and backward over and over again. The name derives from palindrome, a word or phrase that spells out identically when read forward or backward, such as "kayak."

Panorama. In QTVR, a photographed or rendered picture that can be viewed from a single vantage point by panning, tilting, or zooming in or out by dragging a computer mouse. The panorama is different from a normal image in that it gives the illusion of wrapping around the viewer. Panoramas may be completely or partially cylindrical or spherical.

PDF. Portable document format. A file format marketed by Adobe, Inc. for page-oriented, multiplatform documents.

PICT. A still-image file format used widely on the Macintosh platform.

Picture Track. A track containing picture samples. A picture track is often used to provide a static backdrop for a sprite track.

Pixel. A picture element of a computer display, the smallest visible element seen as a tiny dot. A computer raster is made up of thousands of such pixels.

Playhead. A visual indicator in the QuickTime "Tracks" tab to indicate the current point in the linear timeline.

Poster. A still image that holds the place of a QuickTime movie on a Web page. The poster may or may not be an image from the movie itself. The user activates the movie by clicking on the poster.

Preferred Rate. Default playback rate of a QuickTime movie.

Progressive Download. A feature whereby a user may begin watching or listening to a QuickTime or other movie as it downloads over the Web before the actual download is completed. Progressive download is known as "Fast Start" in QuickTime. It is also referred to as HTTP streaming to differentiate it from RTSP or "true" streaming.

Protocol. An agreed-on set of standards for compressing, transmitting, or storing data.

QTVR. QuickTime Virtual Reality. See Virtual Reality.

RAID. Redundant array of inexpensive discs. A method of using several relatively small hard discs in unison to create a synergistic effect of a much larger storage device.

Rate. A measure of how fast a movie plays in multiples of its original or native speed. In QuickTime, a negative rate will enable reverse playing mode in a movie; for example, a rate of −1 will allow a movie to play backward at normal speed, 2.0 will play forward at double speed, and 0.5 will play at half speed.

Relative Path. One of two types of paths used in HTML page construction. A relative path contains directions to the item relative to the HTML page.

RLE. Run-length encoding. The process of searching for repeated runs of a single symbol in an input stream and replacing them by a single instance of the symbol and a run count.

RTP. Realtime Transfer Protocol. A transport protocol that delivers live events to one or more viewers simultaneously, in what is known as RTSP streaming.

RTSP. Realtime Streaming Protocol. The mode for live-streaming media transmission to one or more users simultaneously, while also allowing random access to the media stream.

Scene. A grouping of QTVR nodes that create a composite virtual environment that a user can navigate by clicking in selected hotspots embedded in each QTVR node.

SCSI. Small Computer System Interface. A parallel-style interface used for high-speed transmission of data between computers and peripheral devices such as scanners, CD burners, and so on. SCSI connectors are being gradually phased out in favor of more convenient and faster connection schemes, including Firewire and USB-2.

SDP. Session Description Protocol file. A text file documenting a streaming session that provides a user's computer with access information.

SECAM. Systeme Electronique Couleur Avec Memoire. A television signal standard used in France, eastern Europe, Russia, and certain African nations. SECAM resembles PAL in that it uses 625 (originally 819) lines per frame, 50 fields per second, and a frame rate of 25 fps; it differs in its use of FM-modulated chrominance to encode color.

SIT. A lossless file compression format used with the Macintosh platform, the equivalent of the Windows-based ZIP.

Skin. A custom graphical interface for a QuickTime movie, often including buttons and taking the place of the standard QuickTime Player or Plug-in interface.

SMIL. Synchronized Multimedia Integration Language. A language that lets Web site creators use text files to define and synchronize multimedia elements such as video, audio, and still images for Web presentation and interaction.

Solaris. The Sun Microsystems computer operating system, derived from UNIX.

Spatial Compression. A mode for compressing image files that searches for patterns and repetition among pixels in a single frame. This codec reduces the amount of data needed to represent an image by relying on a generalized description of the data based on color and value redundancy among pixels in the file. Run-length encoding is one form of spatial compression used by many codecs. In this method of spatial compression, the data rate and file size decrease while the picture loses sharpness and definition. For many codecs, the degree of spatial compression is controlled by lowering the values for quality and data options, thus increasing spatial compression.

Sprite. An interactive element in a QuickTime movie that can display an image as well as hold actions to be performed in response to a user's command, such as a mouse click. Sprites can move and change images to create animation sequences. A sprite is defined once and then animated by commands that change its position or appearance.

Sprite Track. A track in a QuickTime movie containing sprite media samples.

Stitching. The technique of joining several photographs or other images together to form a seamless panoramic image, used in QTVR.

Streaming. The transmission of video or audio (or both) data over the Internet continuously in real time, using numbered data packets instead of a single downloaded file.

S-video. A video format, sometimes referred to as "Y-C" (luminance-chrominance), where luminance (brightness) and chrominance (color) information are encoded as separate signals. S-video provides better quality than standard NTSC composite video (where all chrominance and luminance information is encoded together) and less quality than composite (where the primary colors are encoded separately).

T1 Line. A high-speed digital connection that can transmit data at approximately 1.5 M bits/second. Sometimes called a leased line, T1 connections are typically used by small- to medium-sized businesses and educational institutions to link to the Internet.

T3 Line. An extremely high-speed connection that can transmit data at a rate of 45 M bits/second, roughly equal to the bandwidth of 650 telephone lines. T3 connections, capable of transmitting full-motion real-time video, are used by large corporations and universities as well as major Internet service providers.

Targa. See TGA.

TCP. Transmission Control Protocol. A set of rules used along with the IP to send data in the form of message units between computers over the Internet. Whereas IP handles the actual delivery of the data, TCP keeps track of the individual packets (component parts of the message) for efficient delivery of the data for efficient routing through the Internet.

Telecine. The process of transferring motion picture film sequences to video. In the United States, a 3:2 pull-down technique is used to conform the 24-fps rate of film to the 30-fps rate of video.

Temporal Compression. A method of compressing video content by discarding superfluous visual information the codec assumes is redundant. A temporal compression codec describes all pixels in the first frame of a sequence but only pixels that differ from this initial frame for each frame thereafter.

Text Descriptor. A mark-up tag similar to an HTML tag containing formatting information for text tracks.

TGA. A color-image file format created by Truevision. The TGA format supports 8-, 16-, 24-, and 32-bit color depth and an alpha channel and allows lossless compression, including basic run-length compression. Also known as Targa file format.

Tick. One-sixtieth of a second; a QuickTime-specific measure of time.

TIFF. Tagged Image File Format. A public-domain raster file format, TIFF is one of the most popular formats for storing and transporting bit-mapped images. TIFF can store black-and-white, gray-scale, or color graphics of any resolution.

Tiling. A method used in QTVR to divide an image into component slices to avoid having to load the entire image into a user's computer memory during playback.

Time Slider. The timeline portion of the QuickTime controller that lets a user drag a playhead to any place in a movie in order to go directly to that point in the movie.

Time Stamp. Information written in a text sample's code describing start and end times of a QuickTime movie or sequence.

Track. The standard receptacle for media in a QuickTime movie. Each track is independent of other tracks but all tracks in a movie are linked in time. When a movie plays, all tracks in the movie play in unison. Tracks are differentiated according to the type of media they contain, such as video, audio, Flash, VR, or text.

True Streaming. A method of matching the bandwidth of a media signal to the available bandwidth of a user in order to transmit an event in real time; also known as RTSP streaming.

Tweening. The technique of interpolating new information—specifically, new frames—to expand or smooth a movie's presentation between existing frames. Tweening is used extensively in animation applications.

Tween Track. A QuickTime movie track that modifies the display of other tracks through tweening.

UDP. User Datagram Protocol. A connection-less protocol that runs on top of IP networks, offering a direct mode of sending and receiving datagrams over an IP network. UDP is sometimes used in place of TCP/IP, though it does not share the latter's error-recovery capabilities.

Unicast. One-to-one streaming, as opposed to multicast.

URL. Uniform resource locator. The address of a file accessible on the Internet.

USB. Universal serial bus. A plug-and-play connection between a computer and a peripheral device such as a printer or scanner that supersedes the older serial connector. USB supports a data speed of up to 12 M bits/second.

USB 2.0. An upgraded version of the original USB interface, allowing data transfer at rates of up to 480 M bits/second. At 40 times the speed of the original USB protocol, USB 2.0 is poised to rival the existing IEEE 1394 standard.

User Data List. A QuickTime data structure containing readable text information about a movie.

VBR. Variable bit rate. A method of compressing data, especially film and video as well as audio, where certain sections are encoded at different bit rates to ensure that complex segments are encoded at a higher rate while simpler segments are encoded at a lower rate. VBR encoding provides a highly efficient way of preserving the smallest file sizes while ensuring high quality.

Vector. A format enabling graphical information to be stored as mathematical algorithms rather than pixels, enabling accurate scaling and relatively small file sizes.

Viewing Limits. In QTVR, limits programmed into an immersive panorama or object movie to keep the viewing experience within prescribed bounds. QTVR panoramas often limit the degree to which a viewer can tilt or pan within the panorama.

Virtual Reality. The illusion of all-encompassing environmental space, created and experienced with a computer. Virtual reality is highly interactive rather than passive (such as watching a video).

WAV. A Windows format for sound files.

Windows. The computer operating system used by 90% of the world's computers, designed and marketed by Microsoft, Inc.

Wired Movie. A QuickTime movie containing scripts that run in response to a user's actions.

Wired Sprite. A sprite that responds to user interaction, such as in buttons that perform operations when clicked or touched.

XML. Acronym for Extensible Markup Language. A mark-up language similar to but more flexible and consistent than HTML.

ZIP. A lossless compression method used extensively on the Windows platform.

Zoom In/Out Buttons. Buttons in a QTVR movie controller or skin that enable magnification/demagnification of a portion of an image, panorama, or object.

Appendix C
QuickTime Web
Sources and Articles

Perhaps the most up-to-date information on QuickTime and its many applications may be found, logically enough, on the World Wide Web. Some of the information on the sites listed may appear dated, but much of it is still relevant. Peruse the following for even more information than any one book can deliver.

QuickTime in General

The Little QuickTime Page
By Judith Stern and Robert Lettieri
www.judyandrobert.com/quicktime

QuickTime Editing
Editing in QuickTime Player Pro
desktopvideo.about.com/library/weekly/aa052601a.htm

QuickTime 101
edvista.com/claire/qt

The Many Facets of QuickTime (QT4, Part 1)
By Derrick Story
www.storyphoto.com/multimedia/qt_primer/qt_primer1_2.html

QuickTime 4, New Capabilities, Broader Audience
www.storyphoto.com/multimedia/multimedia_QT4_review.html

The Basics of QuickTime 5
By Reno Marioni
hotwired.lycos.com/webmonkey/01/42/index4a.html?tw=multimedia

Text Tracks

LiveStage Pro Tricks: How to Navigate Through a Chapter Track in LiveStage Professional
users.skynet.be/livesite/pages/howtochap.html

Rolling Titles Made Easy
www.oreillynet.com/pub/a/mac/2001/02/23/qt_authoring.html

Creating Rich Media with QuickTime
By Barb Roeder
www.streamingmedia.com/tutorials/view.asp?tutorial_id=107
Good basic wrap-up on text track creation.

QuickTime Media Skins

Creating Media Skins
developer.apple.com/techpubs/quicktime/qtdevdocs/REF/whatsnewqt5/Max.16.htm#211
 23
From the Apple QuickTime API Documentation series.

Gimme Some Skin: How to Use GoLive to Create QuickTime Skins
By Stephen Schleicher
www.creativemac.com/2001/07_jul/tutorials/skin1/skin1-page1.htm

Mastering QuickTime Media Skins
By Julian H. Scaff

Adding Media Skins Using the QuickTime API
developer.apple.com/techpubs/quicktime/qtdevdocs/REF/whatsnewqt5/Max.18.htm
Very technical article on the making of media skins.

Interactive QuickTime, Flash, and Wired Sprites

TotallyHip LiveStage Tutorial Archive
blueabuse.totallyhip.com/tut

Integrating Flash and QuickTime for Dynamic Media Delivery
By Barb Roeder
www.streamingmedia.com/tutorials/view.asp?tutorial_id=142

Making Interactive QuickTime Video
By Tim Kennedy
March 24, 2000
smw.internet.com/video/tutor/flashqt

Interactive QuickTime Authoring, Part 2
By Kevin Schmitt
November 4, 2002
www.creativemac.com/2002/11_nov/features/ishell021104.htm
A tutorial to authoring interactive QuickTime movies using Tribeworks' iShell.

Interactive QuickTime Authoring, Part 3: Is LiveStage Professional Totally Hip?
By Kevin Schmitt
November 4, 2002
www.digitalmediadesigner.com/2002/11_nov/features/iqta3021111.htm

Interactive QuickTime Authoring, Part 4: There's QuickTime Authoring Built Into What?
By Kevin Schmitt
January 14, 2003
www.creativemac.com/2003/01_jan/features/qtia40301143.htm

Interactive Presentations with QuickTime
By Kevin Fraser
hotwired.lycos.com/webmonkey/01/06/index4a.html?tw=multimedia

QuickTime with Flash Interactivity Demo
By Douglas Mills
www.iei.uiuc.edu/qt/debate/debate3QTwF.html

Making Interactive QuickTime Video
By Tim Kennedy
streamingmediaworld.com/video/tutor/flashqt/index.html

QuickTime and Flash 5
www.clickandgovideo.ac.uk/qtflash.htm

Flash Corner Archive
blueabuse.totallyhip.com/flash

Web Streaming

Streaming Media
By Warren Ernst
www.pcmag.com/article2/0,4149,907759,00.asp

Detecting Streaming Media Players and Connection Speed Tutorial
By Larry Bouthillier
www.streamingmedia.com/article.asp?id=8396&c=6
A tutorial on writing code to determine which players your users have installed and what
 bandwidth they have available on their Web connection to stream your content.

Streaming Video for the Masses
By Reno Marioni
hotwired.lycos.com/webmonkey/01/03/index4a.html?tw=multimedia

Live Webcast Case Study: Surf's Up
By Chris Courtney
hotwired.lycos.com/webmonkey/01/15/index3a.html?tw=multimedia

Darwin Streaming Server
By Jayson Lorenzen
www.streamingmedia.com/article.asp?id=7705&c=6

QuickTime enhanced sites

BMW Films International
www.bmwfilms.com

QuickTimers
www.quicktimers.com

Streaming Media

Streaming Basics: Editing Video for Streaming
By Tim Kennedy
www.streamingmediaworld.com/video/tutor/streambasics2/index.html

Streaming Basics: Shooting Video for Streaming
By Tim Kennedy
smw.internet.com/video/tutor/streambasics1

QuickTime 4 Begins to SMIL
By Tim Kennedy
smw.internet.com/smil/tutor/qt4smil

Compression and Codecs

Digital Video Compression
www.benwaggoner.com/articles.htm
Various articles by Ben Waggoner.

The Art of Compression
By Nathan Segal
www.streamingmediaworld.com/video/docs//apple

Video Compression: A Codec Primer
By T. Jay Fowler
hotwired.lycos.com/webmonkey/97/34/index1a.html?tw=multimedia

Sure-Fire Tips for Encoding High-Quality, Low-Bandwidth Audio, Parts 1 & 2
By Dee McVicker
www.streamingmedia.com/article.asp?id=8205&c=3
www.streamingmedia.com/article.asp?id=8208

Media Cleaner 5: Streaming Video Compression (3/2001)
www.manifest-tech.com/media_web/cleaner5.htm

Discreet cleaner

Discreet cleaner 6: Video Encoding and Interactive Suite for Macintosh
By David Nagel
www.creativemac.com/2002/11_nov/reviews/cleaner6021112.htm

Cleaner 6
www.computerarts.co.uk/reviews/review.asp?id=1004

Cleaner 6 Direct
www.digitalproducer.com/2002/11_nov/tutorials/11_18/cleanerdirect.htm

Cleaner 6 Review
www.computerarts.co.uk/reviews/review.asp?id=1004

Discreet cleaner 6
www.dvformat.com/2002/11_nov/reviews/cleaner6021112.htm

Media Cleaner Pro: Tutorial
Barb Roeder
www.streamingmedia.com/tutorials/view.asp?tutorial_id=42

Cleaner Pro 5 Tutorials
www.vtc.com/cleaner.htm

Cleaner Tutorial University of Rhode Island
www.uri.edu/artsci/langlab/documentation/cleaner.html

Getting the Most From Cleaner 5
By Barb Roeder
www.streamingmedia.com/tutorials/view.asp?tutorial_id=106

Final Cut Pro

Final Cut Pro Tricks
www.dvguys.com/fcptricks.shtml

Digital Video Editing
By Reno Marioni
hotwired.lycos.com/webmonkey/02/15/index4a.html?tw=multimedia
Features information regarding both Apple iMovie and Final Cut Pro.

Film Versus Video

Film Versus Videotape
www.cybercollege.com/filmtap.htm

How to Make Video Look Like Film
www.dv.com/print_me.jhtml;jsessionid=OOPC5BXFNP43CQSNDBCSKICCJUMEI
 JVN?LookupId=/xml/feature/2002/jackman1202

Achieving the Film Look
By Steve Saylor
www.cyberfilmschool.com/columns/saylor_DV101_4.htm

Choices: Film Versus Video
By Rick Wise
www.rickwisedp.com/film-vid.htm

24p Is Not the Wave of the Future
By Vinson Watson
www.digitalfilmmaker.com/Vinson24P.html

Shoot Video to Look Like Film (Take 2)
By David Crossman
www.videouniversity.com/filmtovi.htm

Making Video Look Like Film
By Shawn Bockoven
www.lafcpug.org/film_look.html

Film Look for Video
www.bealecorner.com/trv900/filmlook.html

How to Make Video Look Like Film
By Benjamin Cooper
www.b-independent.com/production/filmlook.htm

MPEG-4

Tracking MPEG-4 at Streaming Media East
By Barb Roeder
www.streamingmedia.com/article.asp?id=8270

Where Is MP4?
By Joe Zonker Brockmeier
www.newsfactor.com/perl/story/20021.html

Apple Eyes MPEG-4
By Stephen Jacobs
www.streamingmedia.com/article.asp?id=7469

Navigating the MPEG-4 Labyrinth
By Stephen Jacobs
www.streamingmedia.com/article.asp?id=7468&c=7

QTVR

Fill Screen QTVRs Flourish
By Dennis Sellers
maccentral.macworld.com/news/0211/18.qtvr.php

Virtual Reality and Panoramic Imaging
arttech.about.com/library/weekly/aa061899.htm

TechTV 3D Tour Guide
www.techtv.com/screensavers/showtell/story/0,24330,3421807,00.html

Miscellaneous QuickTime Tutorials and Information

Embedding a QuickTime Movie in FrontPage2002
By David Egbert
home.byu.net/%7edle2/tutorials/quicktime_in_frontpage/index.html

Creating Clickable QuickTime Poster Frame Movies
By Adam Pratt
www.golivein24.com/tips/qtposter/index.html

Creating Interactive QuickTime Movies with Wired Sprites
By Adam Pratt
www.golivein24.com/tips/sprites/index.html

Good News for Creating QuickTime on Linux
February 6, 2003
slashdot.org/article.pl?sid=03/02/06/1836210

QuickTime Workshops: Topics and Tutorials
faculty-web.at.northwestern.edu/music/lipscomb/docs/MusicTech/ATMI_02_Quick
 Time/toc.html

Appendix D
Web Exhibition Venues

Many Web movie exhibition sites stream their movies using Real and Windows Media Player technology but do not support QuickTime progressive download, probably because the sites do not want users to make copies of the films they view. Despite this lack of Quick-Time support, these sites are still interesting to surf, if just to see the variety of film, video, and Flash animation out there.

Ifilm.com
www.ifilm.com
This glitzy site is one of the biggest short-film venues on the Internet. Ifilm has incorporated features such as celebrity content that resembles an entertainment magazine more than an independent film venue, but it remains the most popular site of its kind. If your film is not selected for exhibition by the site's screening board, you have the option of pay for play. Does not support QuickTime.

AtomFilms.com
www.atomfilms.com
Second only to Ifilm, this site often features Academy Award best short film contenders and other high-profile shorts. Atomfilms is said to accept one out of four submissions, and some of those have garnered agents for their filmmakers. Partial support for QuickTime.

BijouFlix.com
www.bijouflix.com
The leading subscription site for cult films, archival art films, and B-movies. Some may balk at this kind of pay-for-viewing arrangement, but the fees are actually quite reasonable. No QuickTime support.

Other Venues

UnderGroundOnline
www.ugo.com

UndergroundFilm.com
www.undergroundfilm.com

The Sync
www.thesync.com

Short T.V.
www.shorttv.com

Animation Express
www.wired.com/animation

Wired QuickTime Gallery
www.wired.com/animation/archive.html?QuickTime=1

Appendix E
Bibliography

Blumenthal, Sean. *Learning QuickTime 5 Pro*. Ojai, CA: Lynda.com, 2001.

Breheny, Terry. *The Guru's Guide to QuickTime VR*. San Francisco: Morgan Kaufman, 2003.

Farrell, John. *Digital Movies with QuickTime Pro*. Hingham, MA: Charles River Media, 2002.

Ford, Bradley, et al. *Revolutionary QuickTime 5 and 6*. Birmingham, UK: Friends of ED, 2002.

Gulie, Steven W. *QuickTime for the Web: A Hands-on Guide for Webmasters, Site Designers, and HTML Authors*, ed. 2. San Francisco: Morgan Kaufman, 2002.

Kitchens, Susan. *The QuickTime VR Book. Create Immersive Imaging on Your Desktop*. Berkeley, CA: Peachpit Press, 1998.

Peterson, Matthew and Michael Schaff. *Interactive QuickTime*. San Francisco: Morgan Kaufman, 2003.

Stern, Judith and Robert Lettieri. *Visual Quickstart Guide: QuickTime for Macintosh and Windows*. Berkeley, CA: Peachpit Press, 1998.

Stern, Judith and Robert Lettieri. *QuickTime 6 for Macintosh and Windows: Visual Quickstart Guide*. Berkeley, CA: Peachpit Press, 2001.

Towner, George. *Discovering QuickTime: An Introduction for Windows and Macintosh Programmers*. San Francisco: Morgan Kaufman, 1999.

Waggoner, Ben. *Compression for Great Digital Video: Power Tips, Techniques, and Common Sense*. Manhasset, NY: CMP Books, 2002.

Introductory Quotation Sources

1. "Bill to Linus: You Owe Me. Did Bill Gates Invent Open Source Software? No, But He'll Take Credit For It, Anyway," *I Cringely: The Pulpit,* November 22, 2001, (www.pbs.org/cringely/pulpit/pulpit20011122.html).

2. Desowitz, Bill, "Digital Cinema Gets a Push; Director Robert Zemeckis Helps Create a USC Center That Will Give Students Hands-on Tech Experience," *The Los Angeles Times,* March 4, 2001.

3. *Mercury News,* December 31, 2001.

4. On QuickTime as an editing application, (web.uvic.ca/akeller/pw408/ht_qtpro_basic_editing.html).

5. Apple's master film compressionist, on the intricacies of optimizing Web movie trailers, "The Art of Compression" seminar, QuickTime Live conference, February 12, 2002.

6. QTVR producer, *The QTVR of Janie Fitzgerald,* (www.beatthief.com/four/text/qtvr.html).

7. "The Digital Revolution is a Revolution of Random Access," (www.numeral.com/articles/weinbren/telepolis/telepolis.html).

8. Filmmaker, Savlov, Marc, "The First Broadcast," *Wired News,* October 23, 1998.

Index